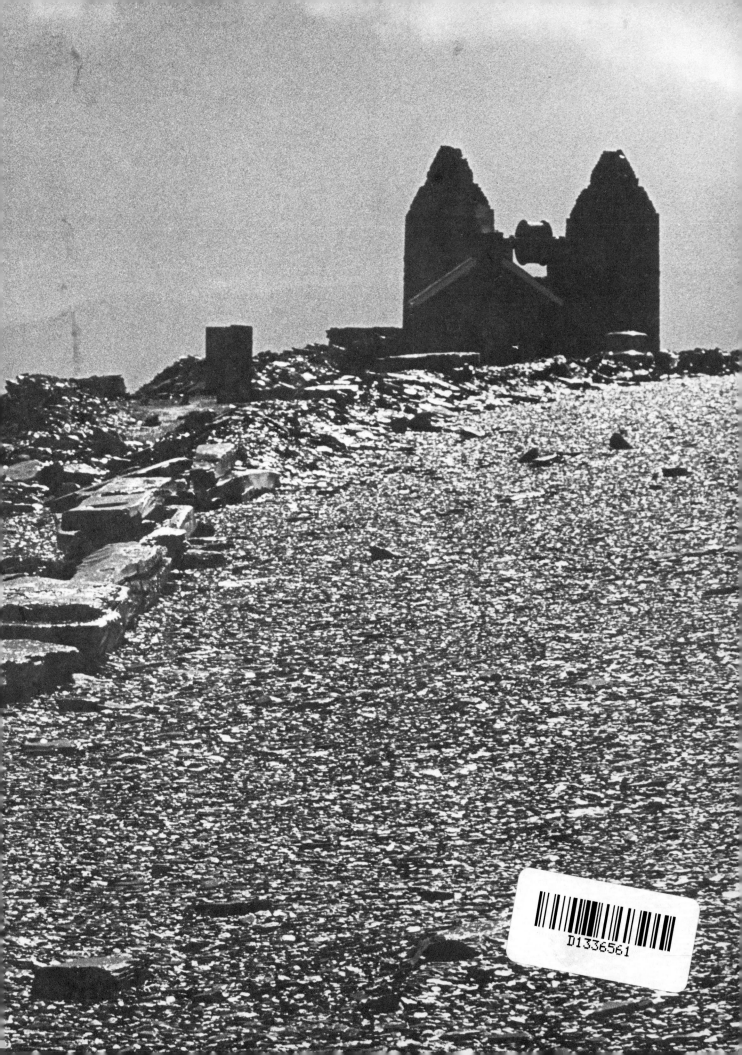

PHOTOGRAPHY YEAR BOOK 1983

INTERNATIONALES JAHRBUCH DER FOTOGRAFIE 1983

Photography Year Book 1983

Edited by R. H. Mason FIIP, Hon. FRPS

**INTERNATIONALES JAHRBUCH
DER FOTOGRAFIE 1983**

FOUNTAIN PRESS

Deutsche Ausgabe: Wilhelm Knapp Verlag, Düsseldorf

Fountain Press Limited
65 Victoria Street,
Windsor, Berks. SL4 1EH
England
ISBN 0 85242 806 5

Deutsche Ausgabe:
Wilhelm Knapp Verlag,
Niederlaśsung der Droste Verlag GmbH
4000 Düsseldorf 1
ISBN 3-87420-146-5

Typography and layout by Kaye Bellman

Origination by Tenreck Limited London

Printed and bound in Great Britain by
W S Cowell Ltd., London and Ipswich

CONTENTS

INHALT

The Photographers/Die Fotografen

Introduction by the Editor

In the space of one year it is impossible to identify any underlying trends in photography, but a study of Photography Year Books over a decade enables one to see quite clearly the changes that have taken place. Many monochrome pictures published or exhibited in 1973 would not gain acceptance today, not necessarily because the subject matter looks old-fashioned, but because the approach and presentation is so different. Likewise, there is no doubt that many pictures exhibited and published today would have gone straight into the waste paper basket ten years ago.

This study would show that good technique was a primary essential formerly, but now the emphasis is on the picture's message, even sometimes at the expense of technique. This is an identifiable trend, but it has taken a decade to make it obvious. In case there is any confusion about the meaning of the word 'Technique' I should explain that in this context it means perfect exposure which produces a full tone scale negative from which a print of sparkling quality with a full gradation of tones and plenty of detail can be made. To quote a cliché used in many circles – "It looks photographic" and it has to be sharp and virtually free from grain. This does not mean to say that pictures were not original or pictorial in the past, but that they had to show good technique before they would be considered.

Many of the black and white prints produced today are deliberately made grainy and they often suppress detail in order to obtain stark contrasts. This has become acceptable because these treatments have been deliberate and therefore sincere, unlike prints which are overprinted or grainy as a result of poor technique. Whether or not today's pictures are good pictures depends on the suitability of the subject for the treatment, and whether they carry a message within a good design. Until a few years ago contrast and grain were a hallmark of the Russian photographers whose prolific portfolios tended to dominate the work submitted for the Year Book. This year, many photographers from other countries and from the United Kingdom have adopted similar methods of presentation. However, the Russians still lead the field in a very creative use of the technique, coupled with multiple printing and some very imaginative ideas.

It is interesting to note that similar trends have arisen in other creative arts, although perhaps over a longer period. Would Picasso have been accepted in the 16th century, Stockhausen in the 18th century or Henry Moore in the 19th? I doubt it – but nobody can deny that by breaking with tradition or convention they have achieved considerable impact. Likewise, the dramatic photographic examples reproduced this year are undoubtedly "eye stoppers" and they have, in my opinion, made this the most exciting collection for some years.

Trends in Colour
Turning to colour, there has been little change. The enormous number of transparencies received were, with a few hundred exceptions, mainly snapshots and postcard views, or technically inadequate natural history studies. The gap between experts and the others is very much wider in the field of colour than black and white. It appears that, even after all these years,

there is still an enchantment with colour itself and this leaves the authors content to "shoot straight" without attempting much creativity or originality of expression. The dramatic rise of interest in Audio-Visual presentations may have something to do with this because their fades and overlaps tend to make slides look more attractive than when viewed individually. Nevertheless, those workers who do produce good colour work are outstanding, although they are fewer than in black and white.

It is also interesting to note that most of them are print workers, no doubt because there is scope for modification, whether the prints are made from colour negatives or colour transparencies. Some very creative colour prints are even being produced from black and white negatives! There is a distinct possibility that a considerable improvement in both the quality and quantity of colour printing may come about in the near future. Many would-be colour workers have been deterred by the necessity for accurate temperature control and the somewhat messy wet processing involved. The newly launched Ektaflex system removes both these disadvantages and provides plenty of opportunity for modification and creative effects. In fact, it has made them really easy. At the time of launching it was only available in paper sizes up to 8 x 10in (20.3 x 25.4cm), but larger sizes will no doubt appear in due course if they have not already. It is worth mentioning that, although 15 x 12in or larger may be desirable for exhibition work, 8 x 10in is satisfactory for reproduction purposes and large enough for shading and other modification work to be carried out.

With transparencies it is a curious fact that the larger sizes are often less creative than the 35mm format.

It comes as no surprise that the best of the sports pictures are in black and white because the majority are taken by press photographers from privileged positions. They have improved their technique enormously in recent years, probably aided by the improvements in cameras and materials. In addition, they show much more originality in the choice of viewpoints as well as subjects. Most of those pictures which show humour are of natural situations spotted by alert pressmen, and they are much funnier and wittier than posed pictures of animals dressed up, or of people pulling faces. The press photographers who work in colour are mainly concerned with magazines and Sunday supplements so their work is more of an illustrative nature than of hot news. A number of these cameramen are producing brilliant work and it has been a pleasure to reproduce some of their photographs in this volume.

Trends in presentation
Whilst it is not easy to identify trends from one year's pictures, I often mentally classify a year's work by a cliché, a gimmick or a subject. For example, last year was "the year of the Cokin", the year before was the "year of the wide-angle close-up" and 1980 was the year of the "funnies". In this vein I could go right back to the early post-war years, one of which I described in my introduction to "Photograms of the Year" as the year of the "sweating close-up" when miners and labourers throughout the country appeared to have been the favourite exhibition subjects.

The reaction to this was the awful year of "September Morn" showing shivering nudes by misty lakes at dawn; and then came the year of the oh-so-formal portraits! The consequence was a return to reality with low angle shots of cloth-capped workers struggling up steep cobbled streets with their loaded bicycles – obviously influenced by Bill Brandt's famous picture in this genre. In fact, one is tempted to think that a lot of work is copyist, or taken under the influence of an innovator.

This year is no exception and I mentally label it as the "year of the black border" because so many pictures from all over the world arrived with black borders as much as three inches wide all round the print – a presentation that was started by the Russians several years ago. It has even spread to colour prints. However, this is only a matter of presentation and I think that there is far less copying of subject matter than before.

It has been said that "father's pictures on the way up to the attic pass grandfather's on the way down" – which is another way of saying that history, or fashion, repeats itself. James Laver once said "A fashion 10 years before its time is indecent; 10 years after it is hideous, but after 100 years it is romantic". This is true of photography as well, and many of the subjects seen this year were popular before the war; only the treatment is different. Many of the romantics are back, so this year's volume has a tremendous variety of styles, subjects and treatments which should together provide pleasant browsing, perhaps stimulate ideas, and form a nostalgic reference in decades to come.

Public Acceptance
The British public has always lagged behind other countries, especially on the Continent, in its acceptance of photography as an art form. Photographers themselves have received little recognition – they are not by-lined so frequently as the writers whose work they illuminate and they are usually depicted on television as either effeminate or moronic – but it is pleasing to note that the prestige of photography and photographers is tending to rise. Prints of distinction are fetching high prices at auctions and good pictures are getting more publicity and exposure. Museum directors and art gallery curators are giving more space to photography and swallowing a former prejudice in favour of painting. These are welcome trends, and it is to be hoped that albums of fine photography such as this will help to encourage a continuance of these trends.

As usual, readers are welcome to submit examples of their best work for possible reproduction in the next volume, and a leaflet outlining the requirements is included in this.

R. H. MASON

Inleiding Door de samensteller

Het is ondoenlijk om in de periode van één jaar nieuwe ontwikkelingen in de fotografie te signaleren, maar als we de tien verschenen jaargangen van het Fotojaarboek doorbladeren kunnen we heel duidelijk de veranderingen zien die hebben plaatsgevonden. Veel zwartwitfoto's die in 1973 zijn gepubliceerd of geëxposeerd zouden momenteel niet langer worden geaccepteerd; niet zozeer omdat het onderwerp uit de tijd is, maar meer omdat de benadering en presentatie zo verschillend zijn. Het lijdt echter evenmin twijfel dat veel van de thans gepubliceerde en geëxposeerde foto's tien jaar geleden regelrecht in de prullenbak zouden zijn beland.

Tot voor kort was een goede techniek de belangrijkste vereiste; tegenwoordig ligt de nadruk op de boodschap van de foto, die soms zelfs ten koste gaat van de techniek. Dit is een aanwijsbare ontwikkeling, maar het heeft ongeveer tien jaar geduurd voordat zij echt duidelijk werd.

Om een veelgebruikt gezegde aan te halen: de afdruk toont alle typische kenmerken die volgens het boekje samen het begrip fotografie vormen; zo moet hij scherp zijn en zonder waarneembare korrel. Ik wil nu niet beweren dat de foto's uit het verleden niet origineel waren of geen zeggingskracht bezaten, maar wel dat zij allereerst moesten voldoen aan de eis van een goede techniek, voordat er aan de inhoud aandacht werd geschonken.

Veel moderne zwartwitfoto's zijn grof van korrel en vaak worden details weggelaten om sterke contrasten te krijgen. Deze werkwijze is acceptabel omdat zij opzettelijk wordt toegepast, in tegenstelling tot afdrukken die te zwart of korrelig zijn als gevolg van een slechte techniek. De geschiktheid van het onderwerp voor een dergelijke behandeling en het uitdragen van een 'passende boodschap' zijn de belangrijkste criteria voor deze foto's. Een jaar of wat geleden waren korrel en contrast het handelsmerk van Russische fotografen, die met hun omvangrijke inzendingen de boventoon voerden in het werk dat werd aangeboden voor het Fotojaarboek. Dit jaar zijn veel fotografen uit andere landen overgegaan tot een soortgelijke presentatie. De Russen lopen echter nog steeds voorop door hun bijzonder creatieve gebruik van de techniek, gekoppeld aan combinatiedrukken en een aantal zeer fantasierijke ideeën. Het is interessant om er hier op te wijzen dat dergelijke ontwikkelingen ook in de andere scheppende kunsten hebben plaatsgevonden, zij het over een langere periode. Zou men Picasso hebben gewaardeerd in de 16de eeuw, Stockhausen in de 18de en Henry Moore in de 19de eeuw? Ik betwijfel het, maar niemand kan ontkennen dat deze artiesten aanzienlijke invloed hebben gehad, juist doordat zij braken met de heersende tradities en conventies. Zo zullen ook de aangrijpende fotografische documenten die u in dit jaarboek vindt ongetwijfeld de aandacht trekken en deze uitgave naar mijn mening tot de boeiendste verzameling van de laatste jaren maken.

Ontwikkelingen in de kleurenfotografie

Kijken we naar de kleurenfotografie, dan bespeuren we weinig verandering. Het enorme aantal ingezonden dia's bestond – met een paar honderd uitzonderingen – voornamelijk uit momentopnamen en ansichtkaartplaatjes, of technisch gebrekkige natuurstudies. De kloof tussen de professionele en de amateurfotograaf is in de kleurenfotografie veel groter dan in de zwartwitfotografie. Na al die jaren blijken nog steeds talloze fotografen geboeid te zijn door de kleuren zelf, waardoor velen van hen tevreden zijn met het simpele plaatjes schieten, zonder naar veel creativiteit of een oorspronkelijke manier van uitbeelden te streven.

Interessant is ook dat de meesten zelf afdrukken maken, ongetwijfeld omdat er dan meer ruimte is voor ingrepen, of de afdrukken nu worden gemaakt van kleurennegatieven of van dia's. Enkele zeer fraaie kleurenafdrukken zijn zelfs gemaakt vanaf zwartwitnegatieven!

De kans is groot dat er in de nabije toekomst een belangrijke verbetering zal plaatsvinden in de kwaliteit en de kwantiteit van de kleurenafdrukken.

Veel kleurwerkers in spe lieten zich afschrikken door de noodzaak van een zorgvuldige temperatuurbeheersing en het bewerkelijke natte procédé van de kleurenafdruk. Het onlangs geïntroduceerde Ektaflex-systeem ruimt deze obstakels uit de weg en verschaft genoeg mogelijkheden voor ingrepen en creatieve effecten. Het maakt deze manipulaties in feite erg gemakkelijk. Ten tijde van de introductie was het Ektaflex-systeem alleen verkrijgbaar in papierformaten tot 20,3 x 25,4 cm, maar de grotere formaten zullen te zijner tijd zeker volgen en zijn misschien nu al verkrijgbaar. Het is de moeite waard om hier te vermelden dat, hoewel het 37,5 x 30 cm formaat of groter wenselijk kan zijn voor tentoonstellingswerk, 20,3 x 25,4 cm voldoende is voor reproduktiedoeleinden en groot genoeg om tegenhouden en andere ingrepen tijdens het afdrukken mogelijk te maken. Vreemd genoeg tonen de grotere formaten kleurendia's vaak minder creativiteit dan het 35mm formaat, maar dit komt waarschijnlijk doordat het grotere formaat meer wordt gebruikt door natuurfotografen en illustrators bij wie, terecht, het maken van een natuurgetrouwe opname met een maximum aan details vooraan staat.

Het is geen verrassing dat de beste sportfoto's in zwartwit zijn. Vele van deze foto's worden genomen door persfotografen vanaf speciale voor hen gereserveerde plaatsen. Zij hebben de afgelopen jaren hun techniek enorm verbeterd, waarschijnlijk geholpen door de ontwikkelingen in camera's en materiaal. Daarnaast vertonen zij veel originaliteit in de keuze van standpunt en onderwerp.

De meeste humoristische foto's zijn afbeeldingen van natuurlijke situaties, die door oplettende persmensen zijn gesignaleerd; deze zijn veel grappiger en spitsvondiger dan de geposeerde foto's van verklede dieren of mensen die gekke gezichten trekken.

Tendensen in de presentatie

Hoewel het niet eenvoudig is ontwikkelingen te signaleren in de ingezonden foto's van één jaar, probeer ik er meestal een cliché voor te bedenken, een gimmick of een bepaald onderwerp dat typerend is voor de nieuwe oogst. Vorig jaar hadden we bijvoorbeeld de Cokin-filters, het jaar daarvoor de groothoek-close-up en in 1980 de 'grappige situaties'. In deze trant kan ik doorgaan tot de vroege naoorlogse jaren, waarvan ik er één in mijn inleiding tot 'Photograms of the Year' omschreef als 'het jaar van de zweterige close-up', omdat mijnwerkers en arbeiders uit de hele wereld het favoriete thema leken te zijn. De reactie hierop was het afschuwelijke jaar van de 'septemberochtend', dat rillende naakten bij mistige meren tijdens het ochtendgloren liet zien, en daarna kwam het jaar van de formele portretten! De consequentie van het voorgaande was een terugkeer naar de werkelijkheid, met opnamen vanuit een laag standpunt van arbeiders met de obligate pet op, die fietsend op steile keienweggetjes heuvelopwaarts ploeterden – kennelijk geïnspireerd door Bill Brandts beroemde foto in dit genre. In feite is men gauw geneigd veel werk als kopieerarbeid te beschouwen, of gemaakt onder invloed van één richtingbepalende fotograaf.

Dit jaar is het opvallend dat veel foto's van een vaak fors zwart kader zijn voorzien; een presentatie waarmee de Russen een paar jaar terug zijn begonnen. Het wordt nu zelfs toegepast bij kleurenfoto's. Het gaat hier echter alleen om een manier van presenteren; wat de onderwerpen betreft is er naar mijn mening veel minder gekopieerd dan in de voorgaande jaren.

Er wordt wel eens gezegd dat 'vaders foto's die naar de zolder verhuizen grootvaders foto's tegenkomen die naar beneden worden gehaald' – een andere manier om te zeggen dat de geschiedenis of de mode zich herhaalt. Van James Laver is de uitspraak: 'Als een mode 10 jaar vóórloopt is zij onbehoorlijk, als zij 10 jaar achterloopt is zij afzichtelijk, maar als zij 100 jaar oud is, dan is zij romantisch.' Dit geldt ook voor de fotografie; veel onderwerpen die nu in de belangstelling staan waren voor de oorlog al populair, alleen is nu de behandeling verschillend. Romantische onderwerpen liggen weer goed in de markt, vandaar dat dit fotojaarboek een enorme verscheidenheid van stijl, onderwerp en behandeling toont.

Algemene erkenning

Het Britse publiek loopt in vergelijking met dat van andere landen, altijd achter als het gaat om de aanvaarding van fotografie als kunstvorm. Fotografen zelf krijgen weinig erkenning; zij worden lang niet zo vaak genoemd als de schrijvers van wie zij het werk illustreren en op de televisie worden zij wel eens afgeschilderd als enigszins verwijfd of apart. Gelukkig lijkt het prestige van de fotografie langzaam aan groter te worden. Bijzondere afdrukken brengen op veilingen flinke prijzen op en opvallende foto's krijgen meer publiciteit en verspreiding.

Museumdirecteuren en galeriehouders gaan meer tijd en aandacht besteden aan de fotografie en proberen hun vroegere vooroordelen ten gunste van de schilderkunst te vergeten. Dit zijn welkome ontwikkelingen en het is te hopen dat uitgelezen fotocollecties zoals deze uitgave een steentje kunnen bijdragen aan het doorzetten van deze ontwikkeling.

Zoals gewoonlijk worden de lezers ook nu weer uitgenodigd om voorbeelden van hun beste werk in te zenden voor een eventuele publicatie in het volgende fotojaarboek. Een informatieblad met de inzendingsvoorwaarden vindt u in dit boek.

R. H. MASON

Einführung des Redakteurs

Innerhalb von einem Jahr können nicht alle in der Fotografie herrschenden Tendenzen festgestellt werden, jedoch zeichnen sich bei Durchsicht des Internationalen Jahrbuchs der Fotografie im Laufe eines Jahrzehnts deutliche Wandlungen ab, die stattgefunden haben. Viele 1973 veröffentlichte Schwarz-Weiß-Bilder würden heute nicht mehr angenommen; nicht, weil ihr Thema altmodisch geworden ist, sondern weil sich Lösung und Präsentation gewandelt haben. In gleicher Weise besteht kein Zweifel darüber, daß viele heute ausgestellte und veröffentlichte Bilder vor 10 Jahren direkt in den Papierkorb gewandert wären.

Diese Untersuchung zeigt, daß früher eine gute Technik von vorrangiger Bedeutung war, heute jedoch die Betonung auf der Aussage eines Bildes liegt, selbst wenn dies manchmal auf Kosten der Technik geht. Das ist eine feststellbare Tendenz, jedoch trat sie erst nach einem Jahrzehnt zutage. Falls Mißverständnisse über die Bedeutung des Wortes "Technik" bestehen, sollte ich erklären, daß es in diesem Zusammenhang perfekte Belichtung bedeutet, so daß ein Negativ mit voller Tonskala entsteht, von dem ein scharf umrissener Abzug mit voller Tonabstimmung und reichlichem Detail angefertigt werden kann. Ein in vielen Kreisen verwendetes Klischee heißt "Es sieht fotografisch aus", und es muß scharf und praktisch körnungsfrei sein. Das bedeutet nicht, daß die Bilder in der Vergangenheit nicht orginell oder bildlich waren, sie mußten jedoch eine gute Technik aufweisen, bevor sie in Erwägung gezogen wurden. Viele der heute hergestellten Schwarz-Weiß-Abzüge sind bewußt körnig gehalten und unterdrücken häufig das Detail, um starke Kontraste zu erzielen. Dies ist annehmbar geworden, weil diese Behandlung bewußt und daher ernsthaft vorgenommen wird, im Gegensatz zu Abzügen, die wegen ihrer schlechten Technik überdruckt oder körnig sind. Die Entscheidung darüber, ob Bilder von heute gut sind, hängt von der Eignung des Themas für ihre Behandlung ab und ob sie bei guter Form etwas aussagen. Bis vor einigen Jahren noch waren Kontrast und Körnung das Merkmal der russischen Fotografen, deren reichhaltige Alben dazu neigten, bei den für das Jahrbuch vorgelegten Arbeiten im Vordergrund zu stehen. In diesem Jahr übernahmen viele Fotografen aus anderen Ländern und aus Großbritannien ähnliche Verfahren für die Präsentation. Die Russen sind jedoch weiterhin führend im sehr kreativen Einsatz der Technik, verbunden mit Mehrfachdruck und sehr einfallsreichen Ideen.

Tendenzen in der Farbe
In der Farbe hat es wenig Veränderungen gegeben. Die enorme Anzahl eingegangener Diapositive war mit einigen Hundert Ausnahmen hauptsächlich Schnappschüsse oder Postkarten-Ansichten bzw. technisch unzureichende naturgeschichtliche Studien. Der Abstand zwischen den Fachleuten und den anderen ist viel größer bei Farbe als bei Schwarz/Weiß. Es scheint, daß nach all diesen Jahren der Zauber immer noch bei der Farbe selbst liegt, und damit bleibt der Fotograf geneigt, eine "einfache Aufnahme" zu machen, ohne große Anstrengungen zu Kreativität oder Originalität des Ausdrucks. Der drastische Anstieg des Interesses an audio-visuellen Präsentationen kann damit etwas zu tun haben, denn durch die Einblendungen und Überdeckungen neigen die Dias zu einem besseren Aussehen, als wenn man sie einzeln sieht. Trotzdem leisten die Fotografen, die gute Farbarbeiten vorstellen, ausgezeichnete Arbeit, obgleich es weniger sind als bei Schwarz/Weiß.

Es ist ferner interessant festzustellen, daß die meisten mit Abzügen arbeiten, zweifellos darum, weil Raum für Änderungen besteht, ganz gleich, ob die Abzüge von Farbnegativen oder Farbdias hergestellt werden. Einige sehr kreative Farbabzüge werden sogar von Schwarz-Weiß-Negativen hergestellt! Es besteht eine eindeutige Möglichkeit, daß in nächster Zeit Qualität und Menge von Farbabzügen wesentlich verbessert werden. Viele, die sich mit Farbaufnahmen befassen möchten, wurden durch die genaue Temperaturkontrolle, die erforderlich ist und die in gewisser Weise unsaubere Naßentwicklung abgeschreckt. Durch das neuerdings eingeführte Ektaflex-System fallen diese beiden Nachteile weg, und es bietet reichlich Gelegenheit zur Änderung und für kreative Effekte. Es hat sie tatsächlich wirklich vereinfacht. Bei der Einführung stand es nur in Papierformaten bis 8 x 10 Zoll (20,3 x 25,4cm) zur Verfügung, jedoch erscheinen zu gegebener Zeit zweifellos größere Formate, wenn sie nicht bereits zur Verfügung stehen. Obgleich 37,5 x 30,4cm oder größer für Ausstellungsarbeiten wünschenswert sind, sollte erwähnt werden, daß 20,3 x 25,4cm für die Reproduktion ausreichen und groß genug zum Abschatten oder zur Durchführung anderer Änderungen sind.

Es ist daher keine Überraschung, daß die besten Sportbilder in Schwarz/Weiß gehalten sind, weil die meisten von Pressefotografen aus privilegierten Stellungen aufgenommen wurden. Sie haben ihre Technik in den letzten Jahren enorm verbessert, wahrscheinlich unterstützt durch die Verbesserungen in Kameras und Materialien. Außerdem weisen sie mehr Originalität in der Wahl von Gesichtspunkten und Themen auf. Die meisten humorvollen Bilder stammen von natürlichen Situationen, die aufmerksamen Presseleuten auffielen, und sie sind viel humorvoller und witziger als gestellte Bilder von bekleideten Tieren oder von Leuten, die Fratzen schneiden. Pressefotografen, die mit Farbe arbeiten, fotografieren in erster Linie für Illustrierte und Wochenbeilagen, so daß ihre Arbeit mehr illustrierender Art ist als daß sie interessante Nachrichten vermittelt. Viele dieser Fotografen leisten brilliante Arbeit, und es war ein Vergnügen, einige ihrer Fotos in diesem Band wiederzugeben.

Tendenzen in der Präsentation
Obgleich es nicht leicht ist, Tendenzen anhand der Bilder eines Jahres festzustellen, klassiere ich häufig im Geist die Arbeiten eines Jahres mit einem Klischee, einem witzigen Einfall oder einem Thema. Das letzte Jahr war z.B. "das Jahr des Cokin", das Jahr davor "das Jahr der Weitwinkel-Nahaufnahme" und 1980 war das Jahr der "Komischen". In dieser Reihe könnte ich bis auf die ersten Nachkriegsjahre zurückgehen, von denen ich eins in meinem Vorwort zu "Fotogrammen des Jahres" als das Jahr der "schwitzenden Nahaufnahme" bezeichnete, als Bergarbeiter und Arbeiter im ganzen Land das beliebte Ausstellungsthema zu sein schienen. Die Reaktion darauf war das schreckliche Jahr des "Septembermorgens" mit bibbernden Nackten an nebligen Seeufern in der Morgendämmerung. Dann kam das Jahr der "Ach-so-formellen Portraits"! Die Folge war eine Rückkehr zur Realität mit Aufnahmen aus der Froschperspektive von tuchbemützten Arbeitern, die sich mit ihren beladenen Fahrrädern steile Pflasterstraßen hinaufkämpften – ein offensichtlicher Einfluß durch das berühmte Bild von Bill Brandt in diesem Genre. Man ist in der Tat versucht zu glauben, daß ein großer Teil der Arbeiten kopiert wurde oder unter dem Einfluß eines "Erneuerers" aufgenommen wurde.

Dieses Jahr ist keine Ausnahme, und im Geiste nenne ich es "das Jahr des schwarzen Randes", denn so viele Bilder aus aller Welt kamen mit schwarzen Rändern bis 7,5cm Stärke um den Abzug an – eine Präsentation, die vor mehreren Jahren von den Russen begonnen wurde. Sie griff sogar auf Farbabzüge über. Das ist jedoch nur eine Präsentationssache, und ich glaube, daß Themen weitaus weniger kopiert werden als früher.

Es wurde einmal gesagt, daß "Vaters Bilder auf dem Weg zum Boden an Großvaters Bilder vorbeikommen, die auf dem Weg nach unten sind". Mit anderen Worten, man sagt, daß sich die Geschichte oder Mode wiederholt. James Laver sagte einmal: "Mode, die ihrer Zeit 10 Jahre voraus ist, ist unanständig; wenn sie ihr 10 Jahre nachhinkt, ist sie häßlich, aber nach 100 Jahren wird sie romantisch." Das gilt auch für die Fotografie, und viele der in diesem Jahr zu sehenden Themen waren vor dem Krieg beliebt, nur die Behandlung ist anders. Viele romantische Bilder sind zurückgekehrt, so daß der Band dieses Jahres aus enorm verschiedenen Stilrichtungen, Themen und Behandlungen besteht, die alle zusammen angenehm durchzusehen sind, vielleicht Ideen schaffen und in einigen Jahrzehnten nostalgische Referenzen sind.

Annahme durch die Öffentlichkeit
Die britische Öffentlichkeit hinkte stets in der Annahme von Fotografie als Kunstform hinter anderen Ländern her, besonders hinter Kontinentaleuropa. Die Fotografen selbst erhielten wenig Anerkennung – sie werden nicht so häufig genannt wie die Verfasser, deren Arbeit sie ergänzen und werden gewöhnlich im Fernsehen entweder als weibisch oder trottelig dargestellt. Es ist jedoch angenehm festzustellen, daß das Prestige von Fotografie und Fotografen zu steigen scheint. Erstklassige Bilder erzielen auf Auktionen hohe Preise, und gute Bilder erhalten mehr Werbung und werden häufiger gezeigt. Museen und Kunstgalerien räumen der Fotografie mehr Platz ein und schlucken ihre frühere Voreingenommenheit zugunsten der Malerei. Das sind willkommene Tendenzen, und wir wollen hoffen, daß Alben der feinen Fotografie wie dieses dazu beitragen, den Fortbestand dieser Tendenz zu unterstützen.

Wie üblich sind unsere Leser eingeladen, Beispiele ihrer besten Arbeiten zur möglichen Wiedergabe im nächsten Band einzusenden. Die Bedingungen für die Teilnahme finden Sie im Handbuch.

R. H. MASON

Introduction par le Rédacteur en Chef

En l'espace d'un an, il est impossible d'identifier des tendances profondes en photographie, mais en examinant les Photography Year Books des dix dernières années nous pouvons voir tout à fait clairement les changements qui ont eu lieu. De nombreuses photos monochromes publiées ou exposées en 1973 ne seraient pas acceptées aujourd'hui, non pas nécessairement parce que le thème paraît dépassé, mais parce que l'approche et la présentation sont totalement différentes. De même, il est certain que de nombreuses photos exposées ou publiées aujourd'hui seraient allées directement dans la corbeille à papier dix ans auparavant.

Il ressort de cet examen que la qualité de la technique était naguère l'élément essentiel, mais qu'aujourd'hui l'accent est mis sur le message de la photo, parfois même aux dépens de la technique. En cas de confusion sur la signification du mot "Technique" il me faut expliquer que dans ce contexte cela veut dire une exposition parfaite qui produit un négatif avec échelle complète des tons, à partir duquel on peut obtenir une épreuve de qualité remarquable avec une gradation complète des tons et quantité de détails. Pour citer un cliché souvent utilisé – "on dirait une photographie", signifiant que cela doit être net et pratiquement sans grain. Cela ne veut pas dire que par le passé les photos n'étaient pas originales ou picturales, mais elles devaient témoigner d'une technique excellente avant de pouvoir être acceptées.

Beaucoup des photos noir et blanc produites aujourd'hui ont un grain délibérément accentué et les détails y sont souvent supprimés afin d'obtenir de forts contrastes. C'est devenu acceptable car ces traitements ont été délibérés et donc sincères, par opposition aux épreuves qui sont surexposées ou grenues à cause d'une technique médiocre. Pour savoir si les photos d'aujourd'hui sont bonnes ou non, il faut voir si le traitement convient au sujet et si les photos transmettent un message dans le cadre d'une bonne facture. Il y a encore quelques années, le contraste et le grain étaient la marque distinctive des photographes russes dont les albums prolifiques tendaient à dominer les travaux soumis pour le Year Book. Cette année, de nombreux photographes d'autres pays, et parmi eux de Grande-Bretagne, ont adapté des méthodes de présentation semblables. Toutefois, les Russes restent les maîtres dans ce domaine où, à une utilisation très créatrice de la technique, viennent s'ajouter les tirages multiples et des idées très imaginatives.

Les tendances de la couleur
En ce qui concerne la couleur, il y a eu peu de changements. Le nombre énorme de diapositives que nous avons reçues était, à quelques centaines d'exceptions près, principalement des instantanés et des vues styles carte postale, ou bien des études d'histoire naturelle techniquement inadéquates. Le fossé entre les experts et les autres est beaucoup plus large dans le domaine de la couleur que dans celui du noir et blanc. Il semble que même après toutes les années d'existence de la couleur, celle-ci continue à exercer un enchantement par elle-même, et les auteurs se contentent donc d'appuyer sur le bouton sans essayer d'exprimer beaucoup de créativité ou d'originalité d'expression. La croissance spectaculaire de l'intérêt pour les présentations audiovisuelles

peut expliquer en partie ce phénomène car les estompages et recouvrements ont tendance à rendre de telles diapositives plus attrayantes que lorsqu'elles sont visionnées individuellement. Néanmoins, les photographes qui produisent du bon travail dans le domaine de la couleur sont remarquables, bien que moins nombreux que dans le domaine du noir et blanc.

Il est également intéressant de noter que la plupart d'entre eux travaillent au tirage; sans doute parce qu'il y a des possibilités de modification que les épreuves soient obtenues à partir de négatifs couleur ou diapositives couleur. Certaines photos en couleur d'une grande créativité sont même produites à partir de négatifs noir et blanc! Il est fort possible qu'une amélioration considérable aussi bien dans la qualité que dans la quantité des tirages en couleur apparaisse très prochainement. De nombreux photographes désirant travailler dans la couleur ont été découragés par la nécessité d'un contrôle précis de la température et par le traitement humide assez salissant. Le système Ektaflex qui vient d'être lancé élimine ces deux inconvénients et apporte de grandes possibilités de modifications et d'effets créateurs. En fait, il a véritablement simplifié leur réalisation. Au moment de son lancement, l'appareil n'était disponible qu'avec un format maximum de 20,3 x 25,4cm, mais des formats plus grands apparaîtront sans doute, s'ils n'existent pas déjà. Il est utile de mentionner que bien que le format 40 x 50cm ou plus grand soit souhaitable pour le travail d'exposition, 20,3 x 25,4cm est satisfaisant pour la reproduction et suffisamment grand pour le dégradé ou autres travaux de modification qu'on désire effectuer.

Il n'est guère surprenant que les meilleures photos de sport soient en noir et blanc car la plupart d'entre elles sont prises par des photographes de presse placés de façon excellente. Au cours des dernières années ceux-ci ont énormément amélioré leur technique, aidés en cela probablement par les améliorations apportées aux appareils et aux produits. En outre, ils témoignent de beaucoup plus d'originalité à la fois dans le choix des points de vue et des sujets. La plupart des photos pleines d'humour sont celles montrant des situations naturelles repérées par des photographes de presse astucieux, et elles sont beaucoup plus comiques et amusantes que des photos où l'on fait poser des animaux habillés ou des gens faisant des grimaces. Les photographes de presse travaillant en couleur sont orientés principalement vers les magazines et les suppléments des journaux du dimanche, aussi leur travail a-t-il davantage un caractère d'illustration que d'information de dernière heure. Un certain nombre de ces photographes font un travail remarquable et nous nous réjouissons de pouvoir reproduire certaines de leurs photographies dans cet ouvrage.

Les tendances dans la présentation
Bien qu'il soit malaisé d'identifier des tendances à partir des photographies d'une année, il m'arrive souvent de classer mentalement l'oeuvre d'une année par un cliché, un "truc" ou un sujet. Ainsi l'an dernier fut l'année du "Cokin", l'année d'avant fut "l'année du gros plan à grand angulaire" et 1980 fut "l'année des comiques". Je pourrais ainsi remonter jusqu'aux premières années de l'après-guerre; j'ai d'ailleurs

surnommé l'une d'entre elles dans mon introduction à "Photographies de l'année", l'année du "gros plan en sueur" car, dans tout le pays, mineurs et travailleurs manuels paraissaient être le sujet préféré dans les expositions, En réaction il y eut ensuite l'année affreuse du "Matin de Septembre" montrant des nus frissonants à l'aube au bord de lacs brumeux, puis vint l'année des portraits "très comme il faut". Ceci eut pour effet un retour à la réalité avec des photos prises près du sol montrant des travailleurs en casquettes peinant le long de rues pavées avec leurs bicyclettes chargées, et influencées de toute évidence par la célèbre photo de Bill Brandt. En fait, on est tenté de croire qu'une grande partie des travaux n'est qu'imitation ou influencée par un innovateur.

Cette année ne fait pas exception à la règle, et mentalement je l'ai qualifiée d'"année de la bordure noire" étant donné le grand nombre de photos prises dans le monde entier qui nous sont parvenues avec des bordures noires, bordures qui ont atteint jusqu'à 7,5 cm tout autour du cliché, présentation qui avait été innovée par les Russes il y a plusieurs années.

On a dit que "les photos du père que l'on monte au grenier se croisent avec celles du grand-père que l'on redescent", ce qui est une autre manière de dire que l'histoire ou que la mode ne fait que se répéter. James Laver a dit un jour "Une mode dix ans trop tôt est indécente; dix ans après elle est horrible, mais 100 ans plus tard elle est romantique". Ceci est vrai en photographie également et parmi les sujets vus cette année nombreux étaient ceux qui furent populaires avant la guerre, seule la manière est différente. De nombreux romantiques sont de retour, aussi le volume pour cette année possède-t-il une variété extraordinaire de styles, de sujets et de méthodes.

La réaction du public
Le public britannique a toujours été en retard par rapport aux autres pays, et en particulier aux pays européens, quant à l'acceptation de la photographie comme forme d'art. Les photographes eux-mêmes ne font pas l'objet d'un très grand intérêt – ils ne sont pas cités aussi souvent que les écrivains dont ils illustrent les oeuvres, et la télévision les dépeint le plus souvent soit comme des efféminés, soit comme des idiots; mais il est agréable de constater que le prestige de la photographie et des photographes a tendance à croître. Les clichés remarquables atteignent un prix élevé aux ventes aux enchères et les photographies de qualité reçoivent davantage de publicité et sont plus connues. Les directeurs de musées et de galeries d'art accordent plus de place à la photographie, abandonnant un ancien préjugé favorisant la peinture. Il s'agit là de tendances dont nous nous félicitons et nous espérons que des albums de photographies de qualité comme celui-ci contribueront à encourager la progression de cette tendance.

Comme d'ordinaire les lecteurs sont invités à présenter des exemples de leurs meilleures photographies susceptibles d'être reproduites dans le prochain volume; et ils trouveront ci-joint une brochure précisant les conditions.

R. H. MASON

Introducción por el Editor

En el corto espacio de un año es imposible identificar cualquier tendencia subyacente de la fotografía, pero el estudio de los volúmenes del Photography Year Book aparecidos en la última década permite ver de un modo claro los cambios que se han producido. Muchas de las fotos monocromáticas que se han publicado o exhibido en 1973 no serían aceptadas hoy, y no porque los temas estuvieran necesariamente fuera de moda, sino porque el tratamiento y la presentación es muy diferente. De la misma forma, gran parte de las fotos que se exhiben y publican actualmente habrían ido directamente a la papelera hace unos diez años.

Este estudio demostrará que anteriormente la técnica correcta era una formalidad esencial, pero que ahora el énfasis está en el mensaje que transmite la foto y no en la técnica. Esta es una tendencia que se puede identificar aunque ha necesitado una década para ponerse de relieve. En caso de que hubiera una confusión a lo que se denomina 'técnica', debo aclarar que en este contexto significa que la correcta exposición produce unos negativos que poseen unas completas gamas de tono, de las cuales se imprimen fotos de brillante calidad con buena gradación de tonos llenos de detalle. Cuando nos referimos al clisé que utilizan muchos círculos, 'Parece una fotografía', queremos decir que es nítida y que la foto está libre de grano. Esto no quiere decir que las fotos del pasado no fueran originales ni pictóricas, sino que además habían de mostrar buena técnica para ser tomadas en consideración.

Gran parte de las fotos en blanco y negro que se imprimen hoy están expresamente hechas con grano y a menudo suprimen los detalles para lograr grandes contrastes. Se ha llegado a aceptar este tratamiento porque es fruto de la sinceridad y está hecho a propósito en lugar de ser el resultado de fotos sobreexpuestas o hechas con malas técnicas.

Que las fotos de hoy sean buenas o malas depende de lo apropiado que sea el tratamiento para el tema y de si el mensaje que conllevan está incluido en un buen diseño. Hasta hace unos años el contraste y el grano eran unas de las características de los fotógrafos rusos, cuyas abundantes participaciones tendían a dominar los trabajos que se presentaban para el Year Book. Este año, muchos fotógrafos del Reino Unido y de otros países han adoptado un método similar de presentación.

Es interesante resaltar que han surgido tendencias similares en otras artes creativas, aunque a través de un período más largo. ¿Se hubiera aceptado en el siglo XVI a Picasso, en el XVIII a Stockhausen o en el XIX a Henry Moore? Dudo que nadie pueda negar el considerable impacto logrado cuando se han roto los moldes tradicionales y convencionales. De la misma forma, los dramáticos ejemplos fotográficos que hemos reproducido este año 'captan la mirada' y, en mi opinión, hacen de ésta la más excitante de las colecciones.

Tendencias en color

En cuanto al color, pocos han sido los cambios. La gran cantidad de transparencias recibidas han sido – a excepción de varios cientos – principalmente instantáneas, postales con alguna vista o estudios de historia natural con una técnica inadecuada. El abismo que separa a unos expertos de los otros es mucho más grande en el color que en blanco y negro. Parece ser que, después de todo este tiempo, el atractivo del color por sí mismo deja a los autores satisfechos cuando disparan directamente en lugar de buscar más creatividad u originalidad en la expresión. El dramático aumento del interés por las presentaciones audiovisuales puede que tenga que ver con ésto, pues el descolorido y la yuxtaposición influye en que las diapositivas sean más atractivas que cuando se las ve por separado.

También es interesante destacar que la mayoría son trabajos de artes gráficas; sin duda, porque hay campo para la modificación, tanto si la impresión viene de un negativo como si lo hace de una diapositiva. También están las impresiones en color hechas con negativos en blanco y negro. Hay que considerar las posibilidades de mejora en la calidad y cantidad de las impresiones en color que vendrán en el futuro.

Muchos de los que serían fotógrafos de color retroceden ante la necesidad de mantener un control de la temperatura y luego por el fastidioso proceso húmedo del revelado. El nuevo sistema Ektaflex ha superado estas dos desventajas y proporciona la oportunidad para que se introduzcan efectos creativos; en realidad, lo ha convertido en un proceso bastante fácil. Al principio sólo venía en papel de tamaño 20.3 x 25.4cm pero si aún no han aparecido tamaños mayores pronto serán una realidad. Hay que mencionar que, aunque para exhibir se prefieren tamaños de 40 x 50cm las de 20.3 x 25.4 son satisfactorias para la reproducción y lo suficientemente grandes para ser descoloreadas o cualquier otra modificación que se desease hacer. Por lo que respecta a las diapositivas, las de formatos grandes se prestan más difícilmente a la creación, que las de 35mm, pero tal vez sea así porque las suelan emplear los trabajadores de historia e ilustradores, quienes, como es lógico, intentan obtener registros que proporcionen el máximo de detalles.

A nadie sorprende que las mejores fotografías deportivas se hagan en blanco y negro, porque generalmente las toman fotógrafos de la prensa situados en lugares privilegiados. También la técnica de éstos ha mejorado en los últimos años a la par de la mejora en las cámaras y resto del material. Además, ha mejorado la selección y originalidad tanto del punto de vista como del sujeto fotografiado. Los fotógrafos de la prensa que trabajan con el color son en su mayoría los de las revistas o suplementos dominicales, para quienes una ilustración de la naturaleza es más importante que la noticia más candente. Una buena parte de estos hombres de la cámara están produciendo un trabajo brillante, y ha sido para nosotros un placer reproducir algunas de estas fotografías en el presente volumen.

Tendencias de la presentación

Si bien resulta difícil la identificación de las tendencias, mentalmente suelo clasificar el trabajo de un año por su cliché, presentación o tema. Por ejemplo, el año pasado fue el año de la "cocaína", el año anterior a éste era el de las tomas "de cerca con gran angular" y 1980 fue el año "de los graciosos". Siguiendo esta línea podría llegar hasta los primeros años de la postguerra, uno de los cuales apareció en la introducción que hice para 'Photograms of the Year' como el año de las tomas "de cerca sudorosas", cuando los mineros y demás obreros del país pasaron a ser los temas favoritos. A éstos les siguió una reacción llamada "duelo de septiembre" donde aparecían temblorosos desnudos cerca de lagos brumosos al amanecer; ¡y luego vino el año de los retratos clásicos! Esto produjo un retorno a la realidad, con instantáneas tomadas, desde puntos de vista bajos, donde aparecían obreros en ropa de trabajo, montados en bicicletas muy cargadas que con dificultad circulaban por calles adoquinadas, consecuencia obvia de la famosa instantánea de Bill Brandt acerca de este género.

Este año no es excepción y mentalmente le llamo "año de los bordes negros" porque una importante cantidad de las fotos tienen un borde negro – hasta de 7.5cm – alrededor de la fotografía. Se trata de una presentación que empezaron los rusos hace unos años. Esta técnica también ha llegado a las fotografías en color. Sin embargo, esto sólo se refiere a la presentación, porque en cuanto al tema, las obras son más originales que como solían ser.

Se ha dicho que "las fotos que hizo papá, y que ahora suben al desván, se encuentran a medio camino con otras que bajan, y que son las que hizo el abuelo", con lo que se quiere decir que la historia y la moda se repiten. James Laver dijo una vez: "Una moda que llega con diez años de adelanto es una moda indecente, si llega con diez de retraso es odiosa, pero si tarda cien años en llegar es romántica." Esto también es aplicable a la fotografía; muchos de los temas que aparecen este año fueron populares antes de la guerra; la diferencia está en el tratamiento.

La aceptación pública

El público británico tiende a quedarse rezagado en reconocer la calidad artística que puede tener la fotografía, con respecto a otros países, sobre todo los europeos. Los propios fotógrafos reciben poco reconocimiento – no suelen recibir mención frecuente, otros, reciben los escritores, e incluso en la televisión suelen ser considerados un tanto afeminados e incluso cretinos; me complace notar que últimamente la fotografía y los fotógrafos están ganando prestigio. Cada vez alcanzan precios más elevados las fotografías que se exponen en las subastas, y las buenas tomas se exhiben con más frecuencia y reciben más publicidad. Los directores de museos y los cuidadores de las galerías de arte están confiriendo espacios mayores a las fotografías, pasando por alto el antiguo prejuicio que se fallaba hacia las obras de pintura. Recibimos con los brazos abiertos todas estas tendencias, y también esperamos que álbumes fotográficos de calidad, como el presente volumen, sirvan para animar la continuación de esta tendencia. Como siempre, los lectores que quieran someter algunos ejemplares de sus mejores trabajos para la posible publicación en el próximo volumen, han de acompañarlos con los requisitos que se detallan en el folleto que acompaña a este que tiene el lector en las manos.

R. H. MASON

Denis Thorpe

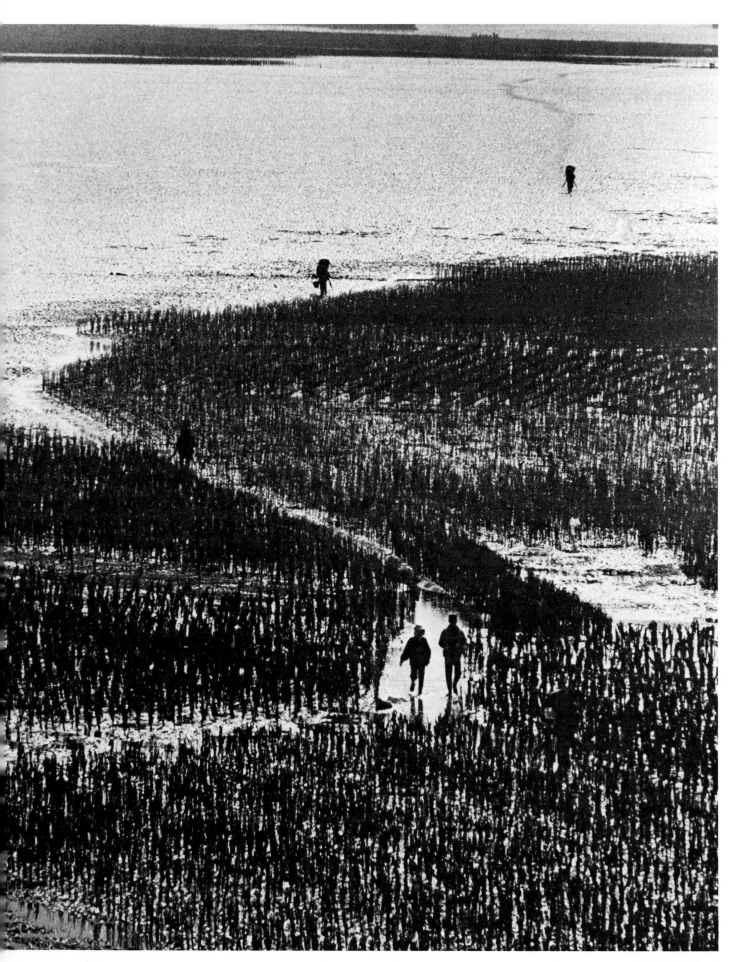

Ha Won Bark

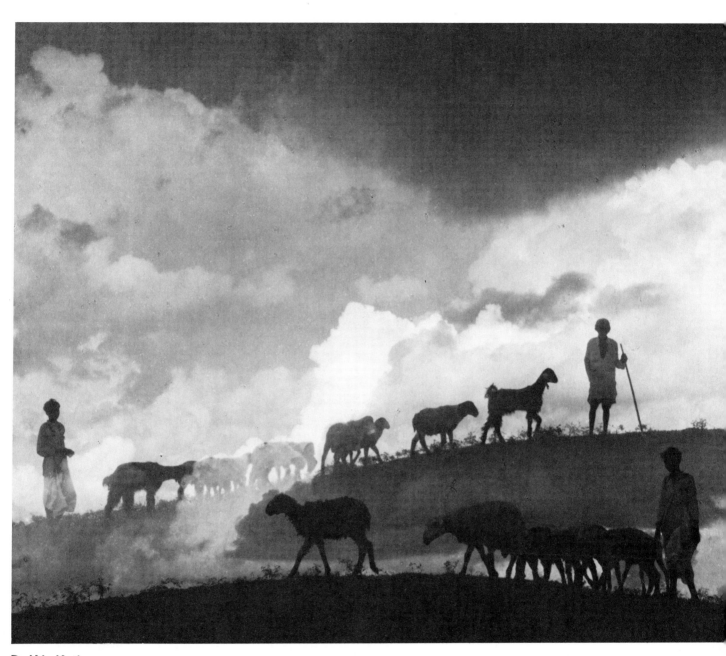

Dr K.L. Kothary

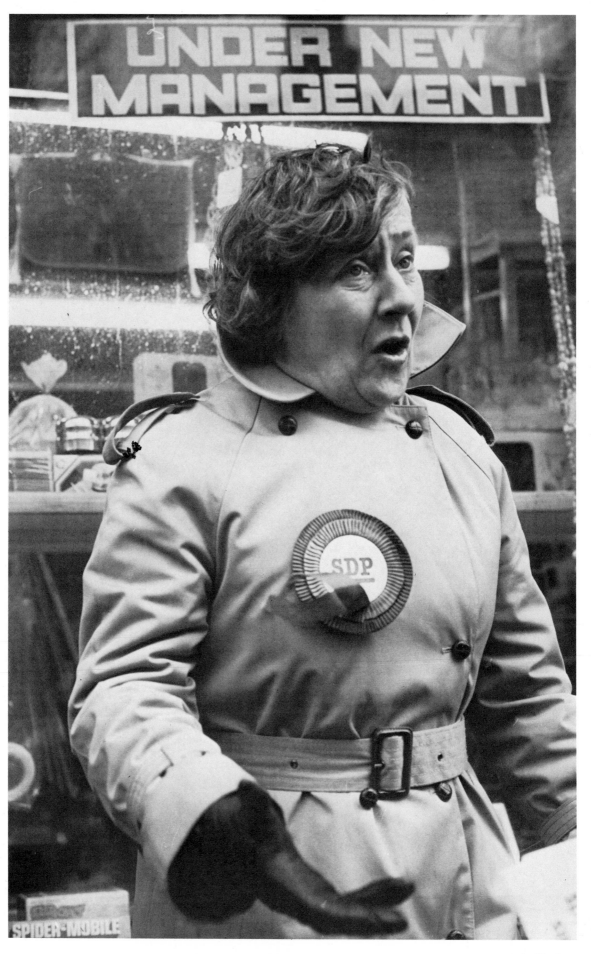

A. Markey

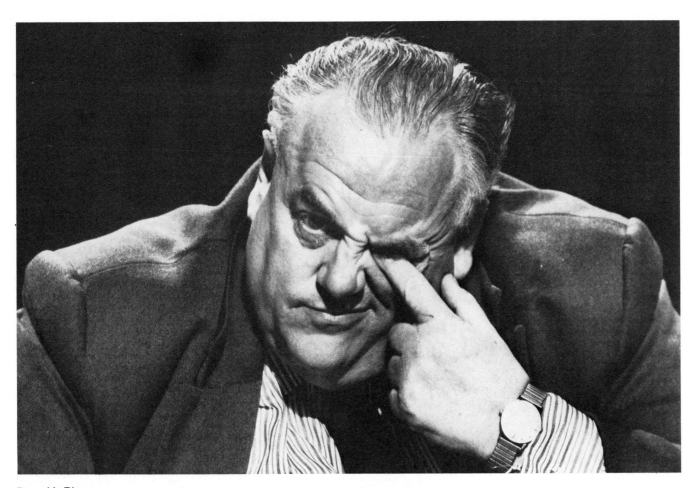

Don McPhee

Mike Hollist

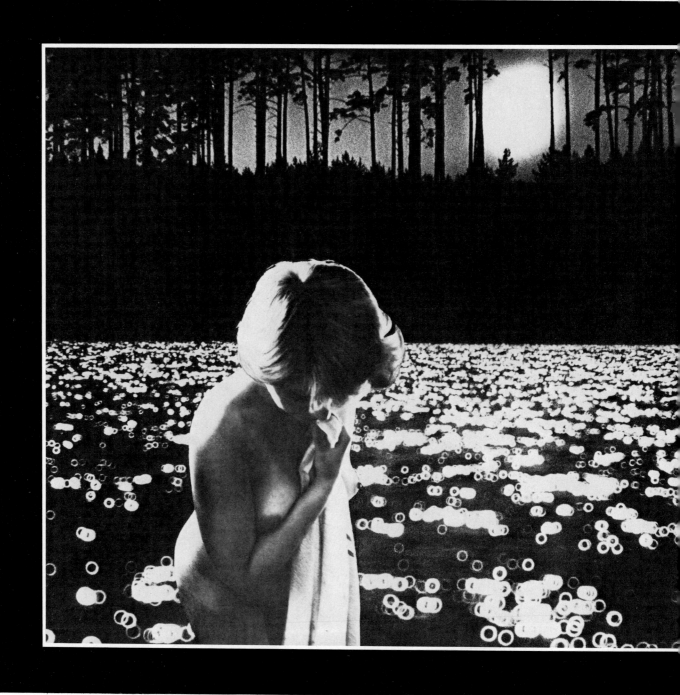

Andrej Lashkov

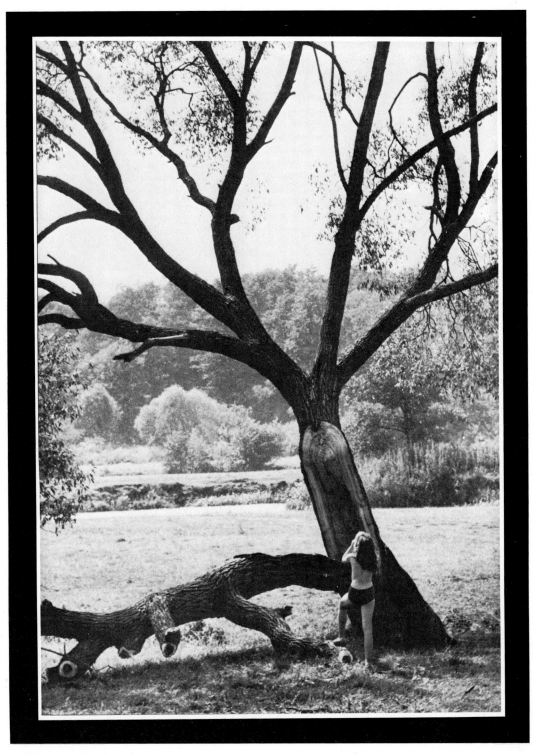

V. Shegelman

Domènec Bataller i Tortosa

Jochen Ehmke

Clive B. Harrison

Jim Chambers

Brian Duff

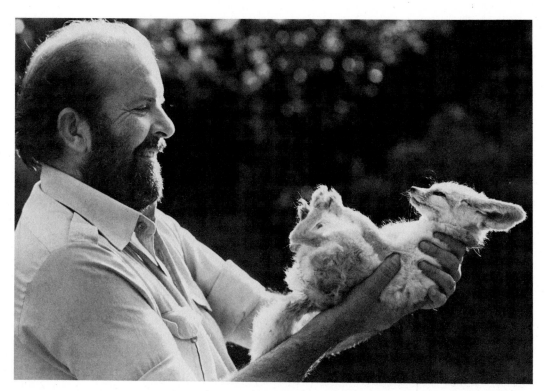

Mike Hollist

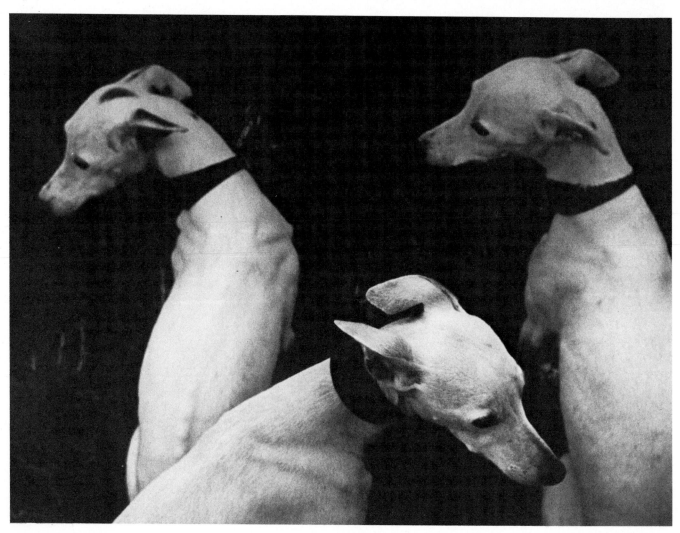

Brian R. Bricknell

Pedro Luis Raota

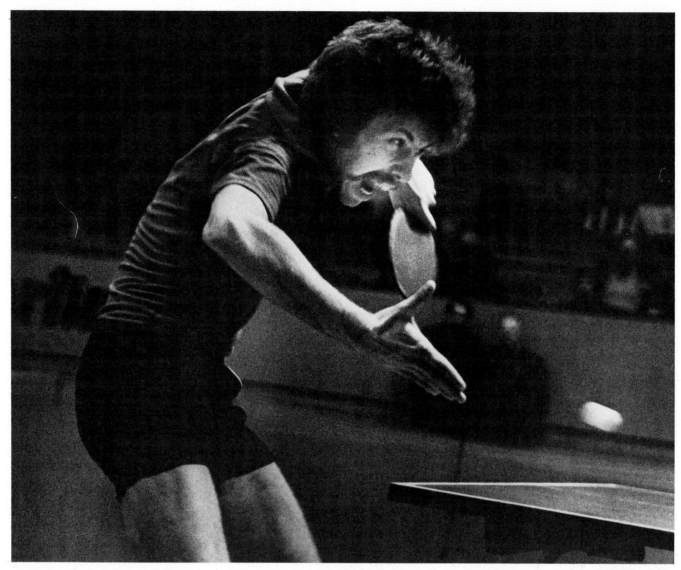

L. Grubinskas

Per-Anders Jörgensen

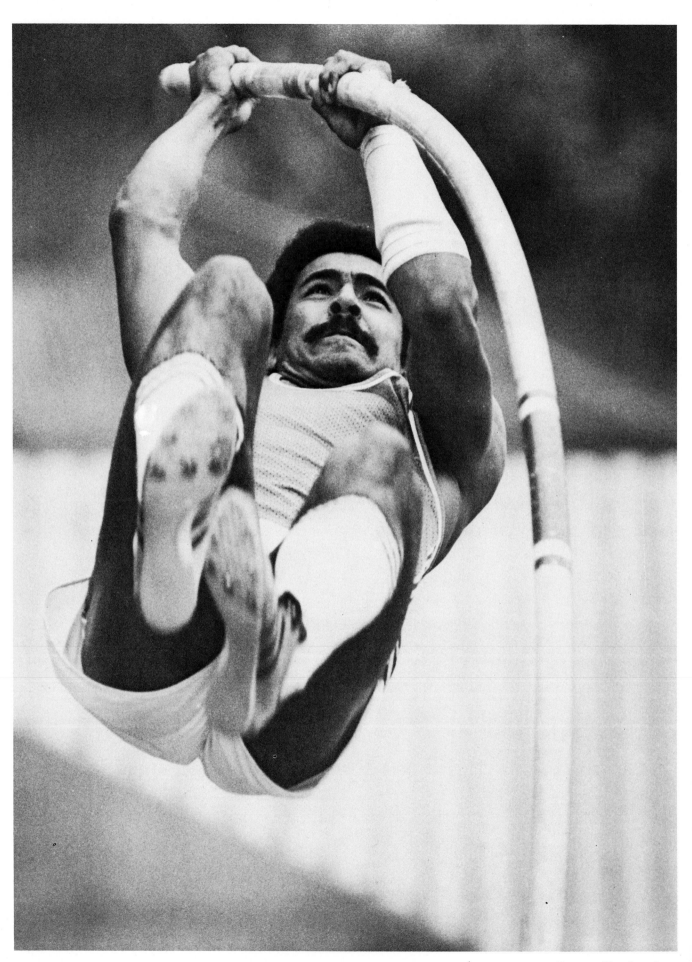

George Herringshaw

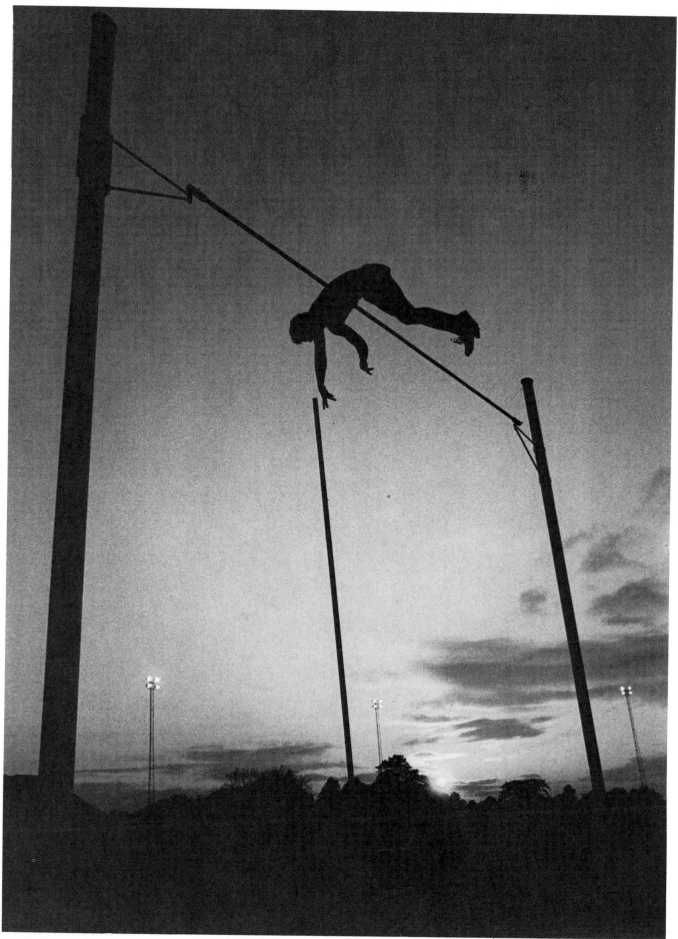

Denis Englefield

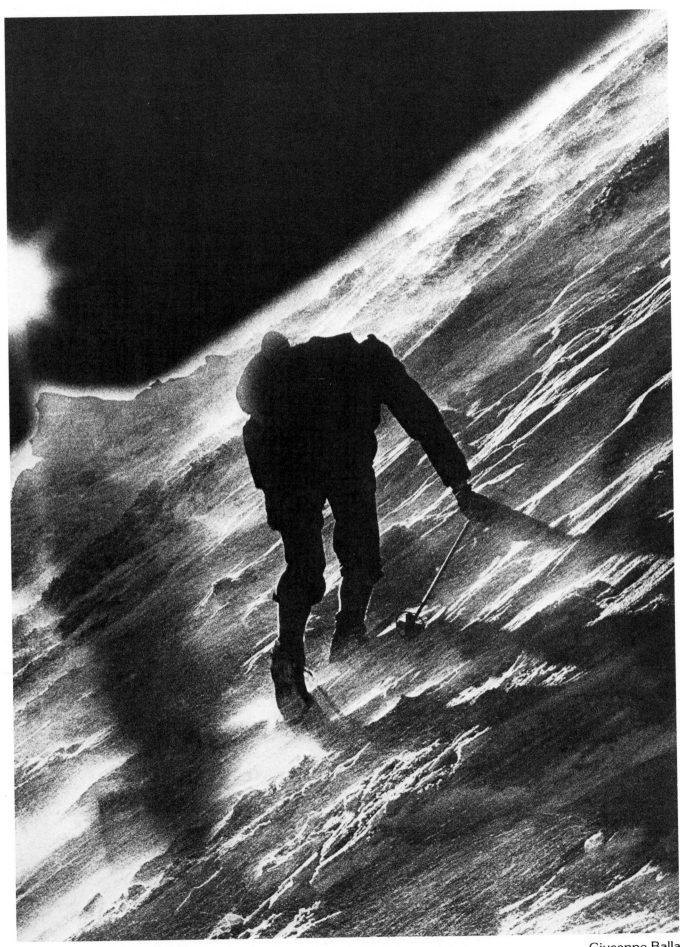

Giuseppe Balla

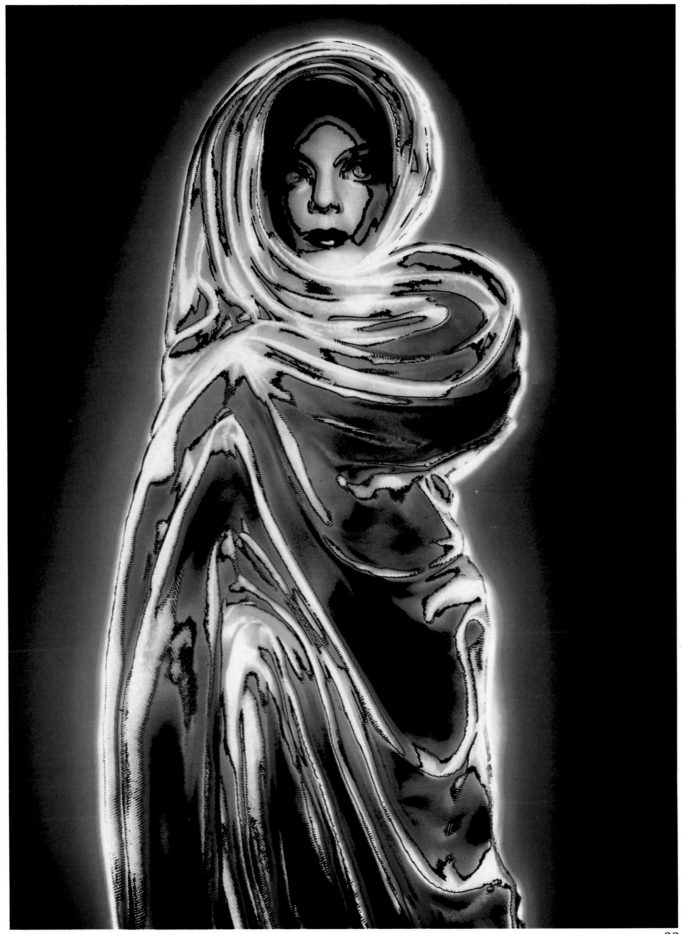

Ozaki Kakuji

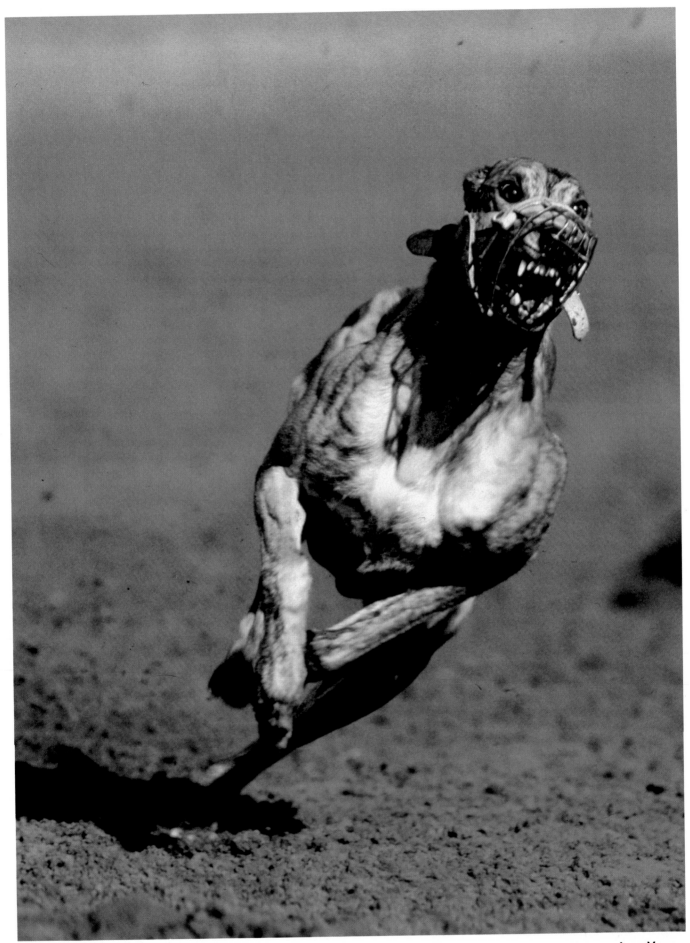

Leo Mason

Joseph Cascio

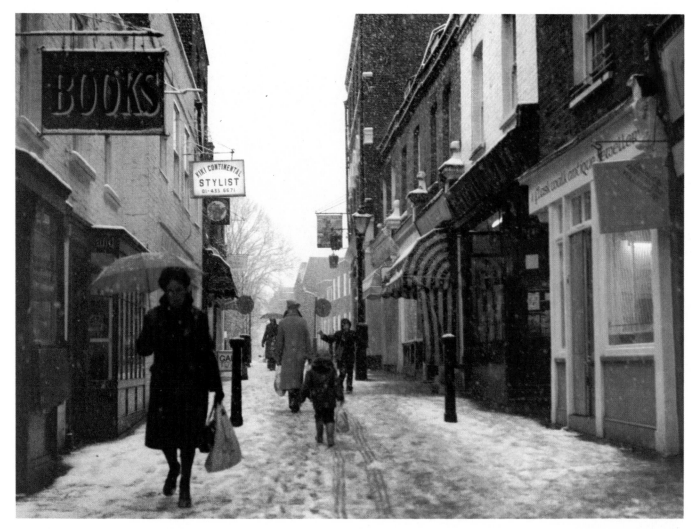

Edward Bowman

Horst Kunert

Josep Maria Ribas I Prous

Ursula Jeffree

Joachim Blanch

John Hillbom

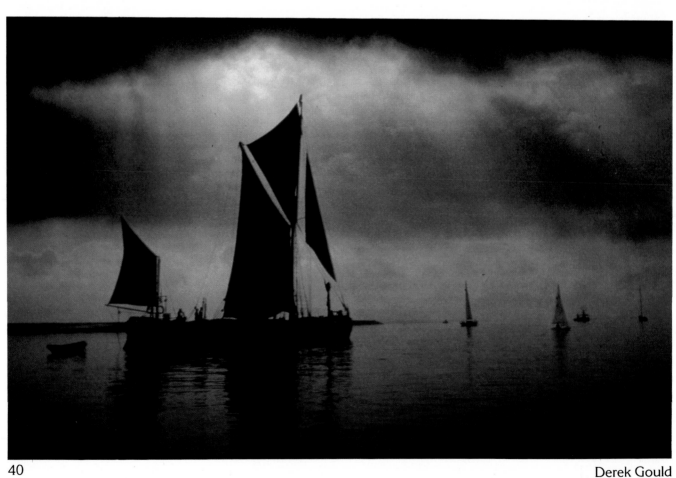

Derek Gould

John Hillbom

42

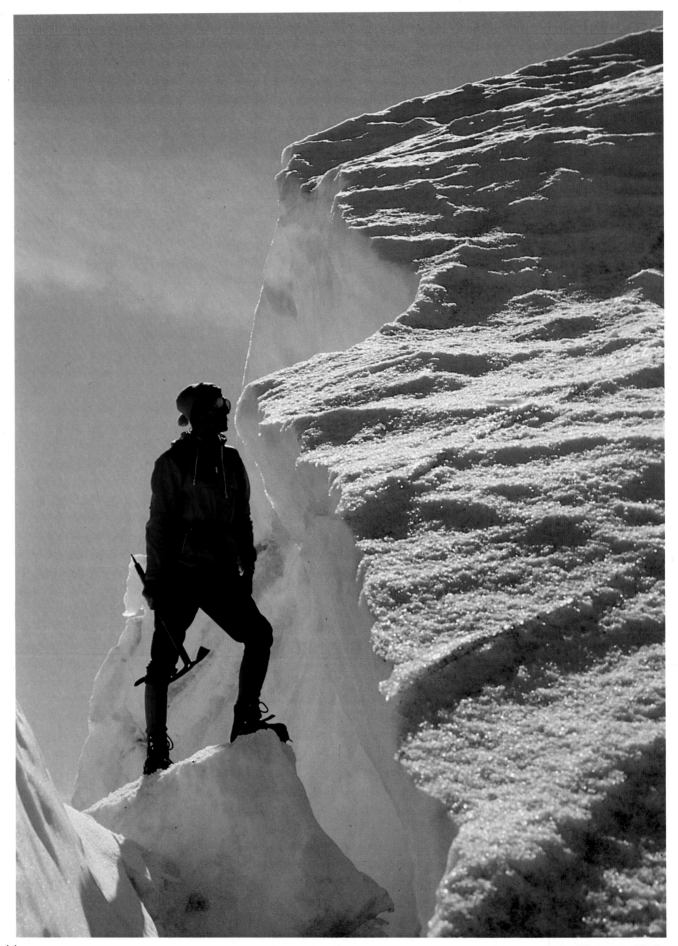

Giuseppe Balla

Leo Mason

Rafael Valor Pascual

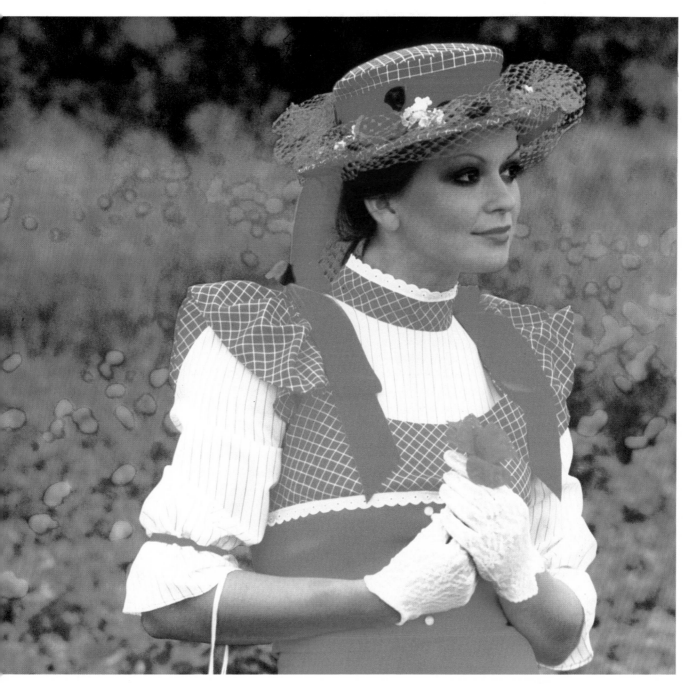

Erwin Kneidinger

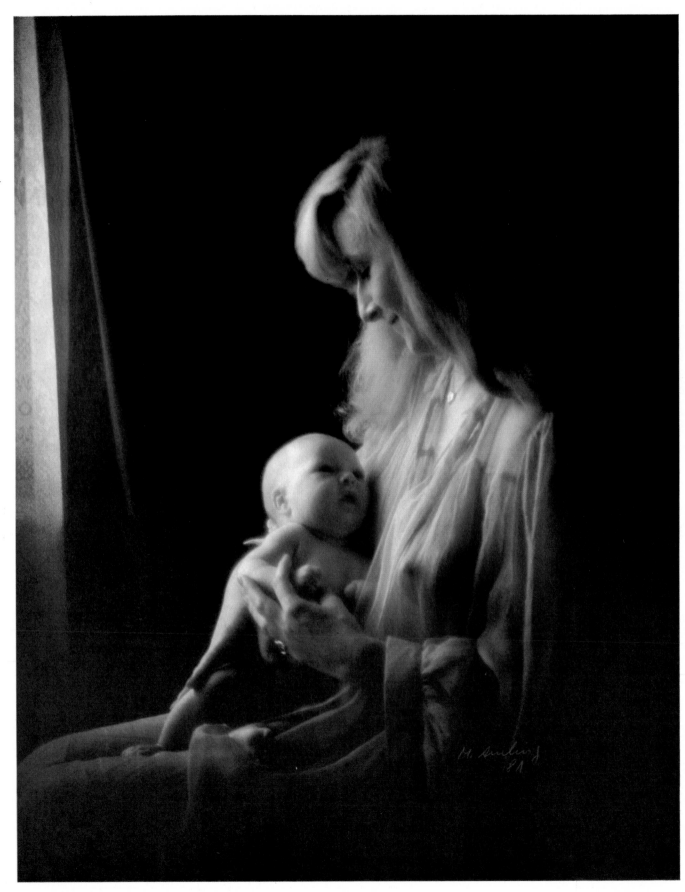

Marlies Amling

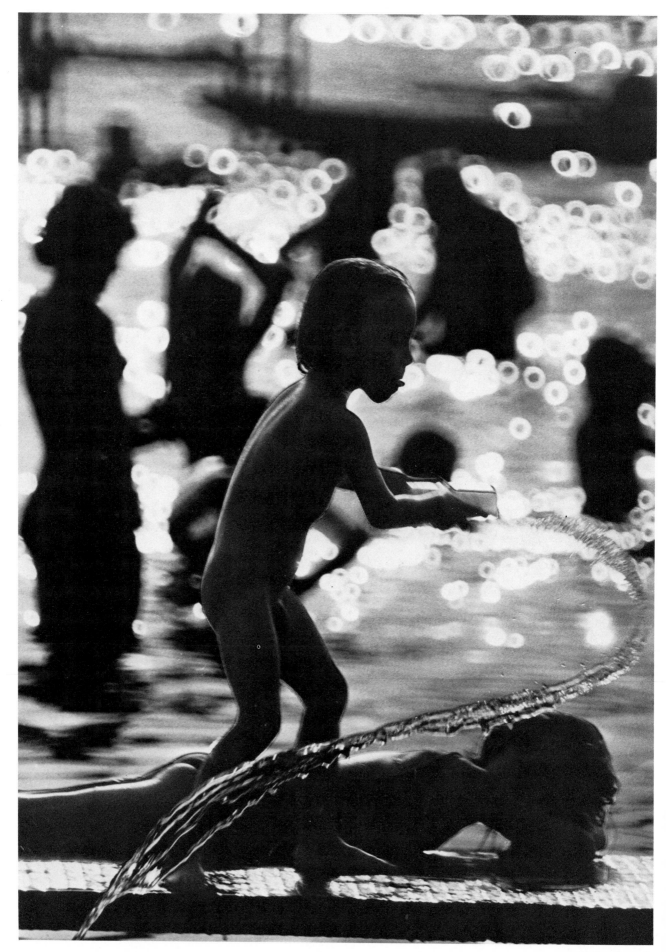

50

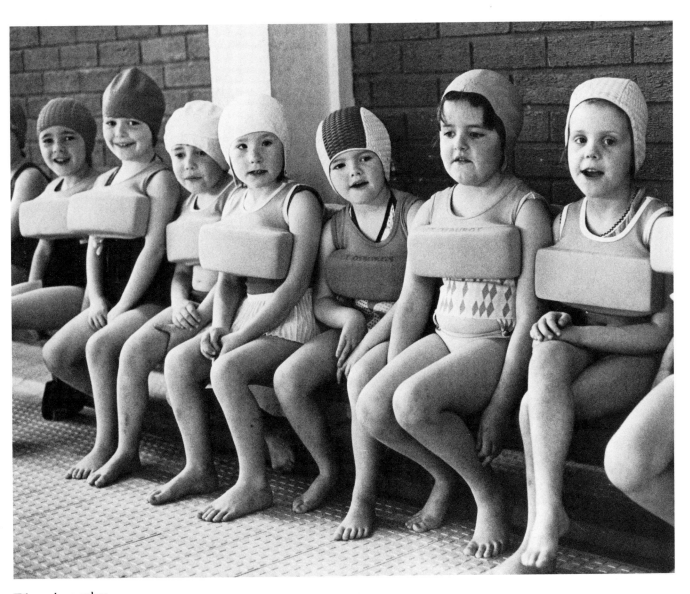

Eileen Langsley

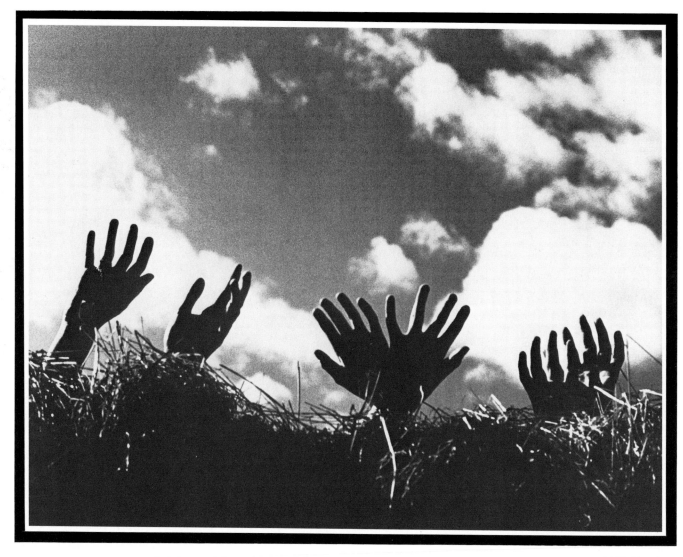

U.E. Baukus

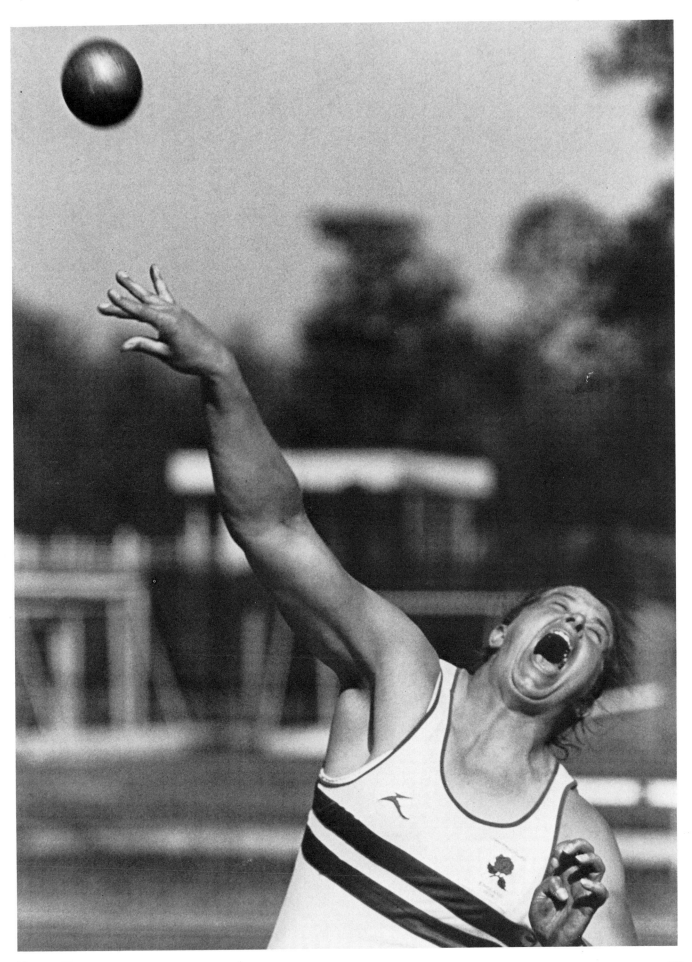

Mervyn Rees

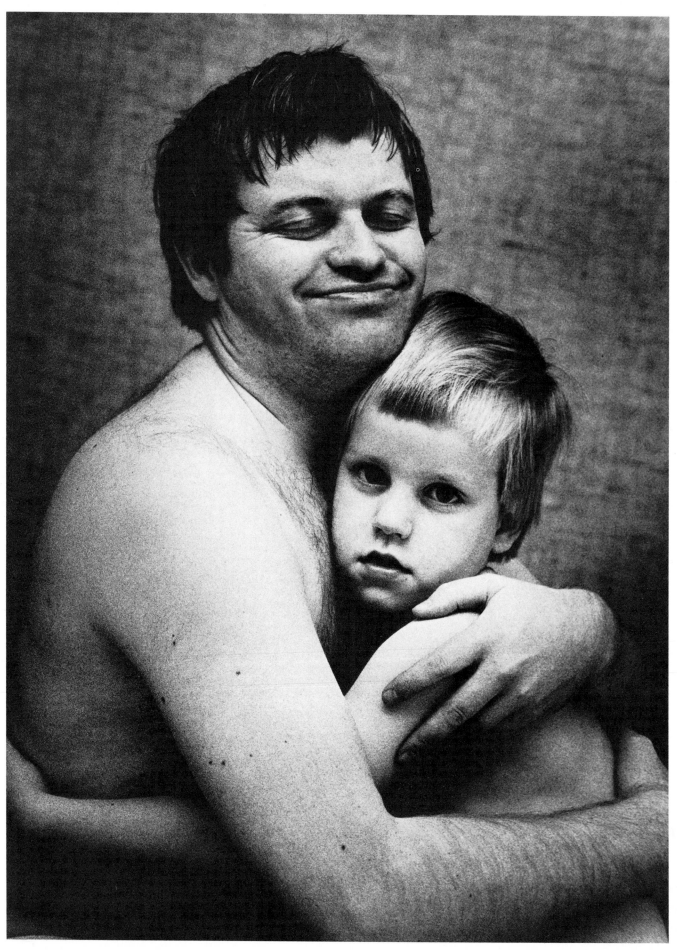

Veikko Wallström

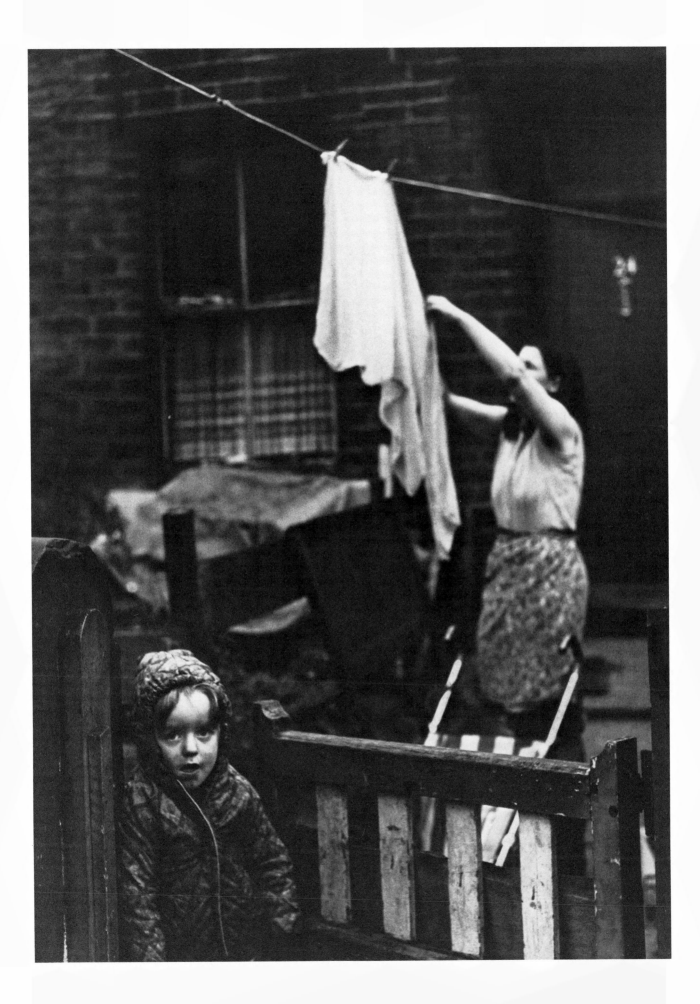

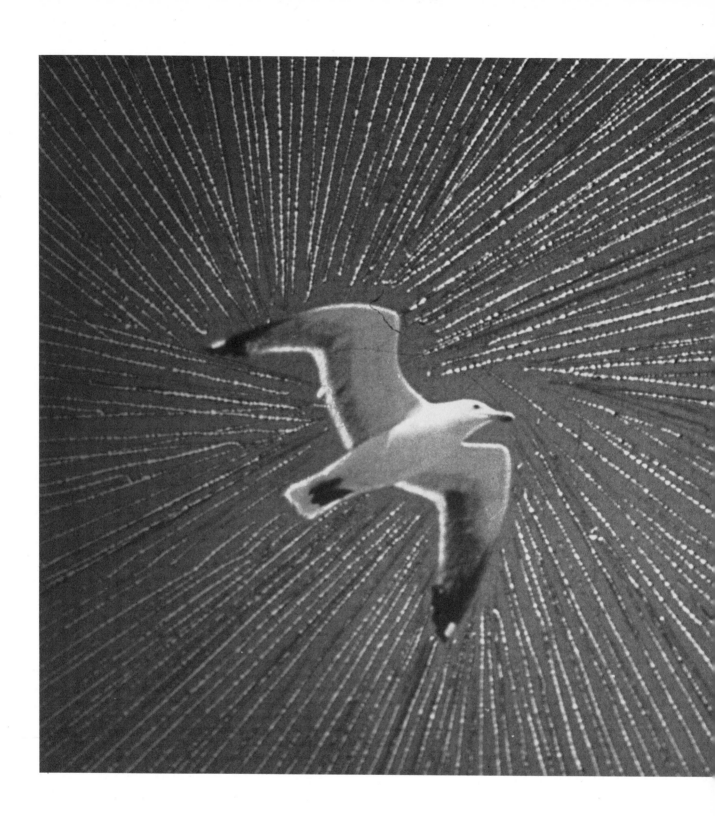

Santokh Kochar

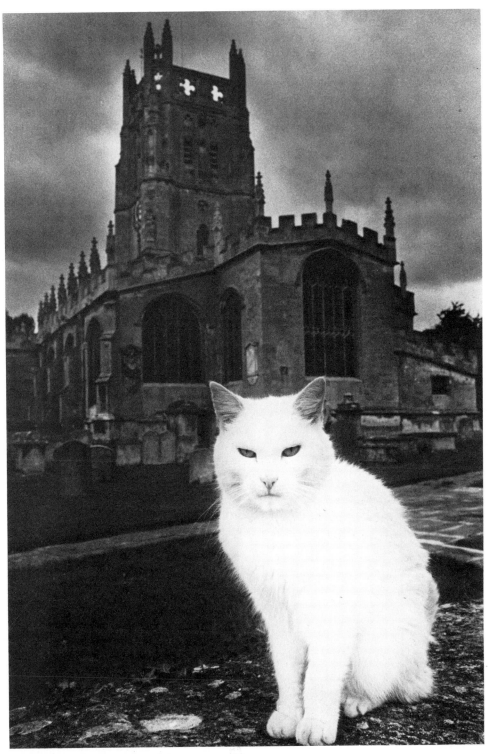

Stephen Whitfield-Almond

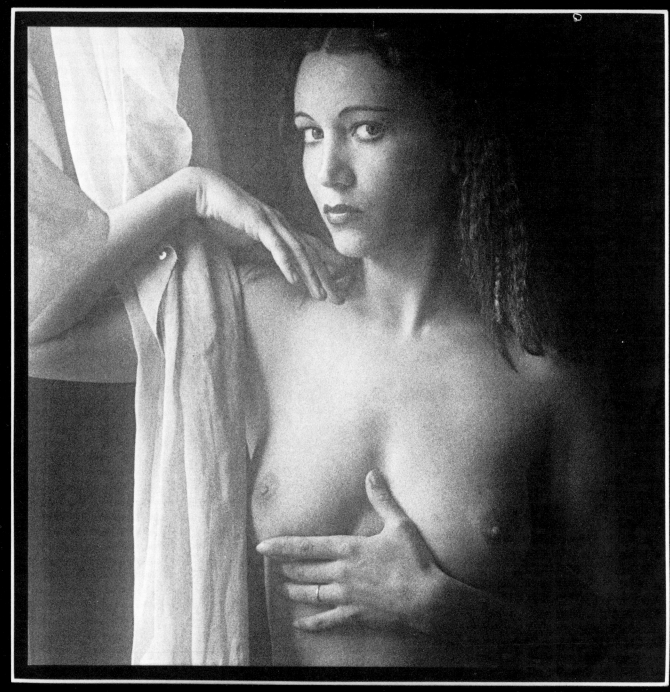

Josep Maria Ribas I Prous

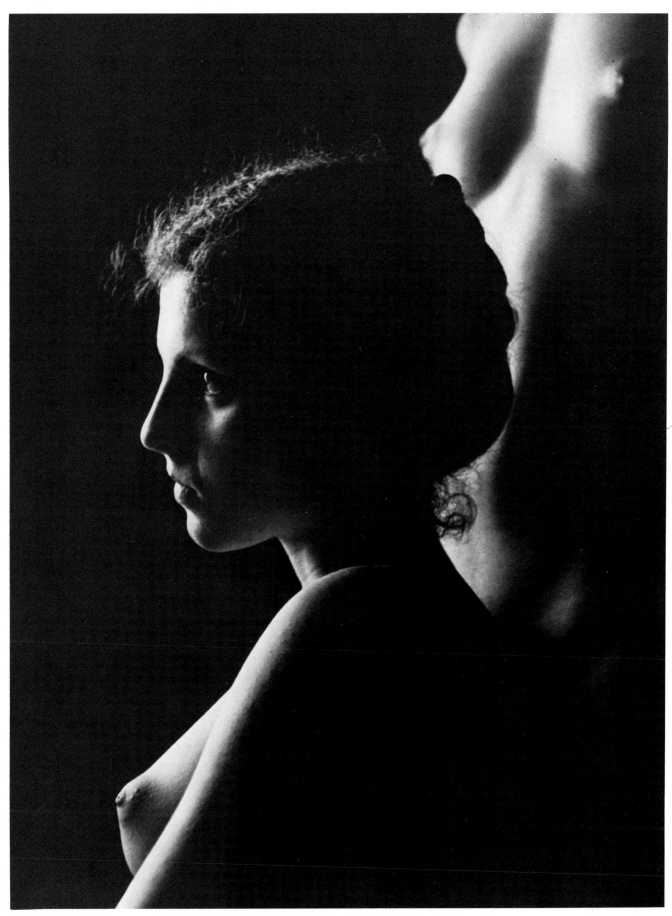

Alena Vykulilova

Gary Browne

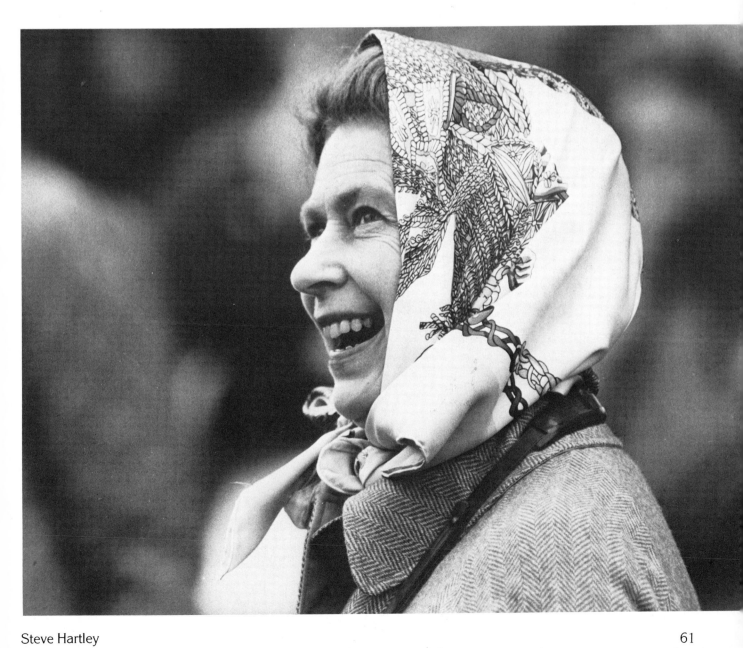

Steve Hartley

C. Churchil

Veikko Wallström

Denis Thorpe

John Davidson

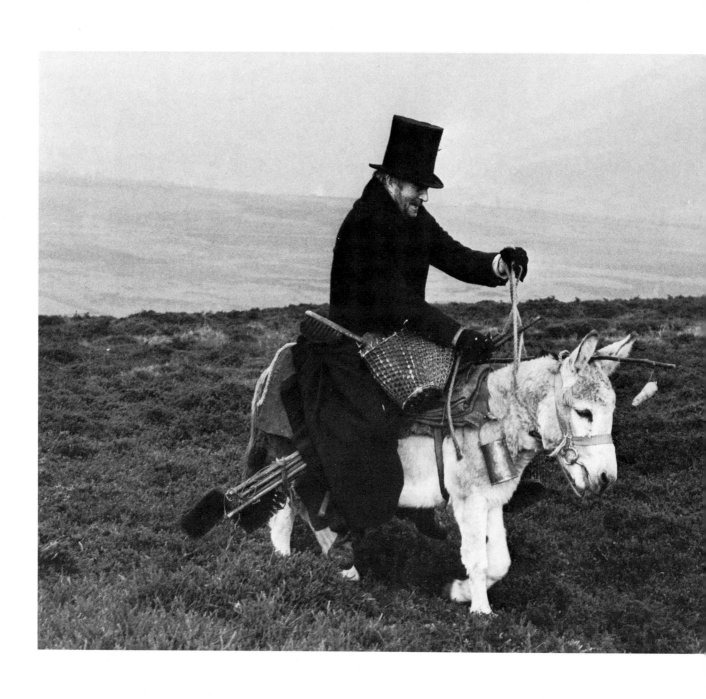

Brian Duff

Neale Davison

Mel Digiacomo

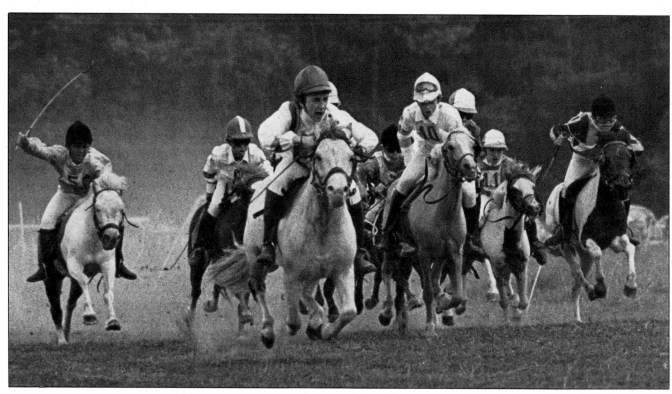

C. Scheurweg

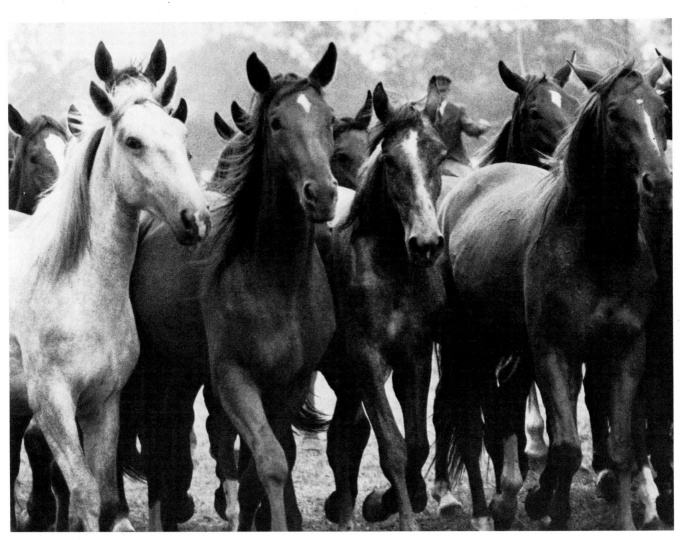

Jan Anděl

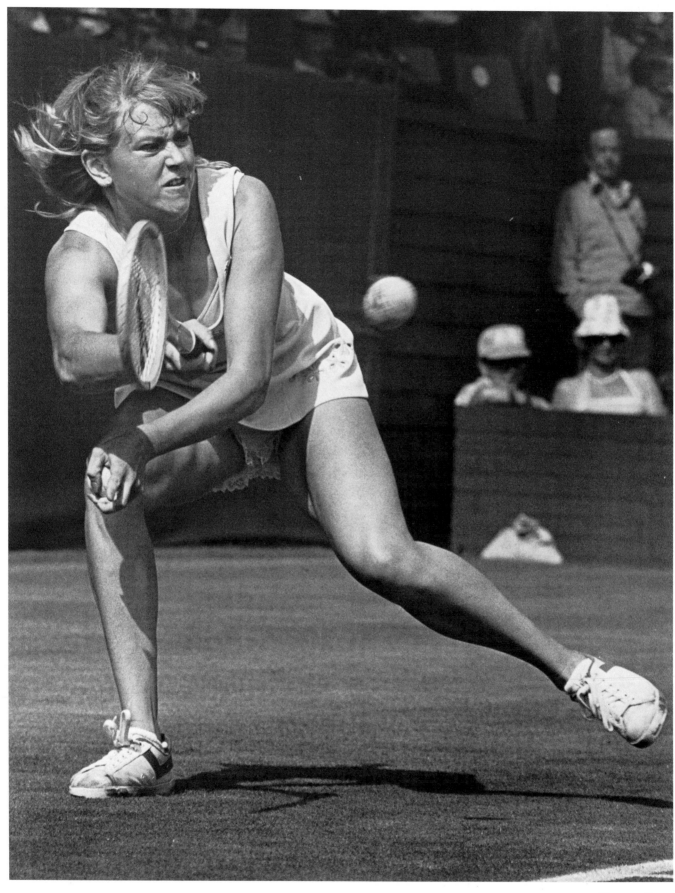

Mervyn Rees

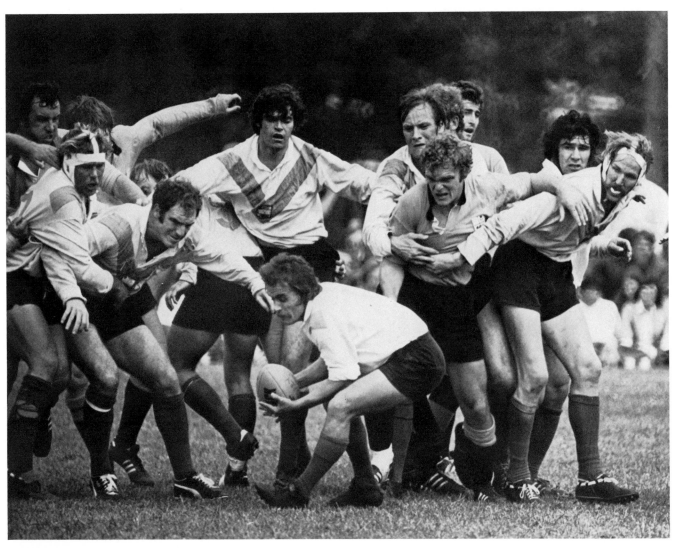

Mel Digiacomo

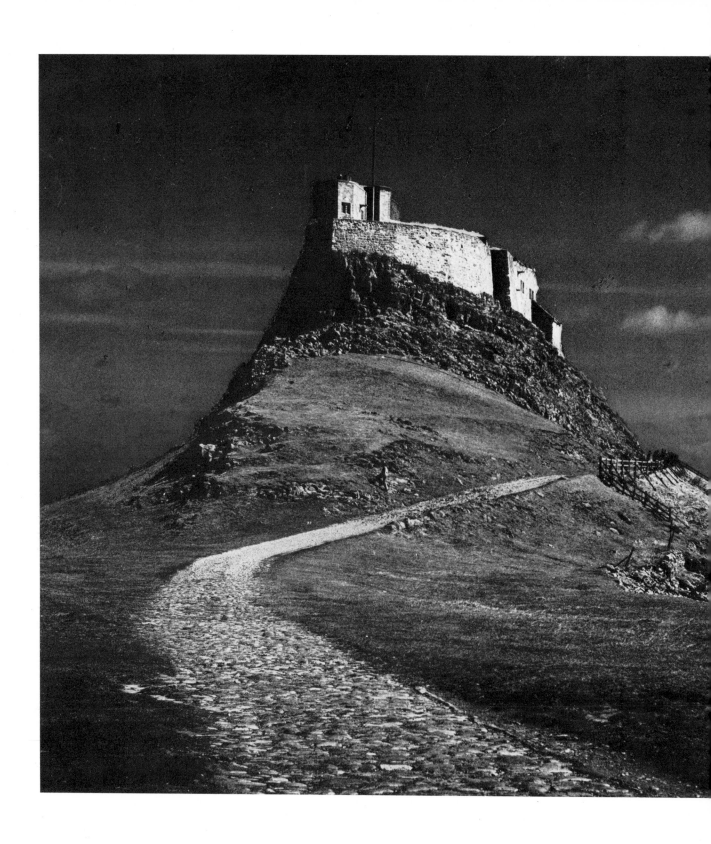

Geoffrey J. Jefferson

M.L. Brehant

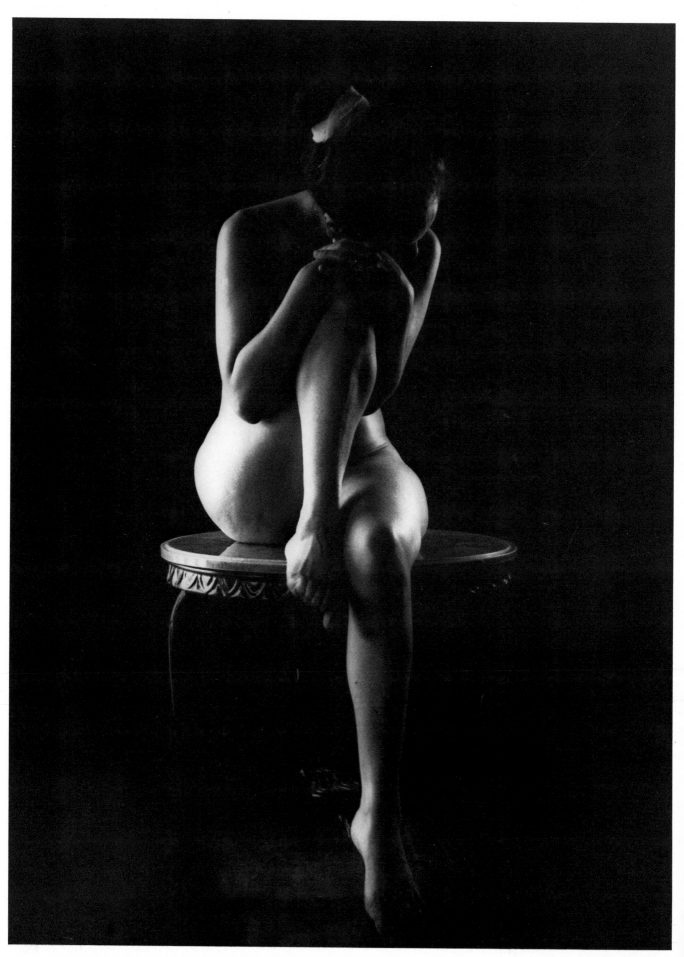

Guillermo Proaño Moreno

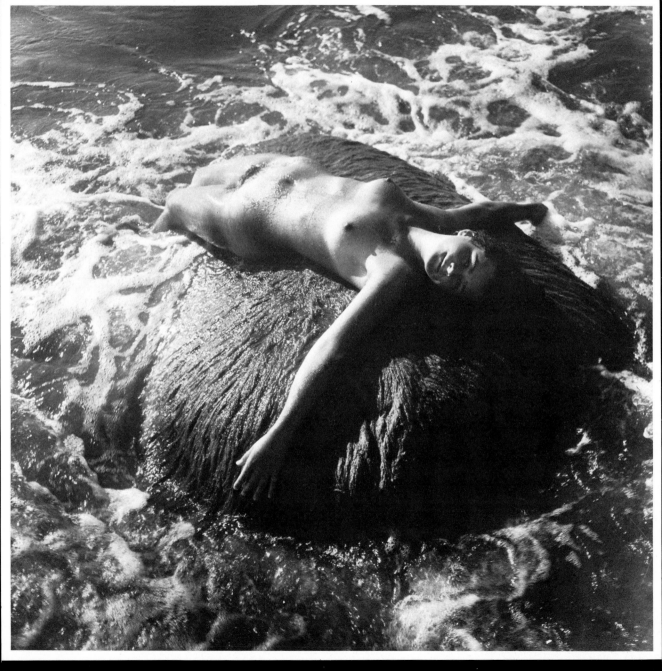

R. Dichavičius

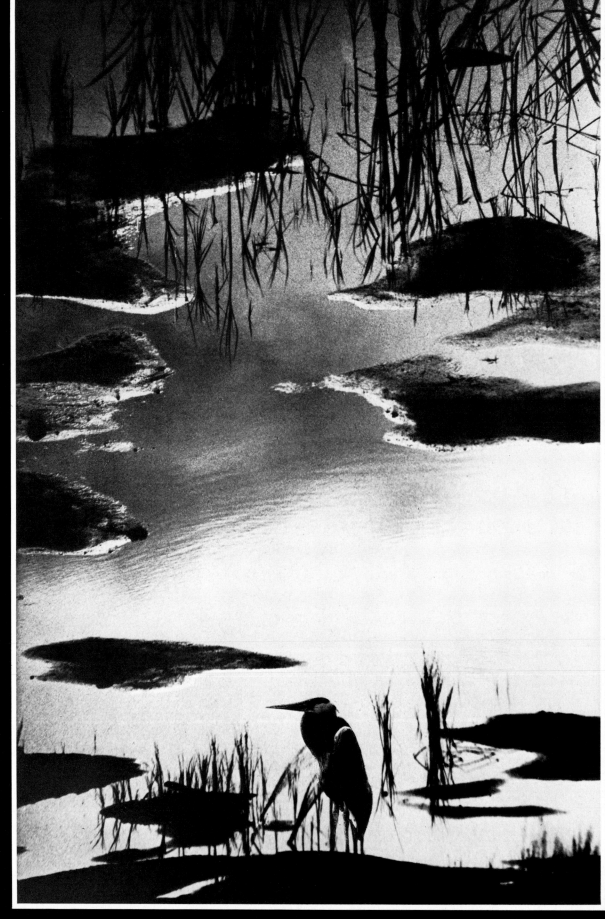

Oleg Burbowski

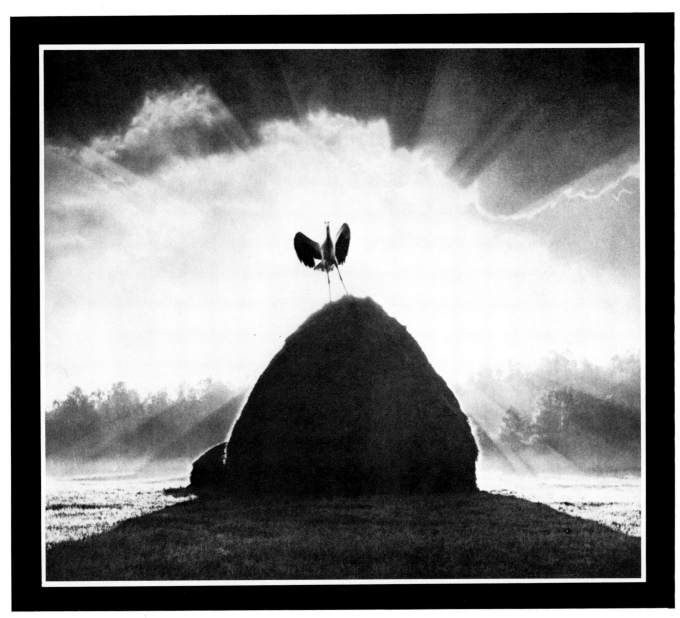

Pavel Tishkovski

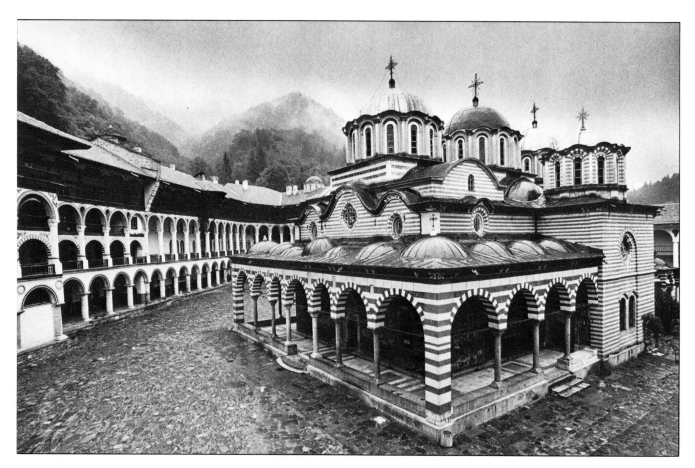

Jiři Bartos

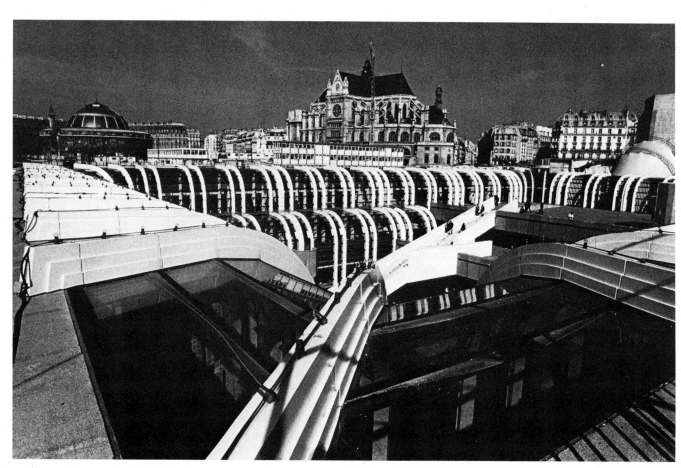

Peter Hense

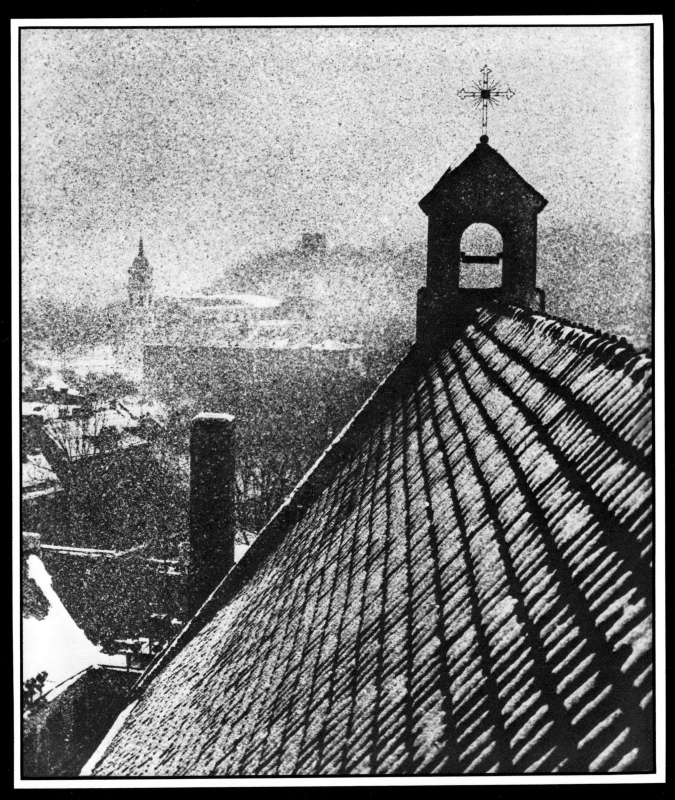

A.M. Cerniauskai

Mike Brett

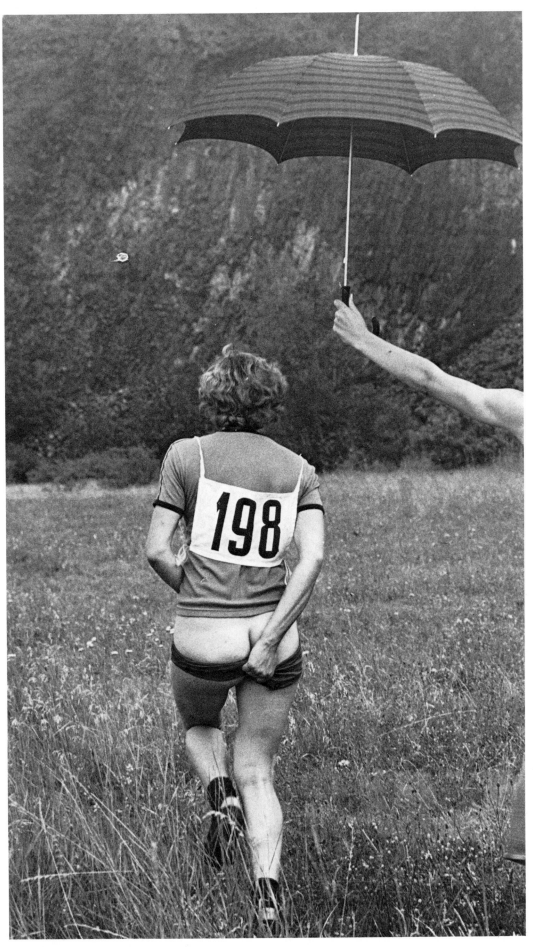

V.L. Pokorny

Cori Pedrola

Cori Pedrola

Willy Hengl

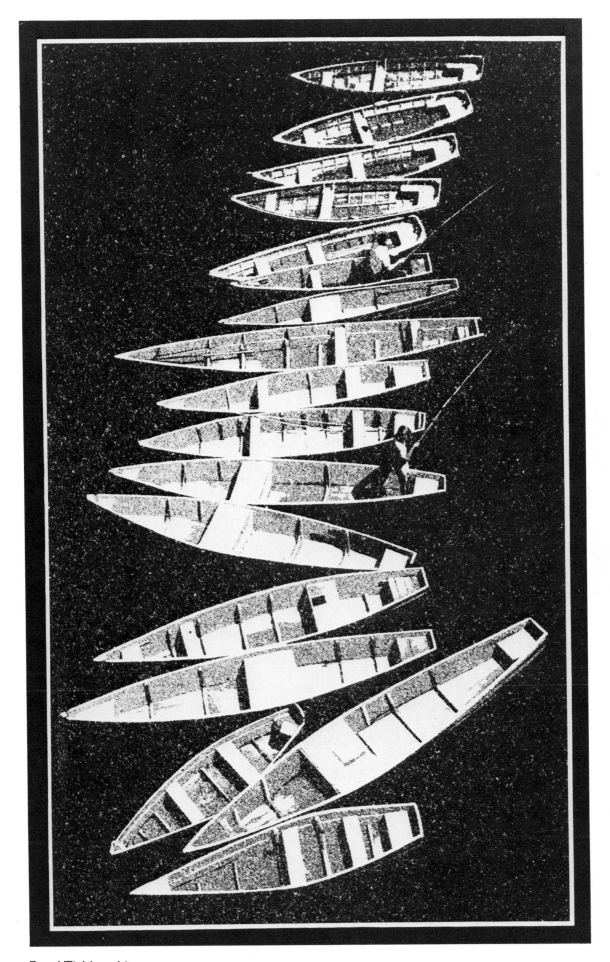

Pavel Tishkovski

Giuseppe Balla

Erwin Kneidinger

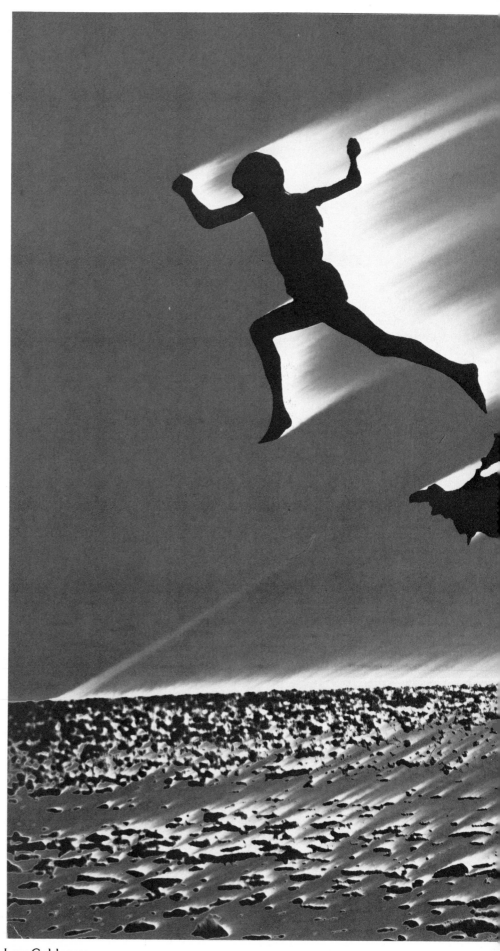

Lew Gelderman

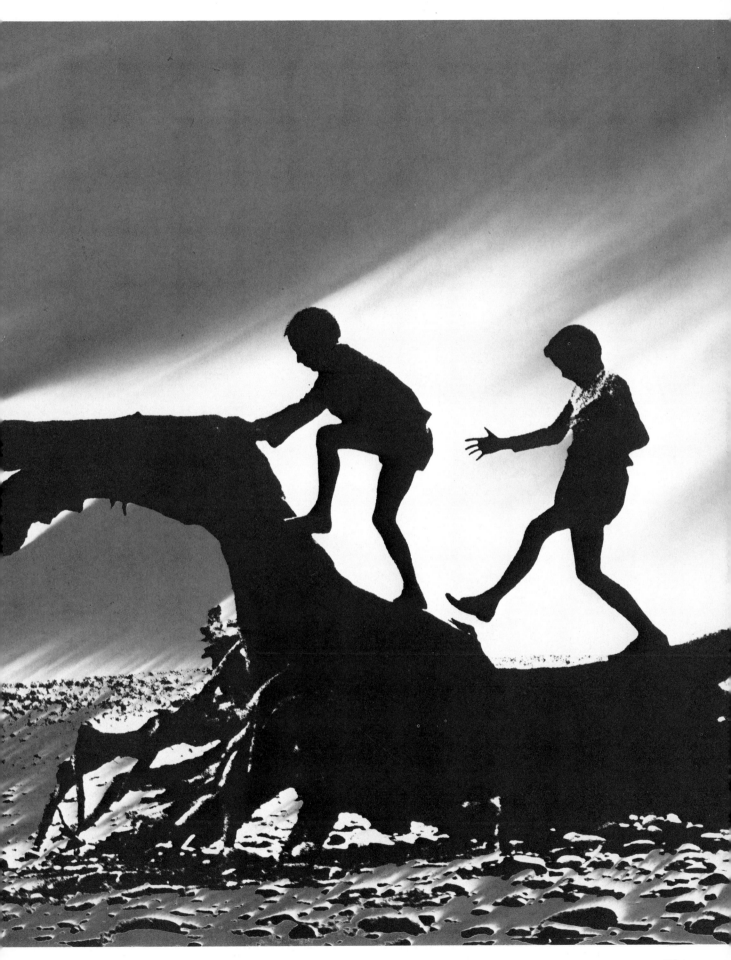

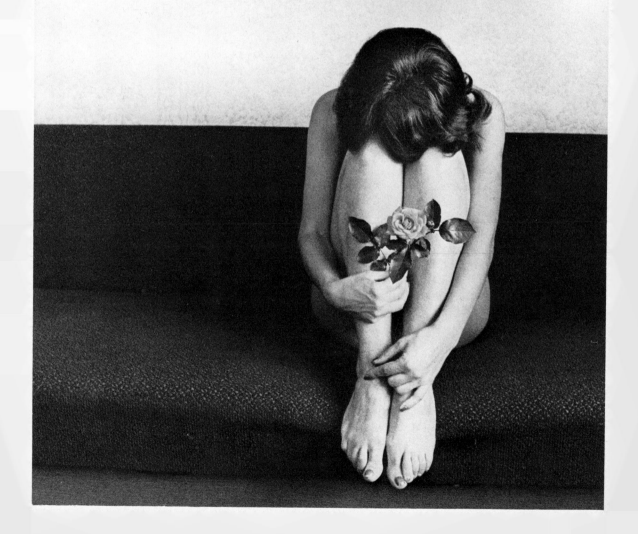

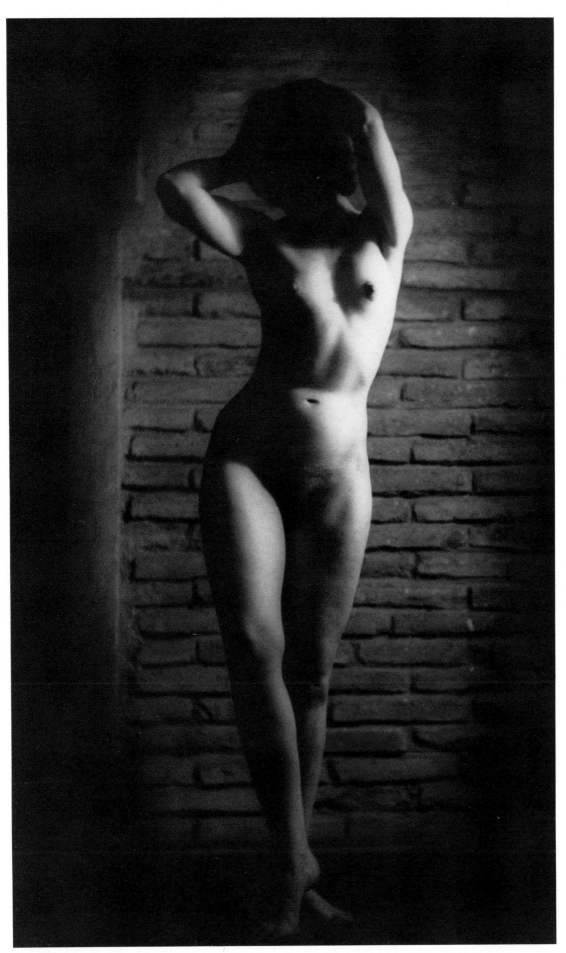

Guillermo Proaño Moreno

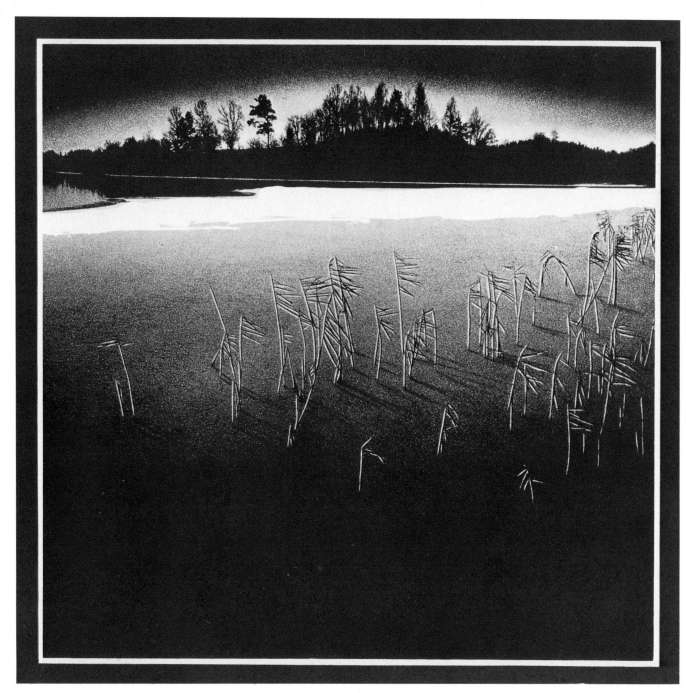

Z. Bulgakovas

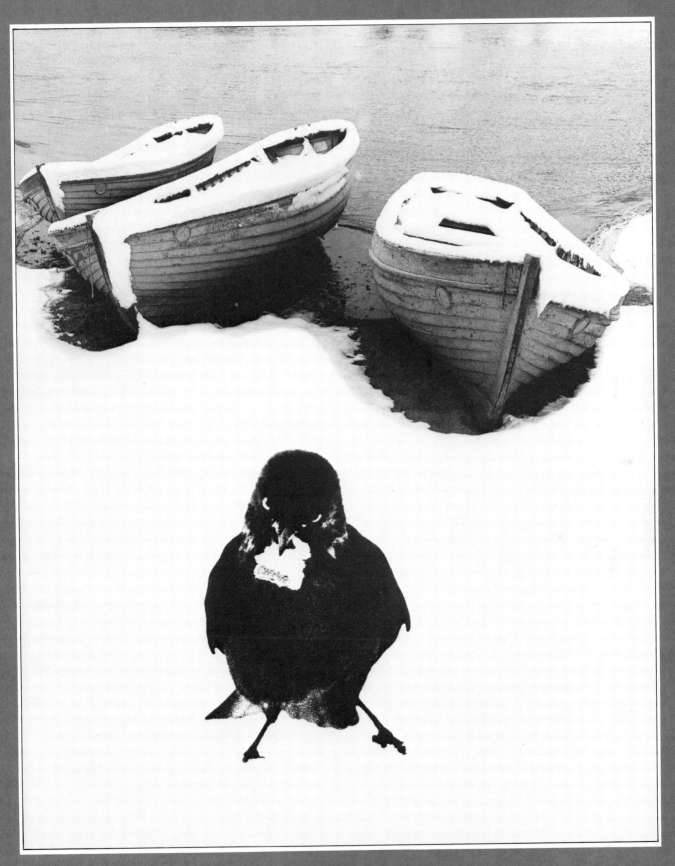

Pavel Tishkovski

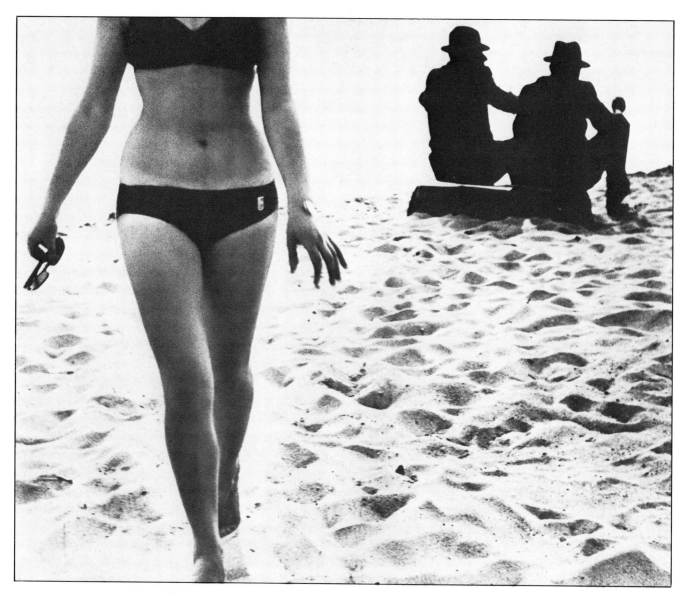

Oleg Burbowskij

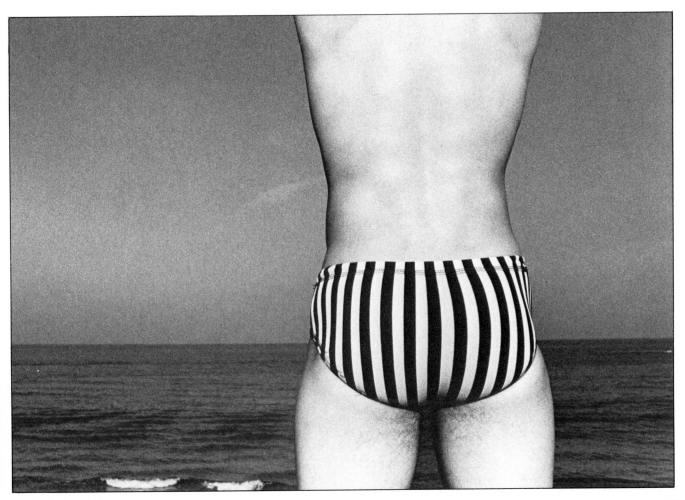

Julio Alvarez Yague

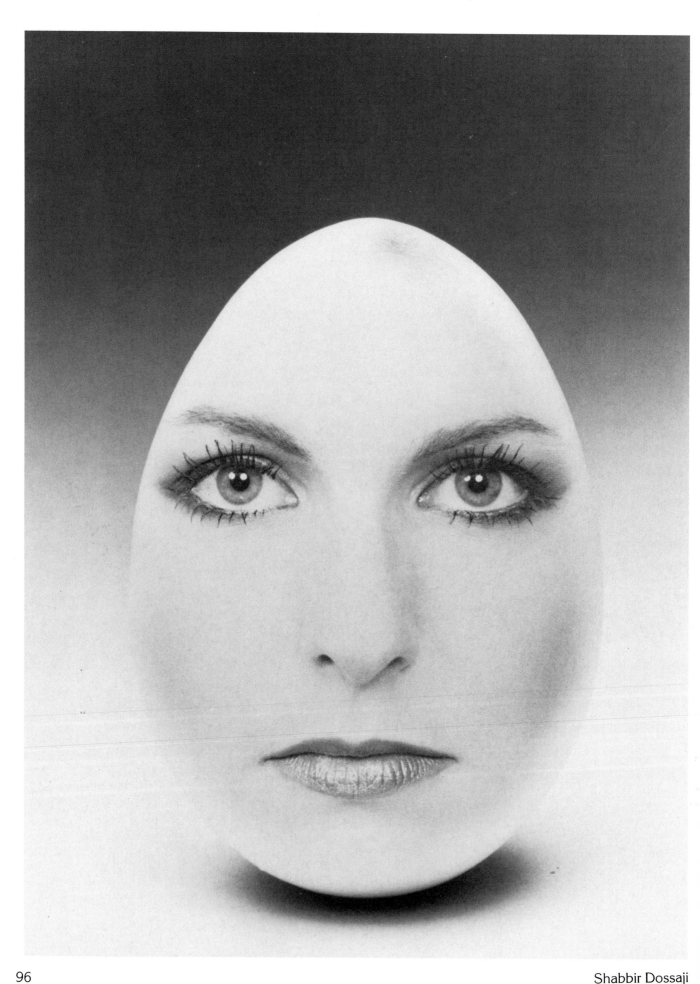

Shabbir Dossaji

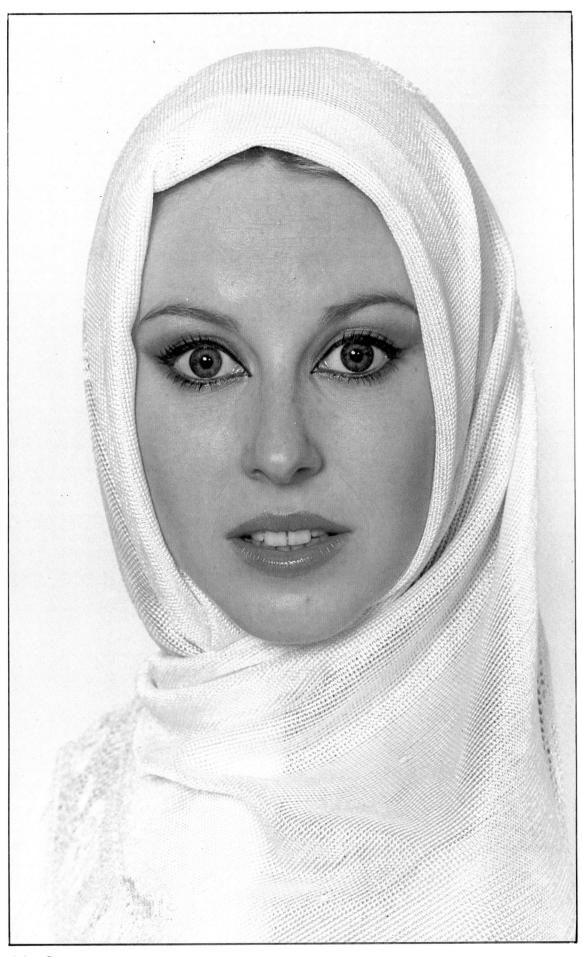

Jules Copus

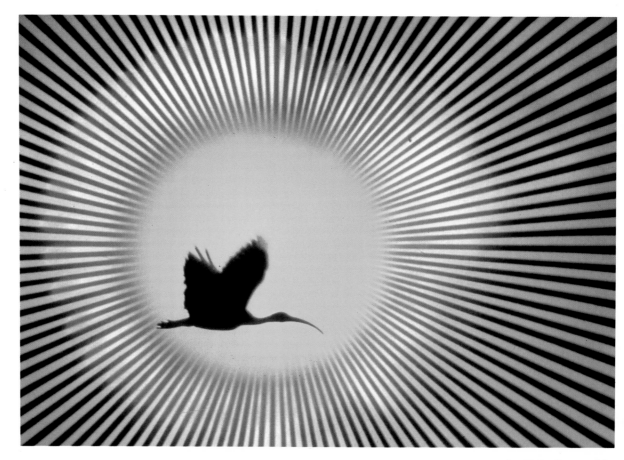

Dr M.D. Constable

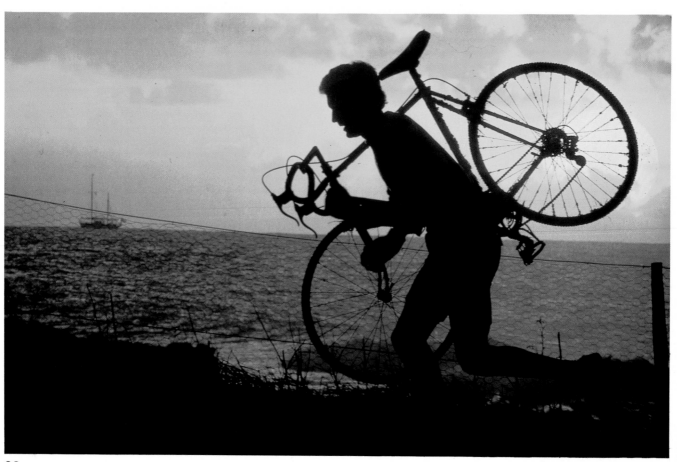

Steve Powell

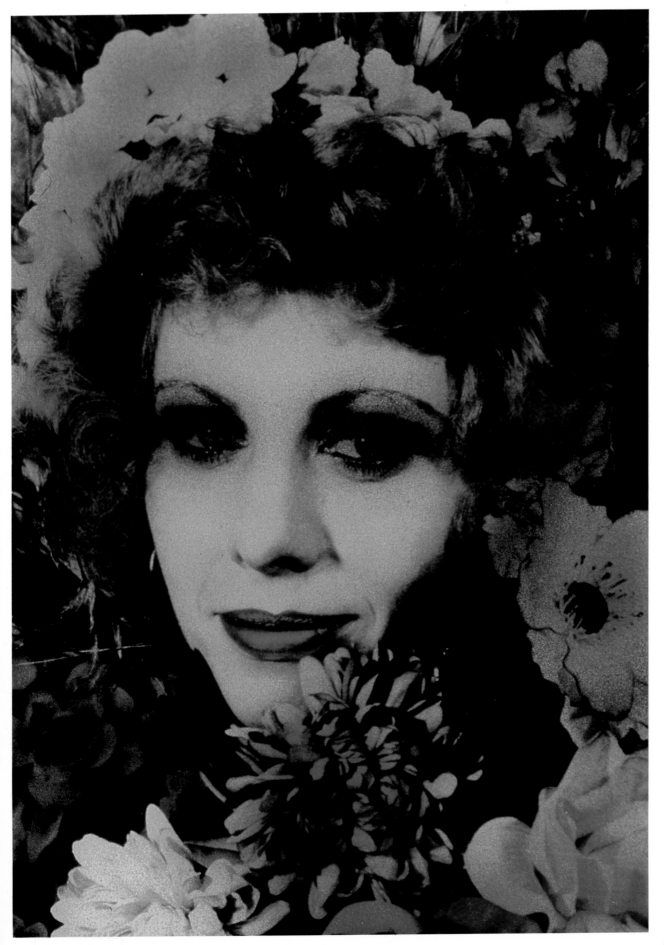

John M. Vijlbrief

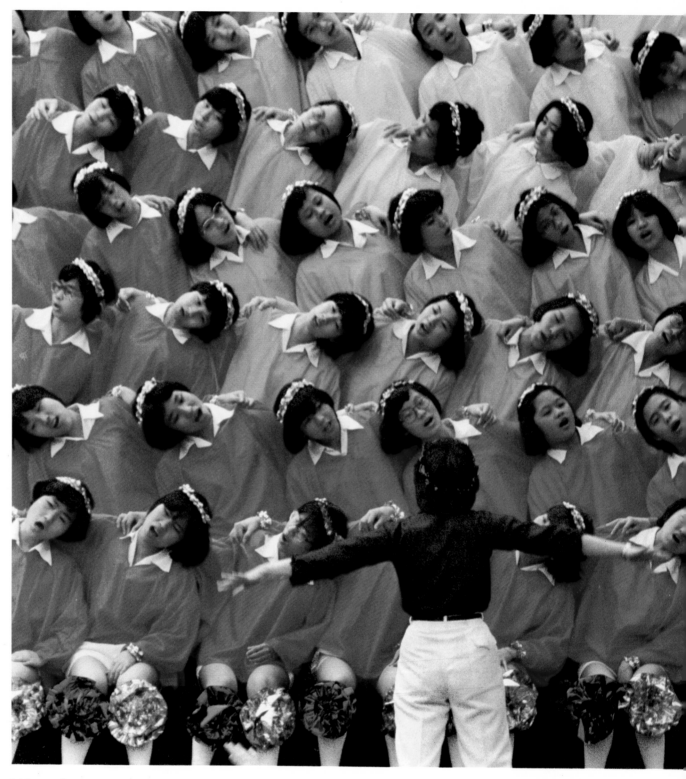

I-Hsung Lee

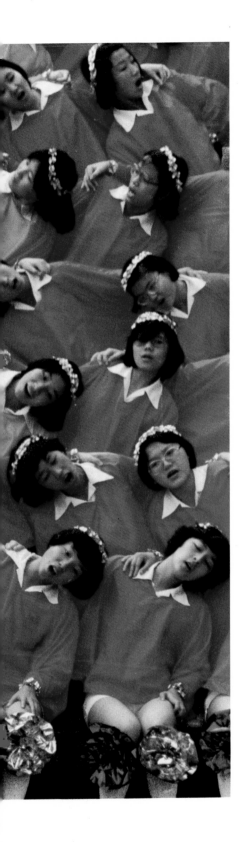

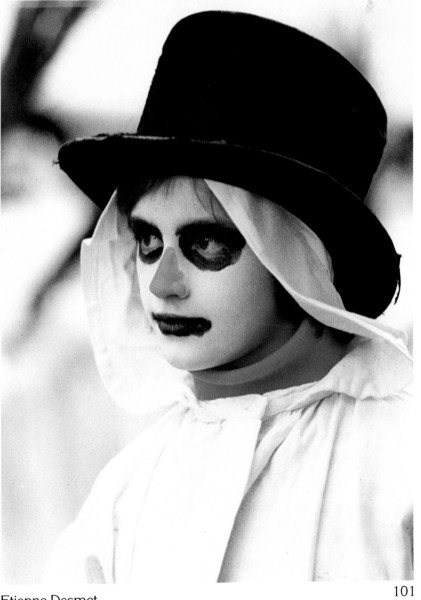

Etienne Desmet

Robert Martin

Steve Powell

I-Hsung Lee

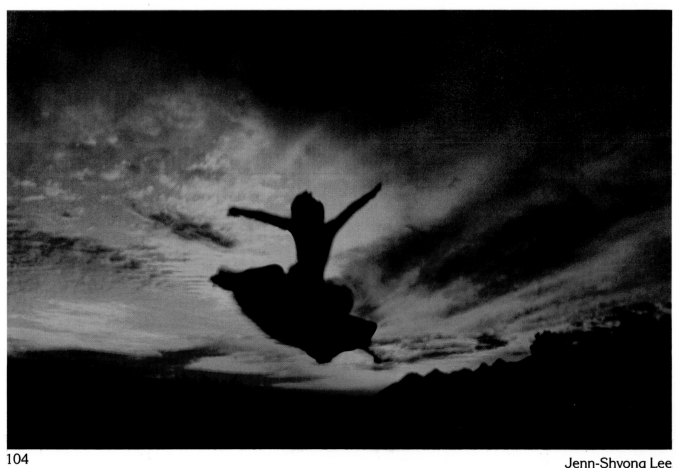

Jenn-Shyong Lee

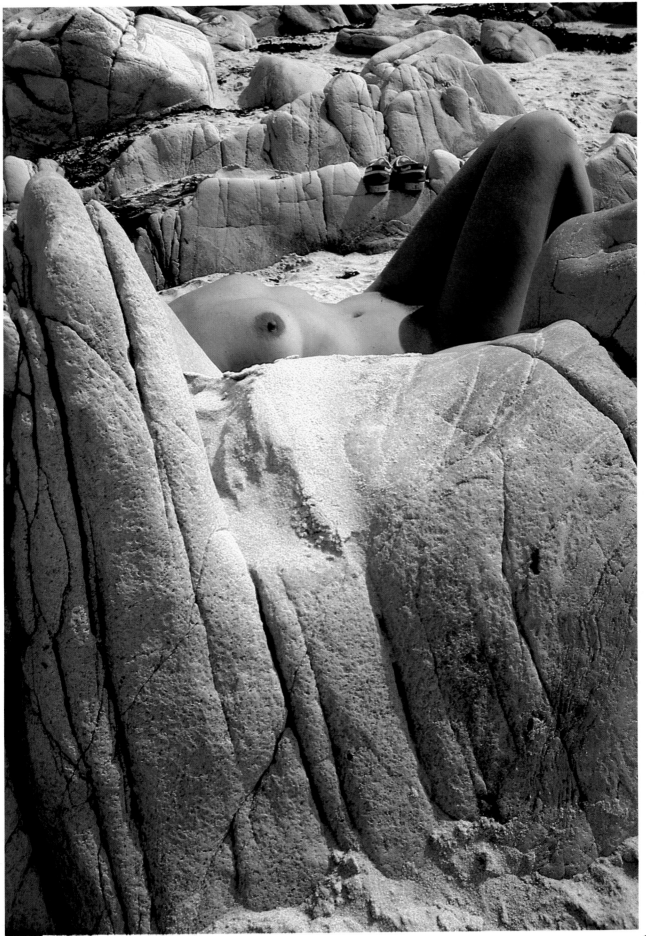

Peter M. Rees

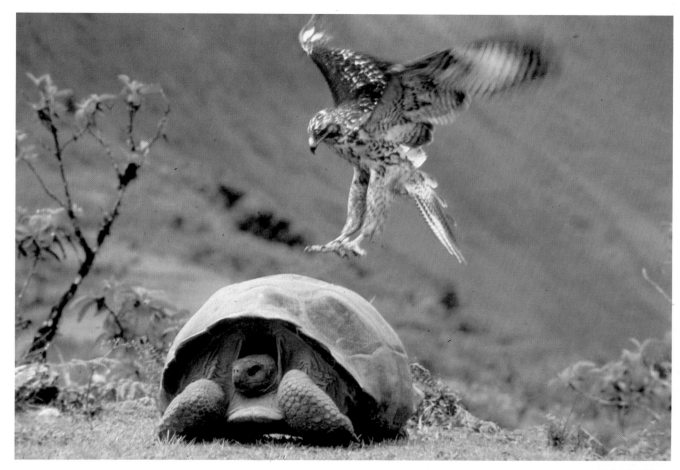

Fritz Pölking

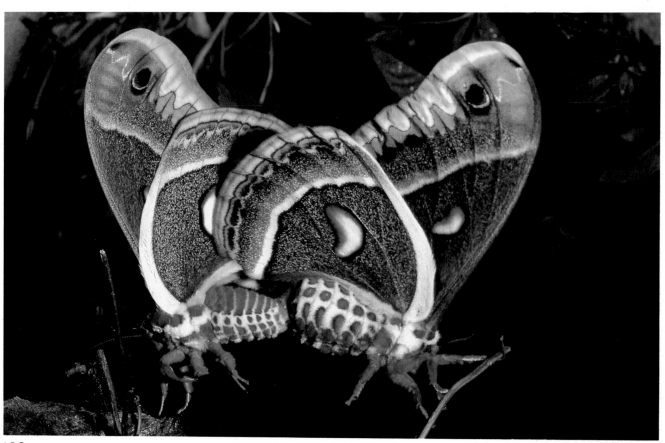

Santokh Kochar

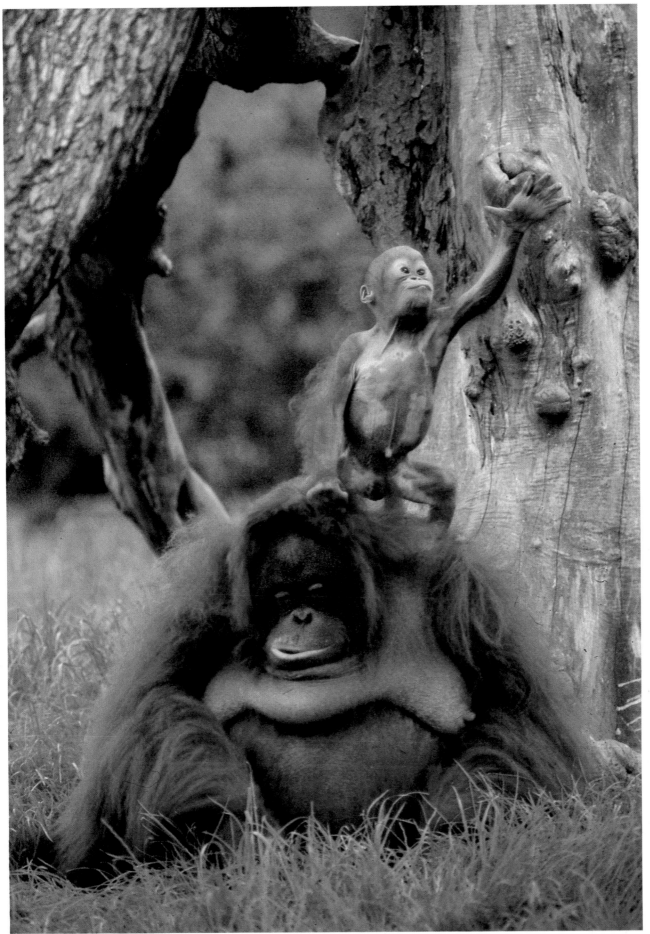

Peter W. Tryuk

Steve Powell

Tony Duffy

Clive B. Harrison

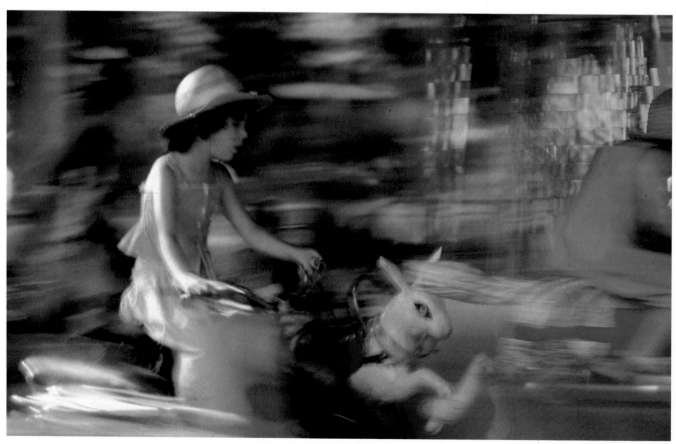

Philippe Massenat

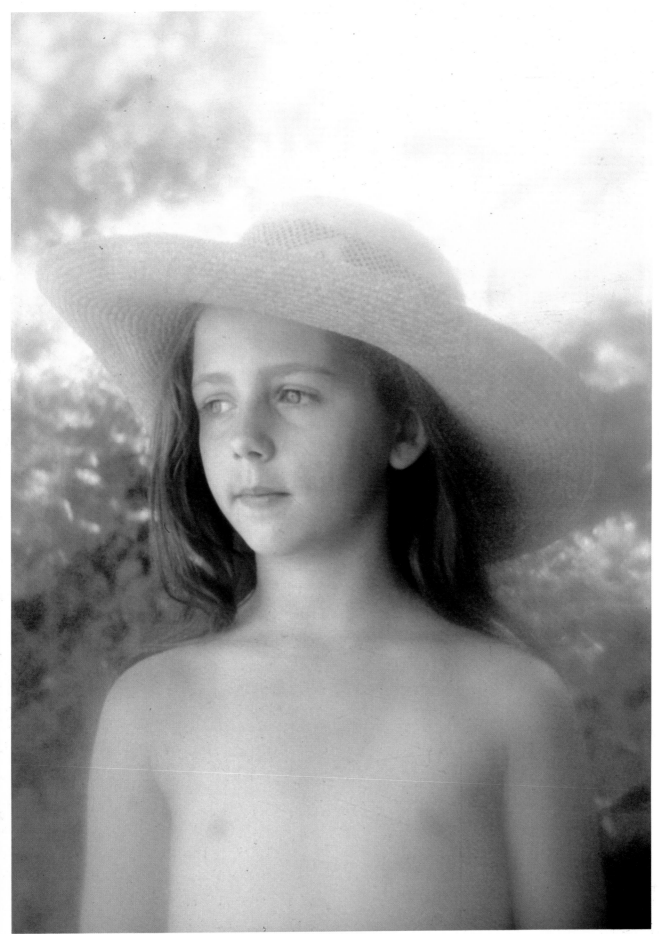

Joachim Blanch

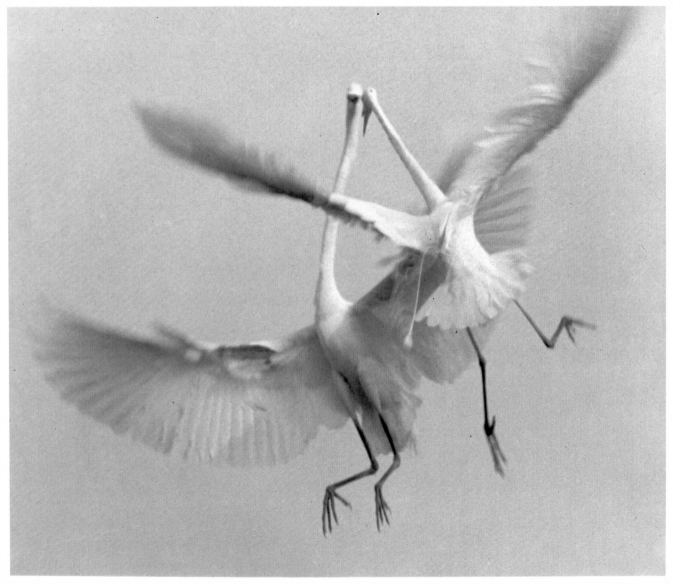

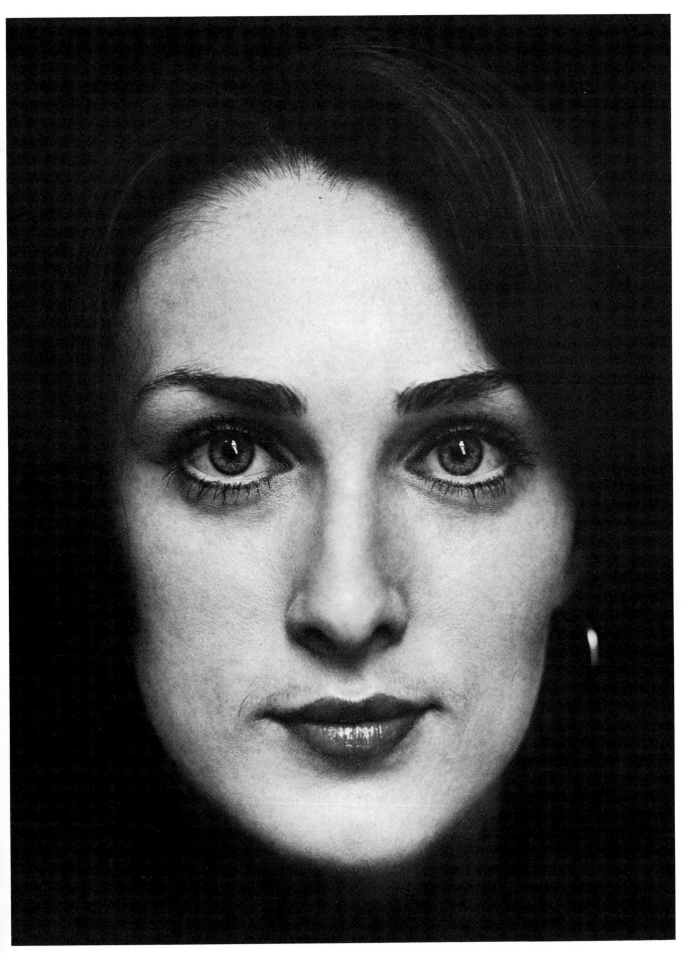

Oleg Burbowskij

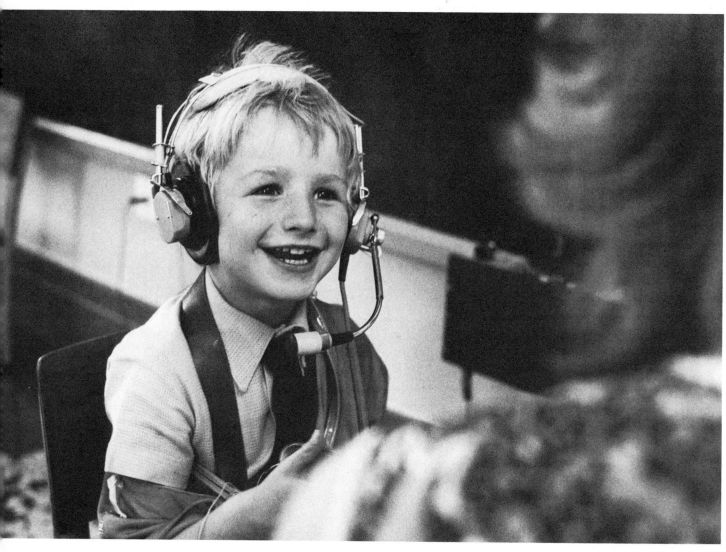

Denis Thorpe

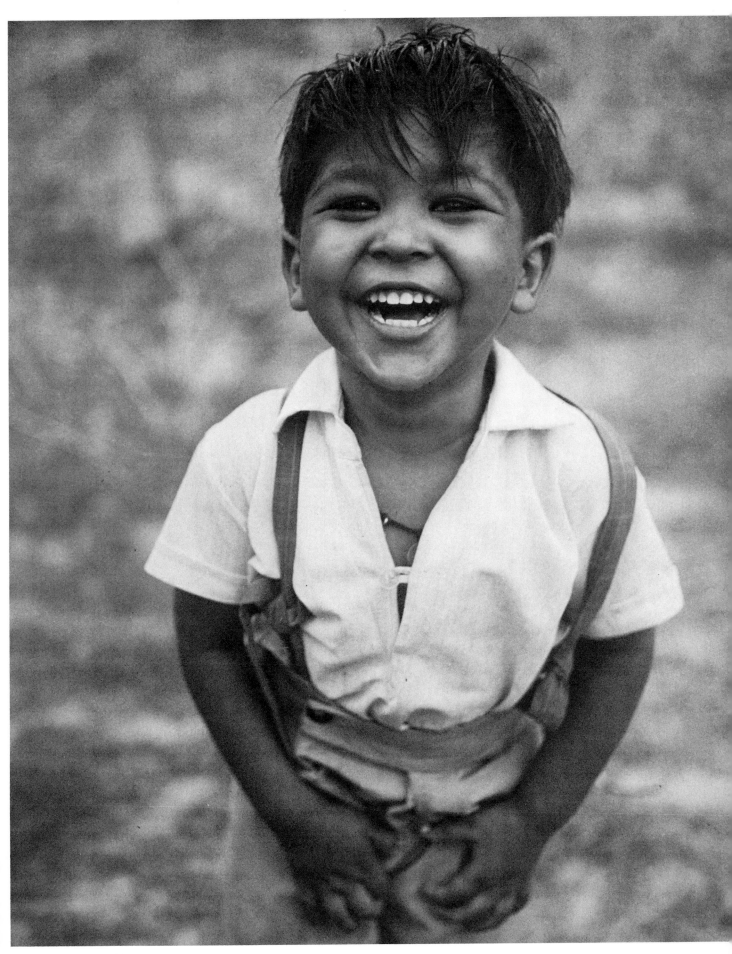

Dev Raj Agarwal

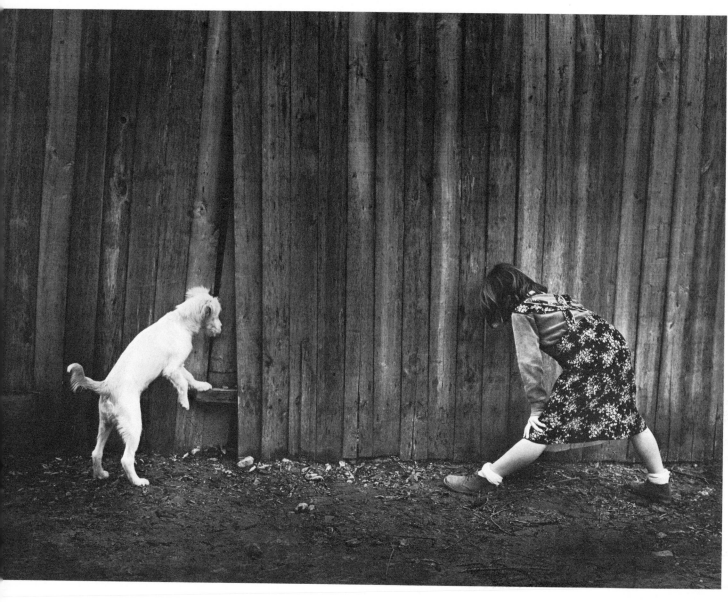

Pedro Luis Raota

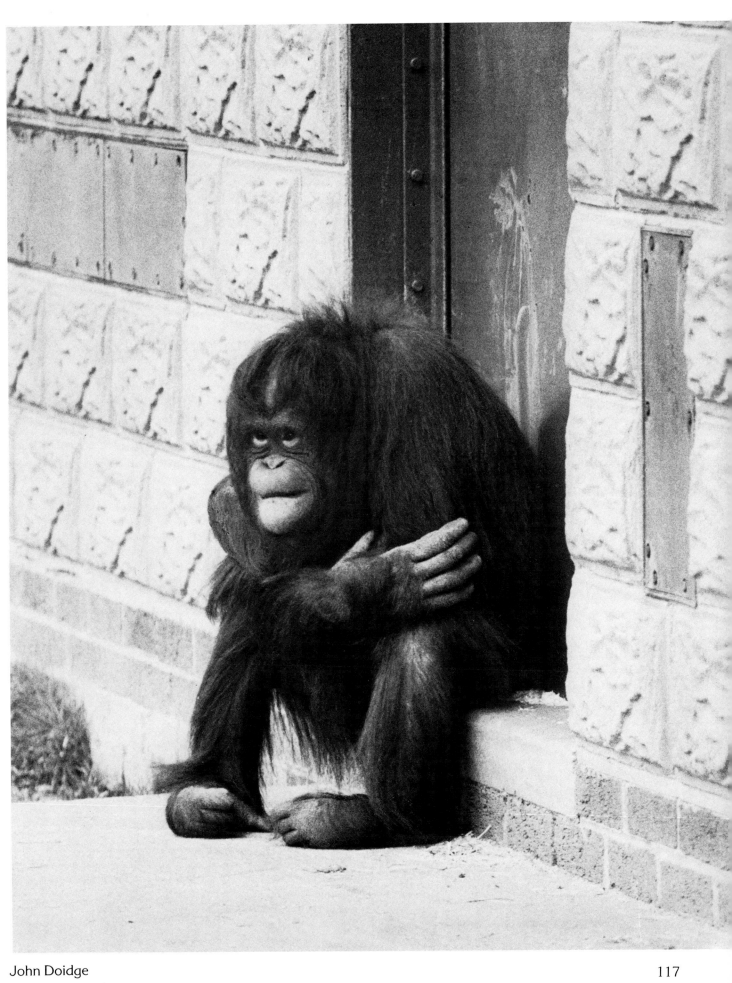

John Doidge

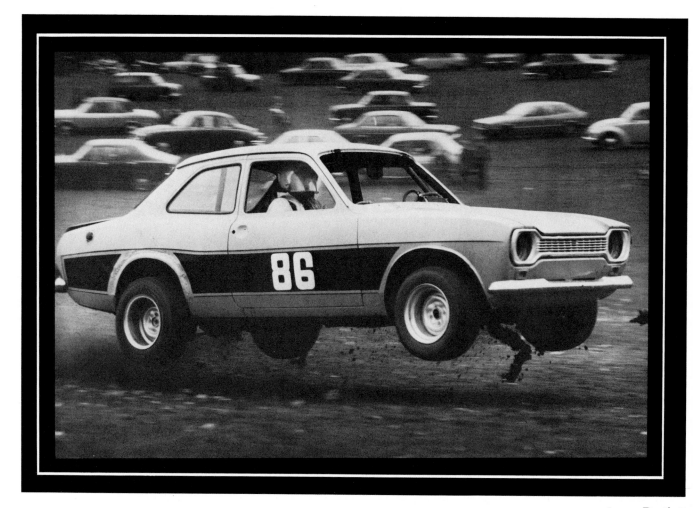

Larry Bartlett

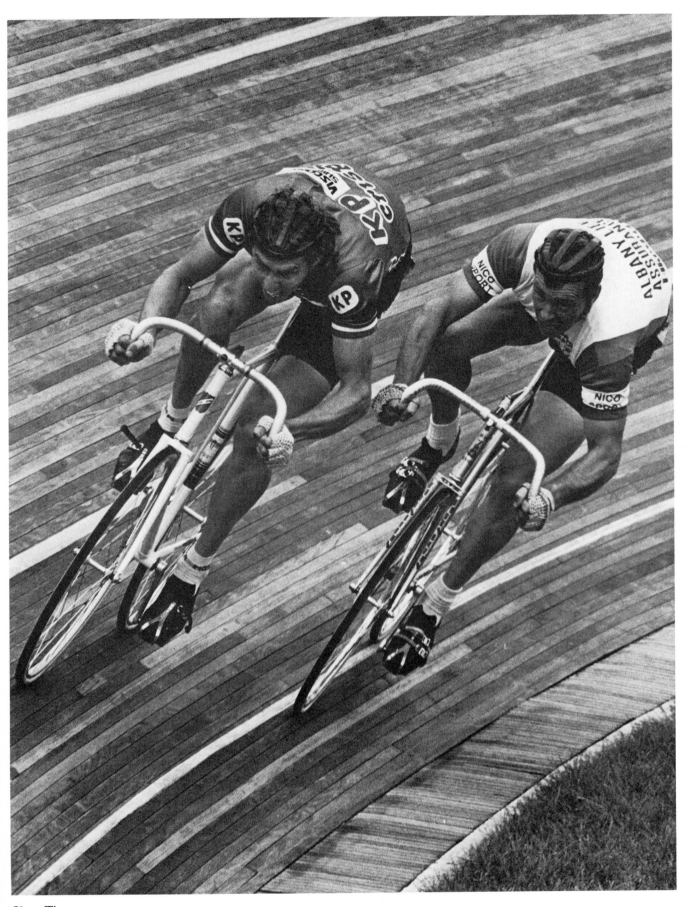

Chas Thompson

S. Žvirgždas

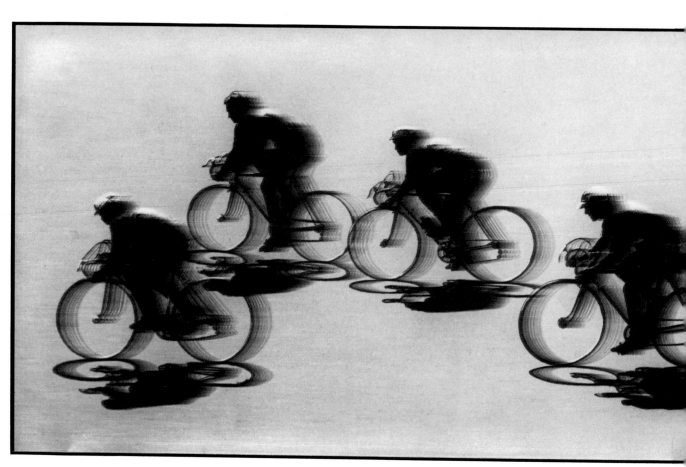

Pavel Tishkovski

Howard Walker

Mike Hollist

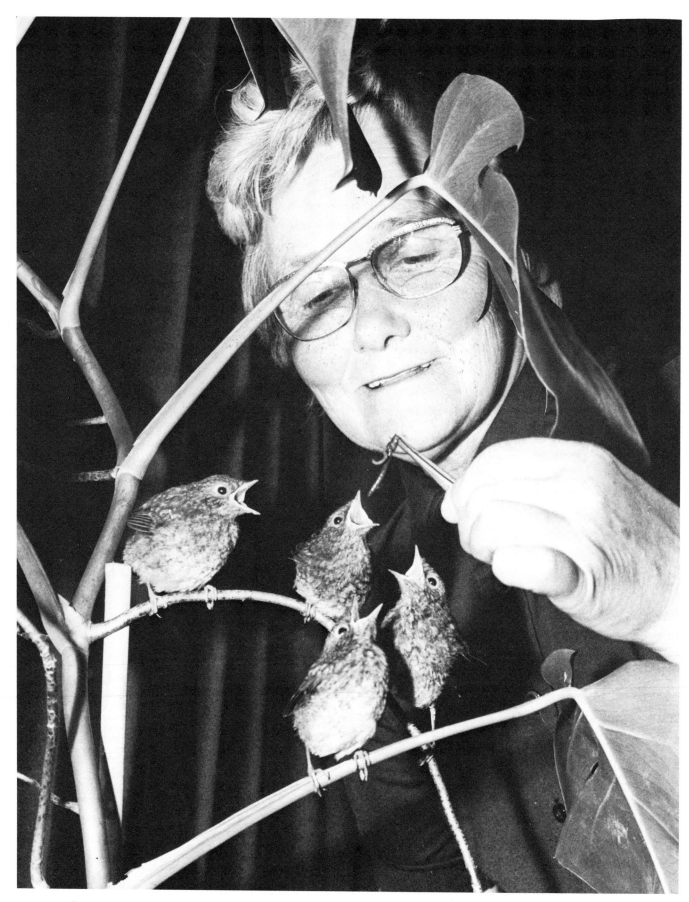

Gerry Lockley

124

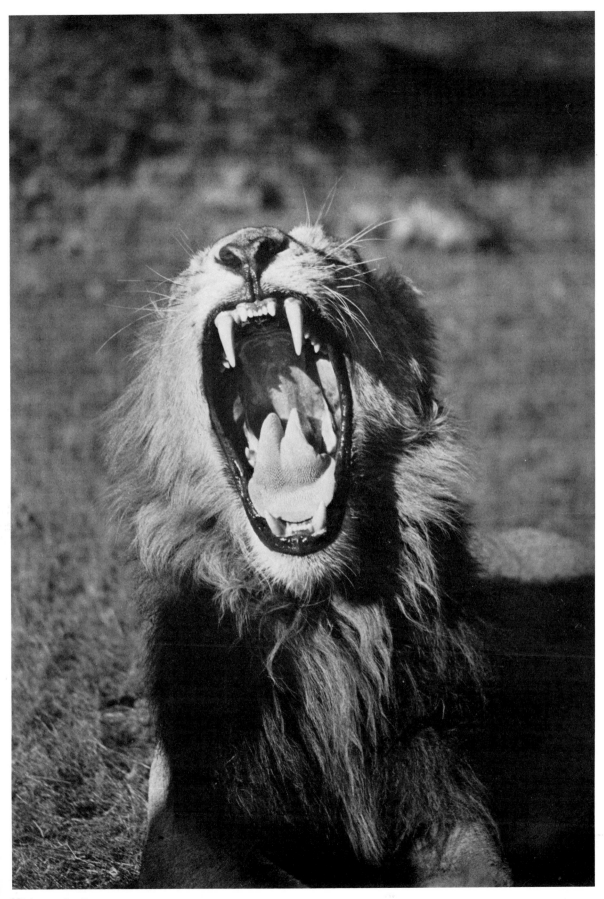

Kishore Joshi

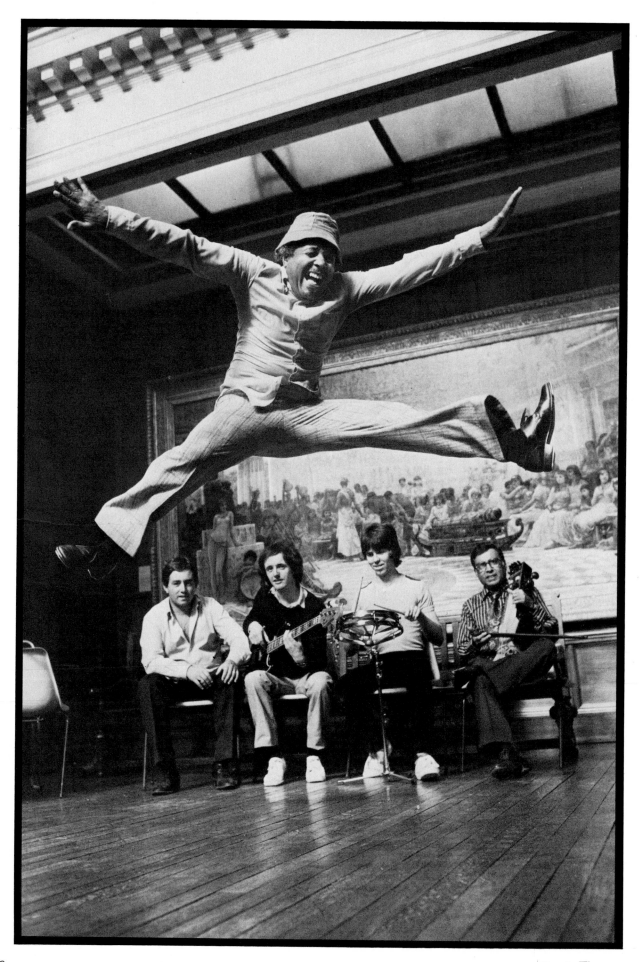

Denis Thorpe

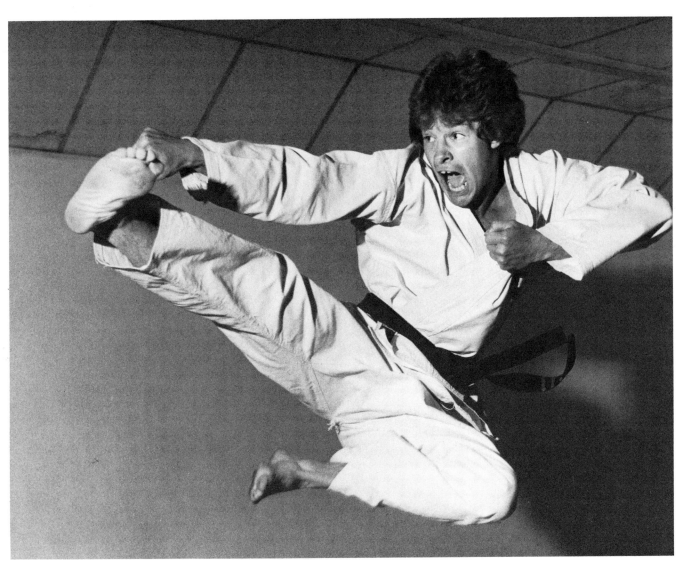

John Doidge

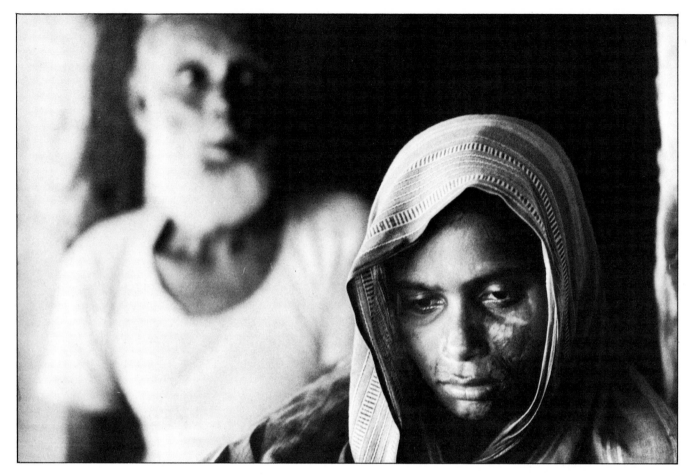

Aloke Mitra

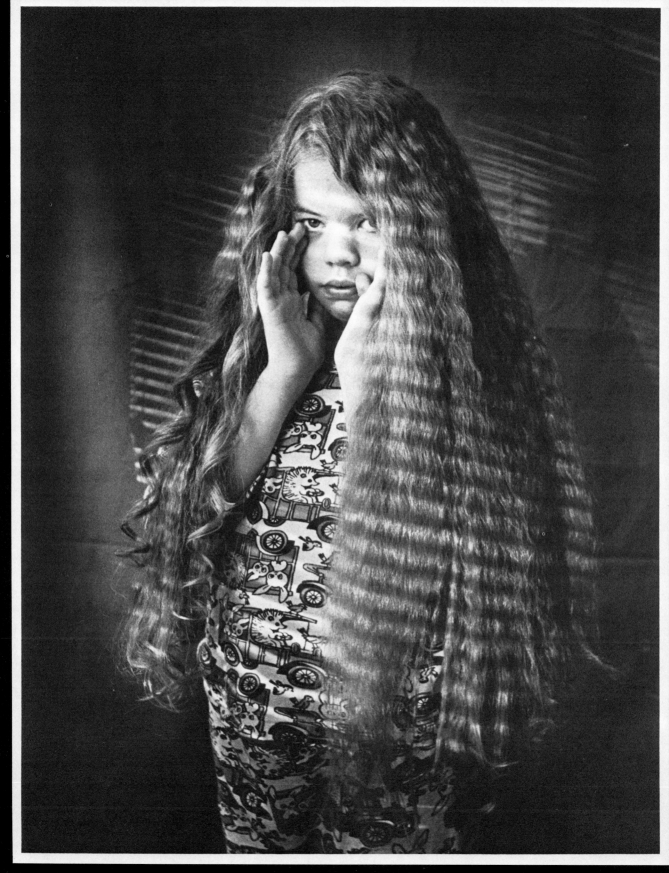

Veikko Wallström

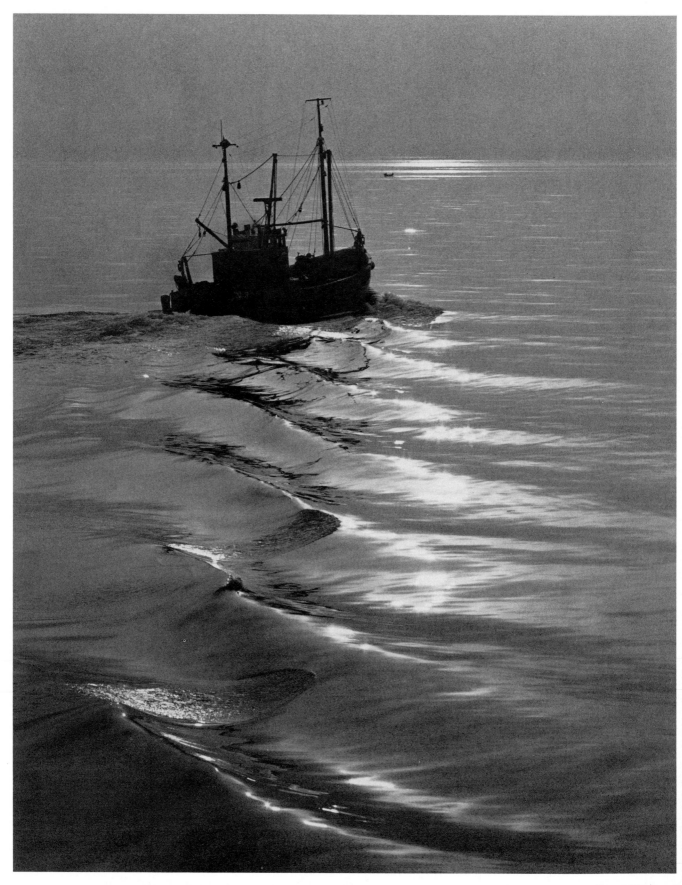

David Herrod

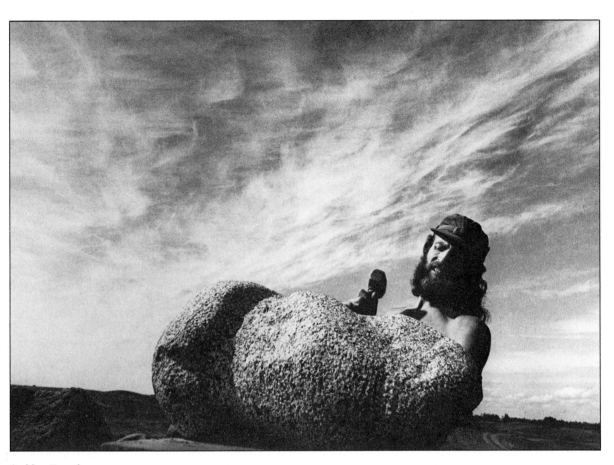

A. Macijauskas

Tony Ward

Steve Templeman

Jim Miller

Peter Stickler

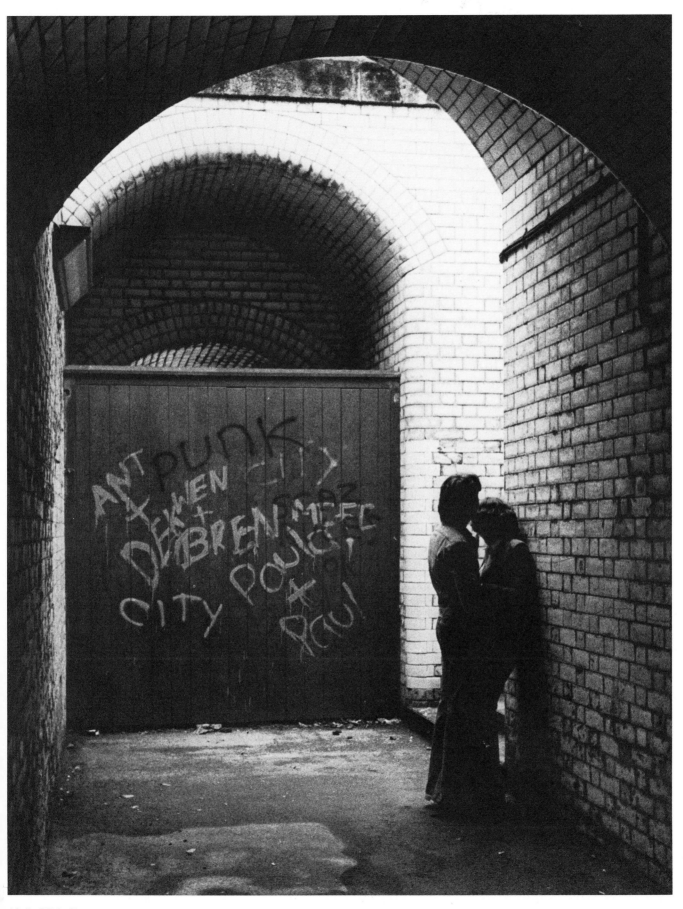

M.J. O'Neill

John Doyle

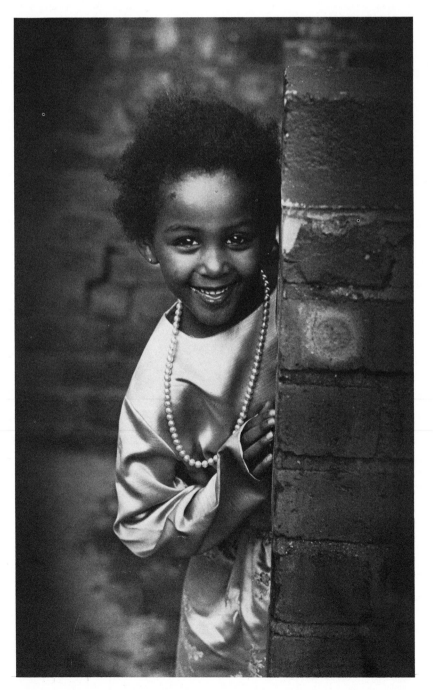

Stephen Shakeshaft

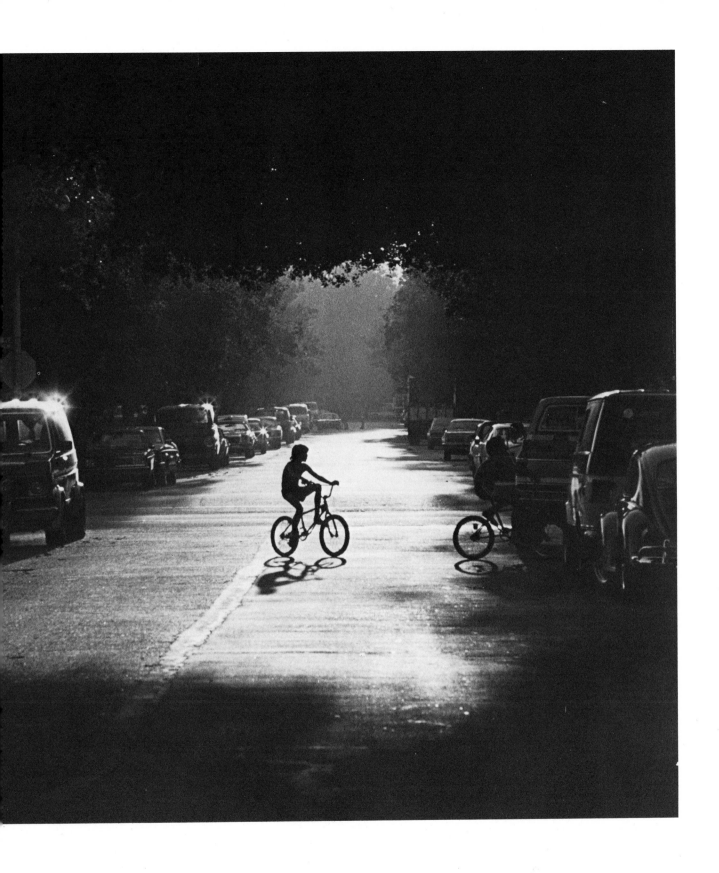

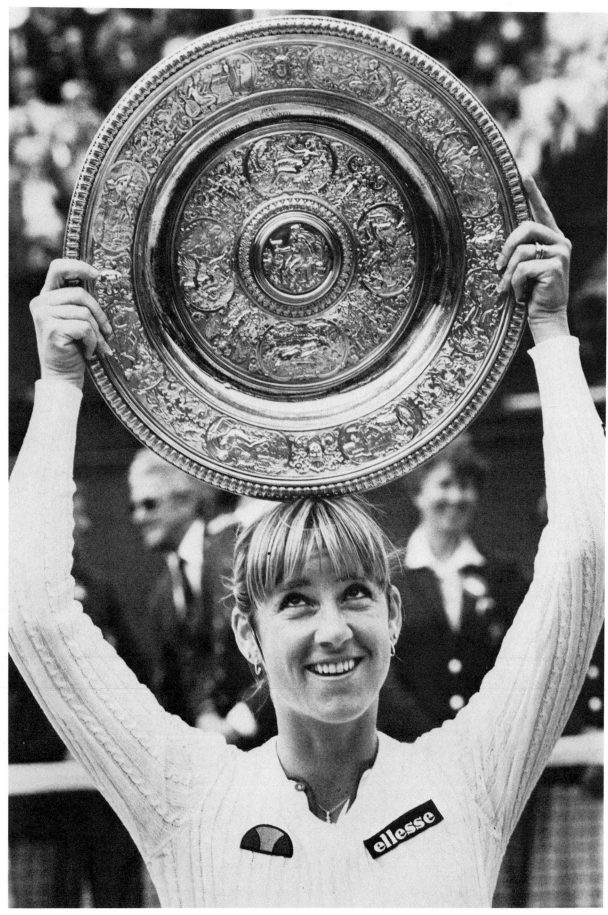

Steve Hartley

Zinovi Shegelman

Chris Peet

Andreas Markiewicz

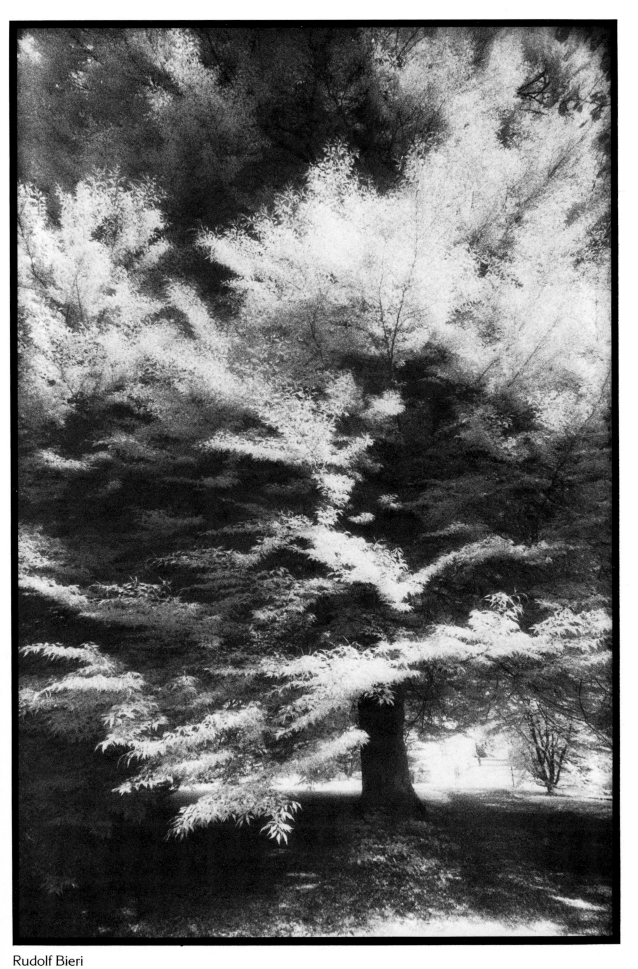

Rudolf Bieri

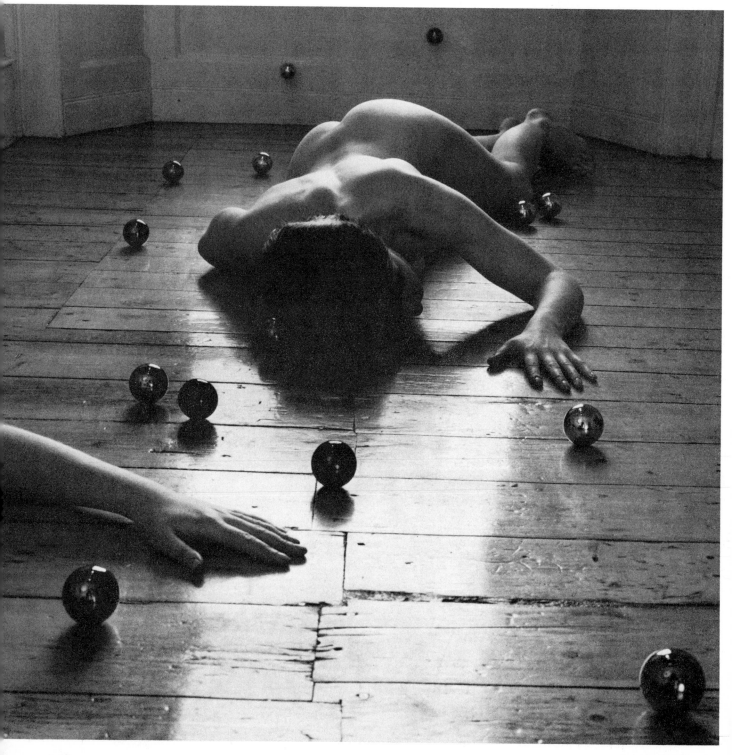

142

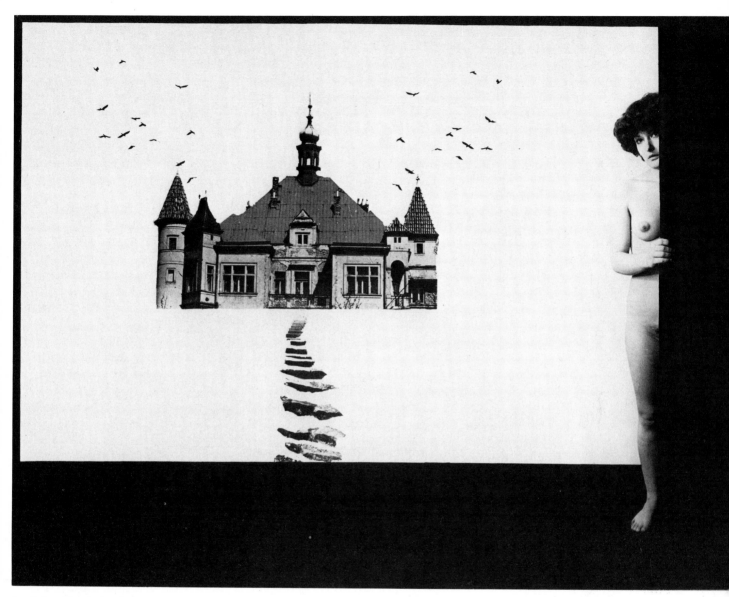

Ladislav Formánek

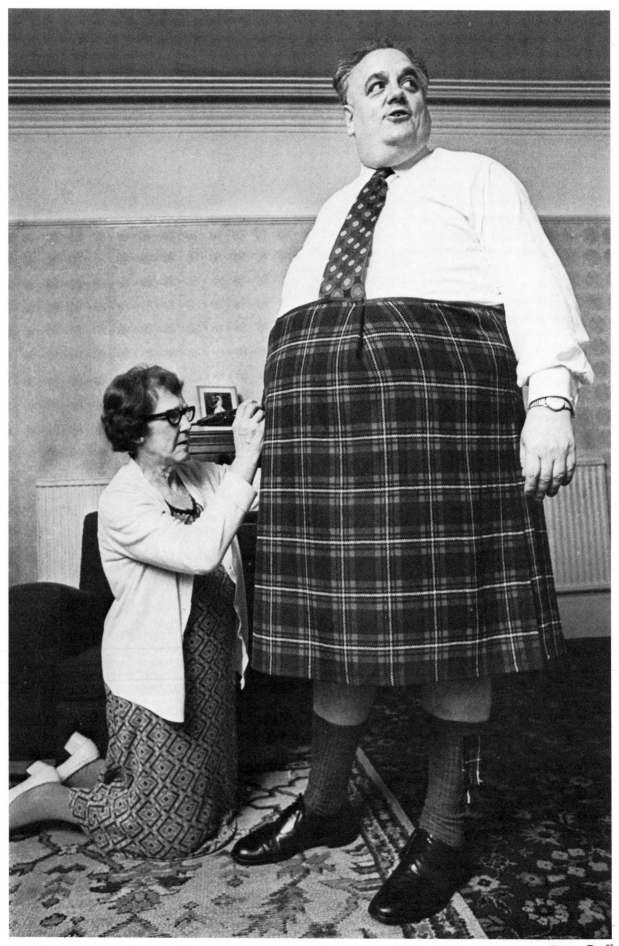

Brian Duff

Arch White

Colin Hutchby

Brian Duff

Vaclovas Straukas

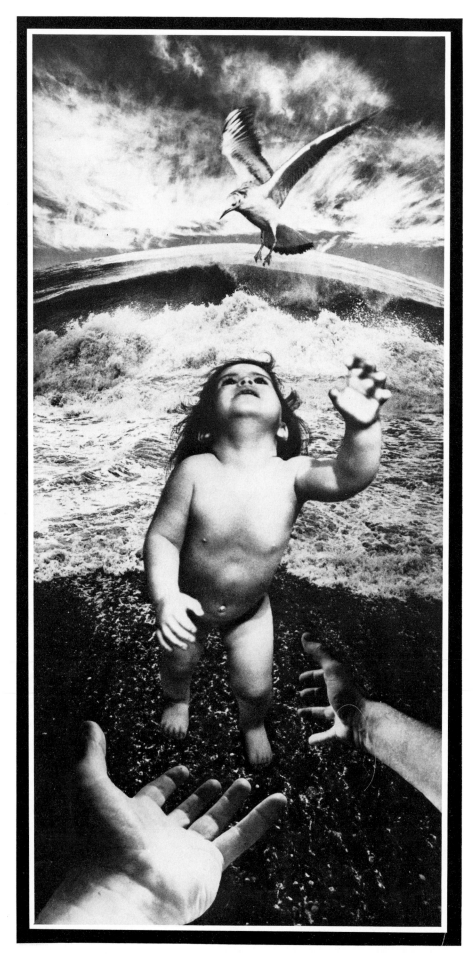

Vladimir Vitow

Sjur Roald

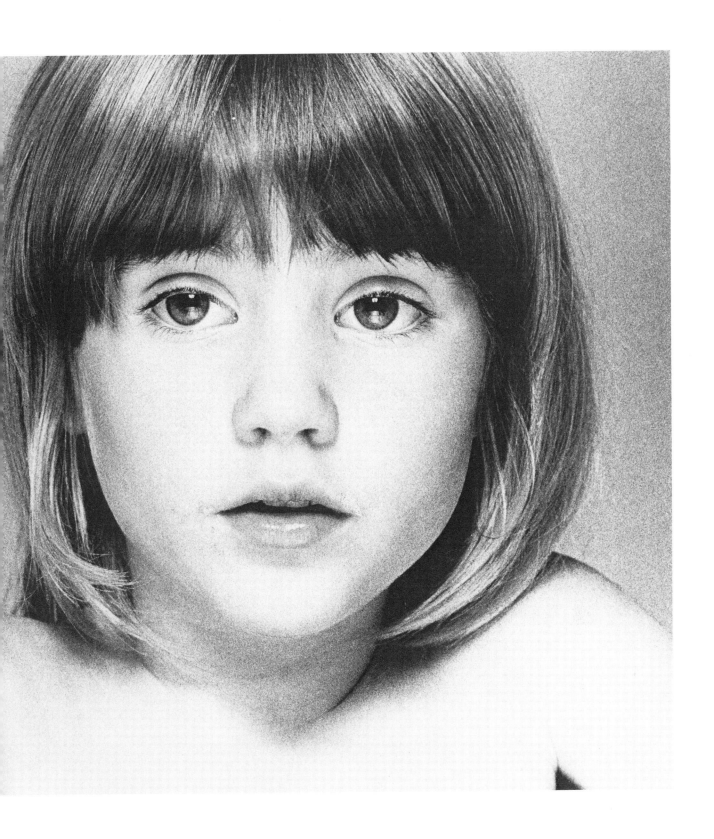

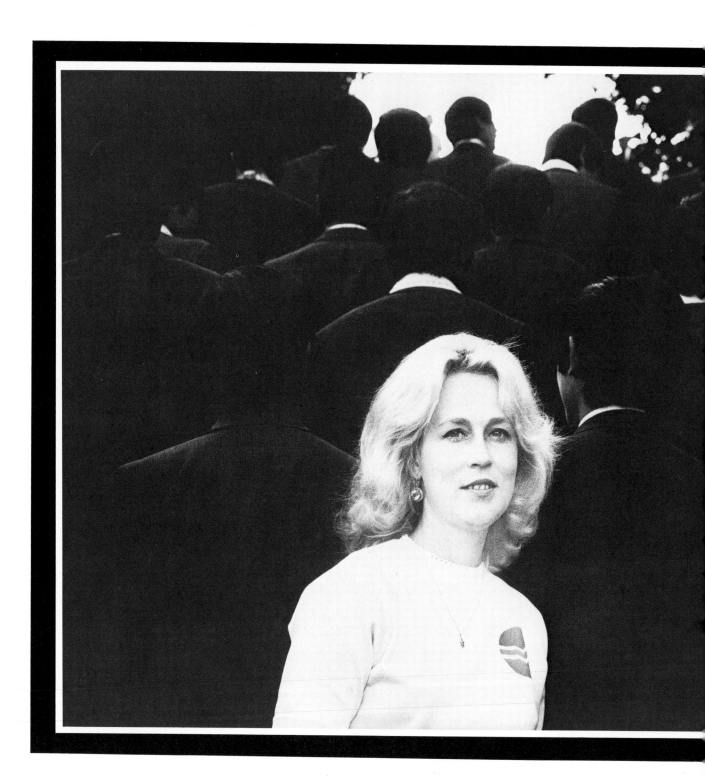

Zinovi Shegelman

Guillermo Proaño Moreno

M.L. Brehant

Wilhelm Hagenberger

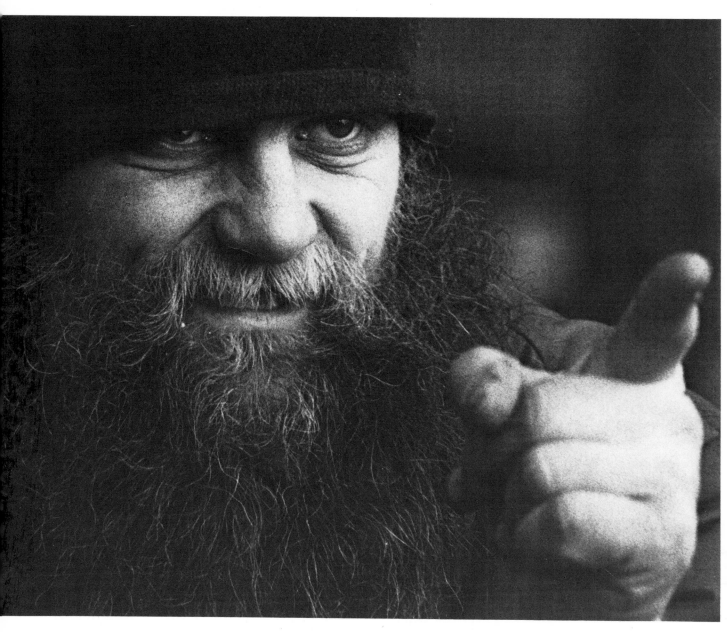

Neale Davison

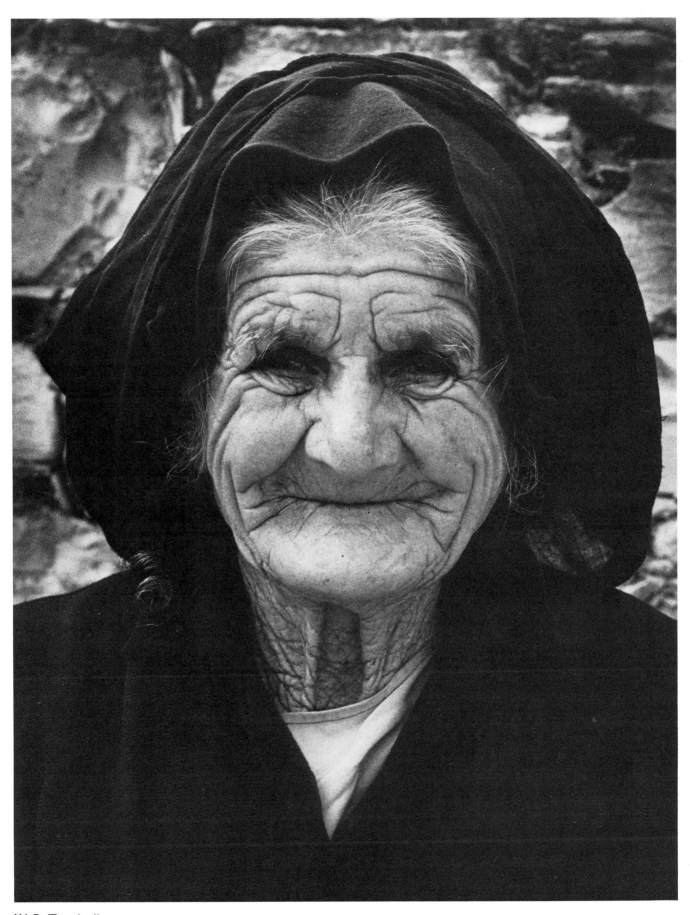

W.O. Turnbull

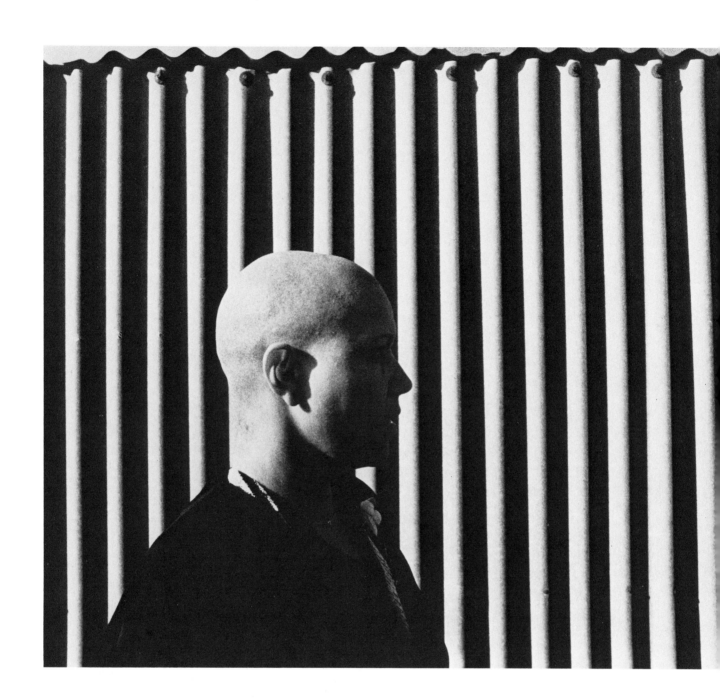

ank Peeters

Steve Templeman

Stanley Matchett

Pedro Luis Raota

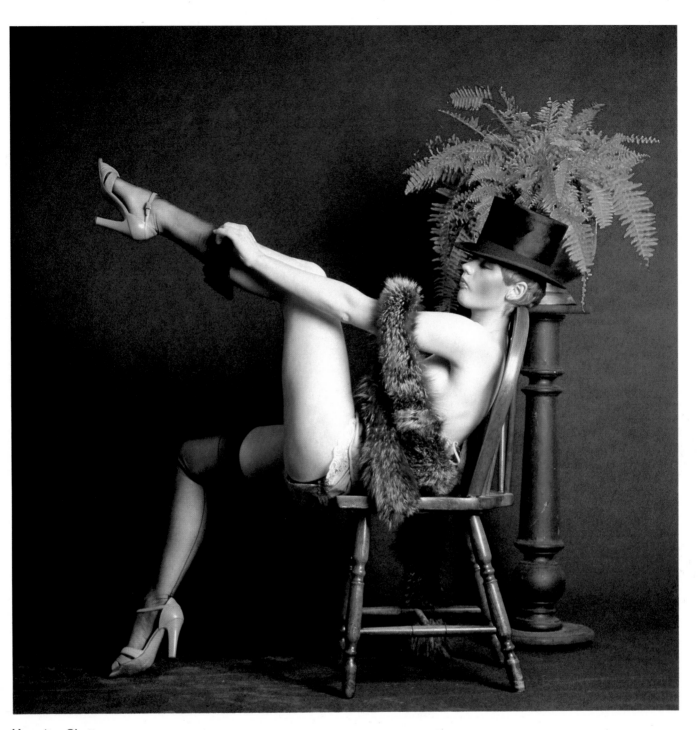

Henning Skytte

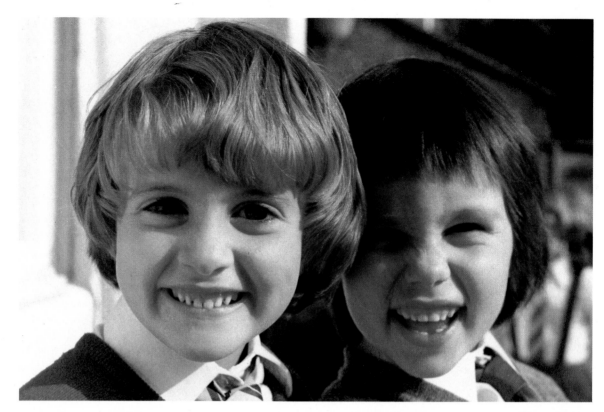

Peter Dainty

Ramon Riu Martinez

Erik Steen

Domingo Batista

Kevin Peschke

Dr Leo K.K. Wong

Steve Yarnell

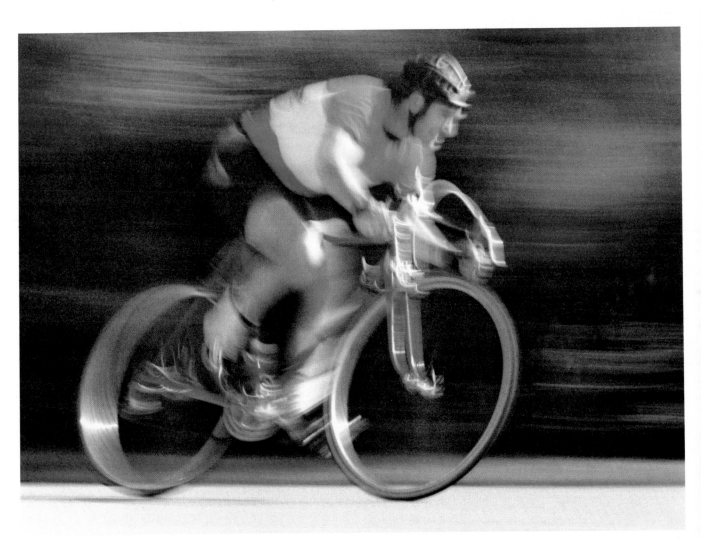

Paul McMullin

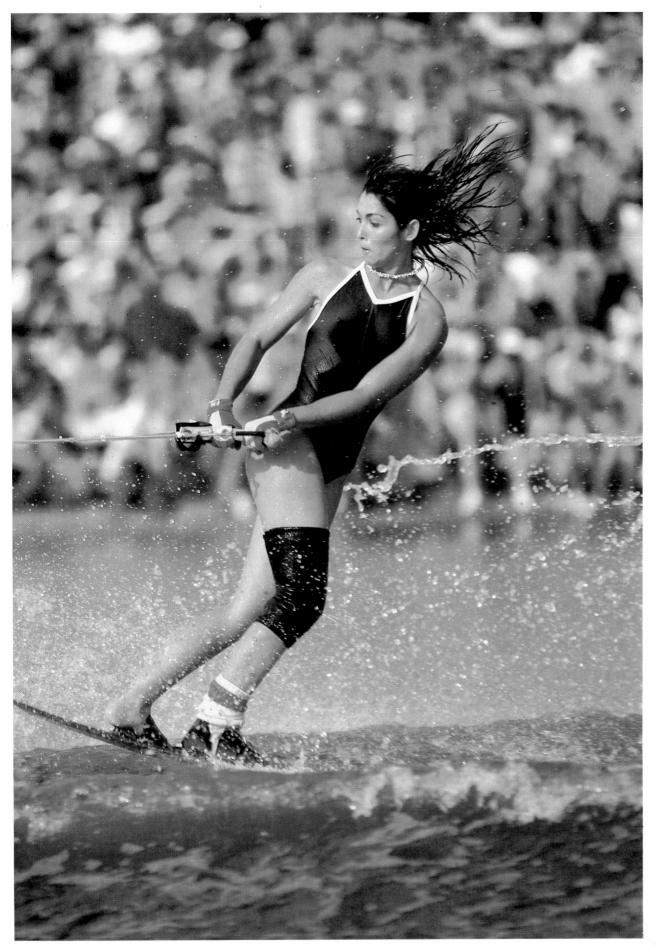

Duncan Raban

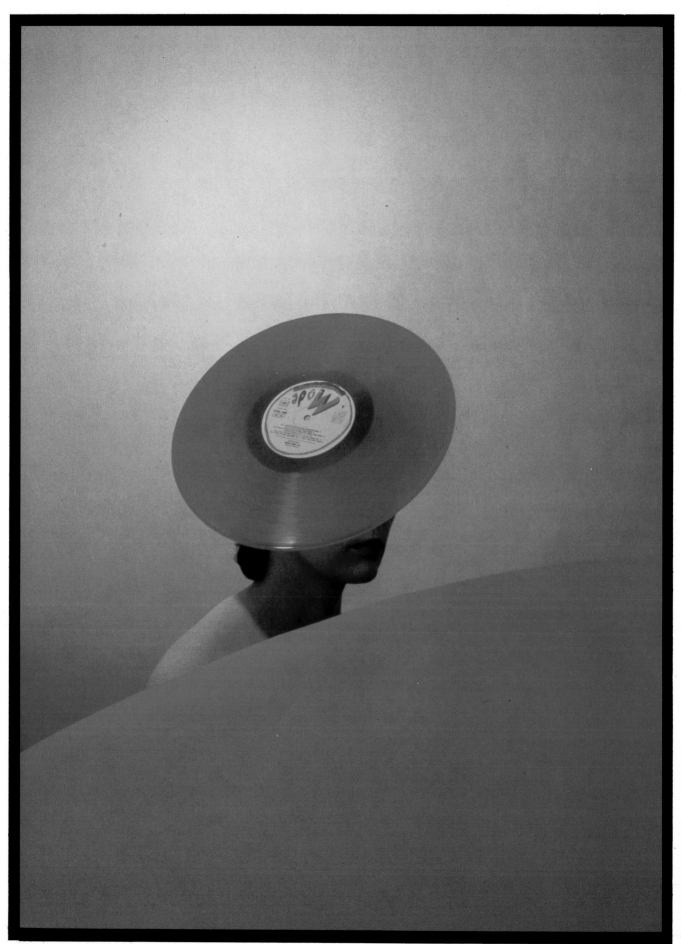

F. Karikese

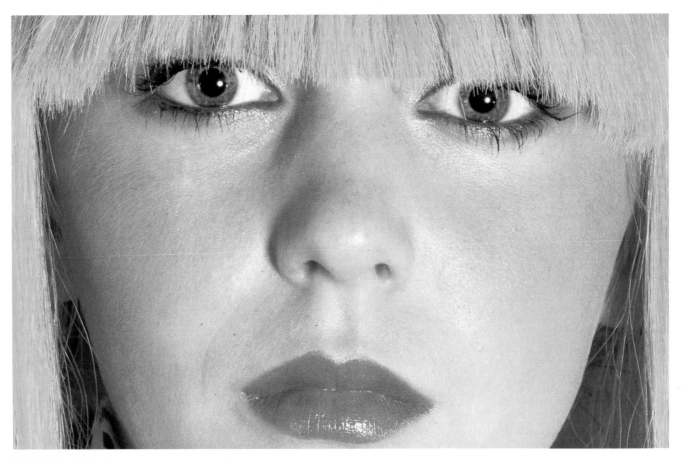

Kevin Peschke

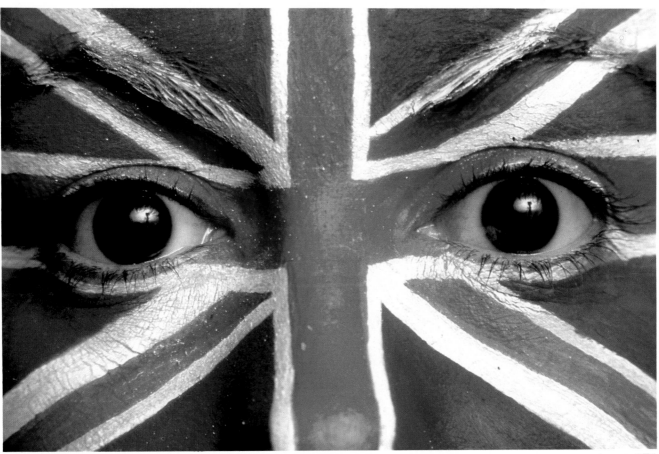

Forrest Smyth

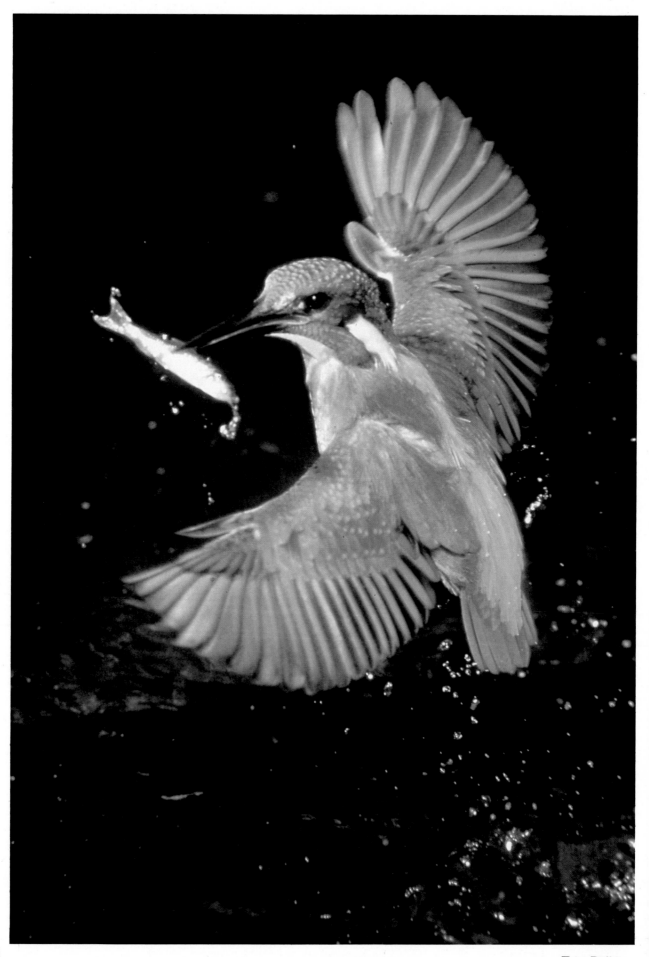

Fritz Pölking

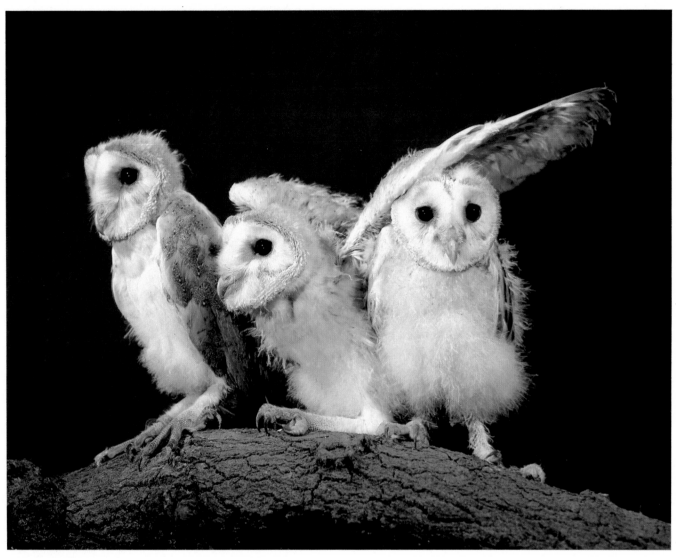

Robert Hallman

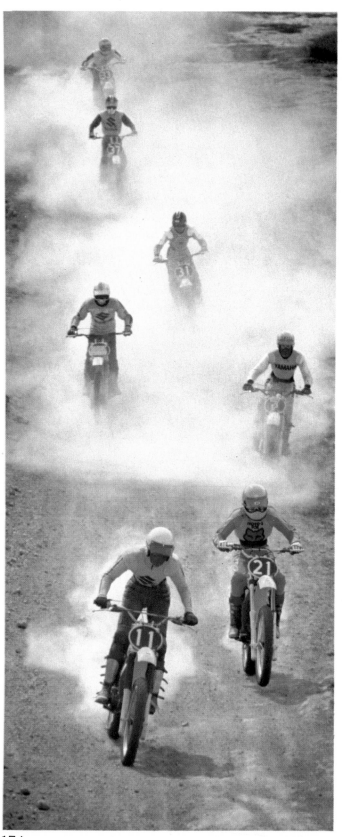

174

David Lau Chi Wai

Etienne Desmet

Kevin Peschke

Dave Hartley

Stephen Shakeshaft

Stephen Shakeshaft

Mervyn Rees

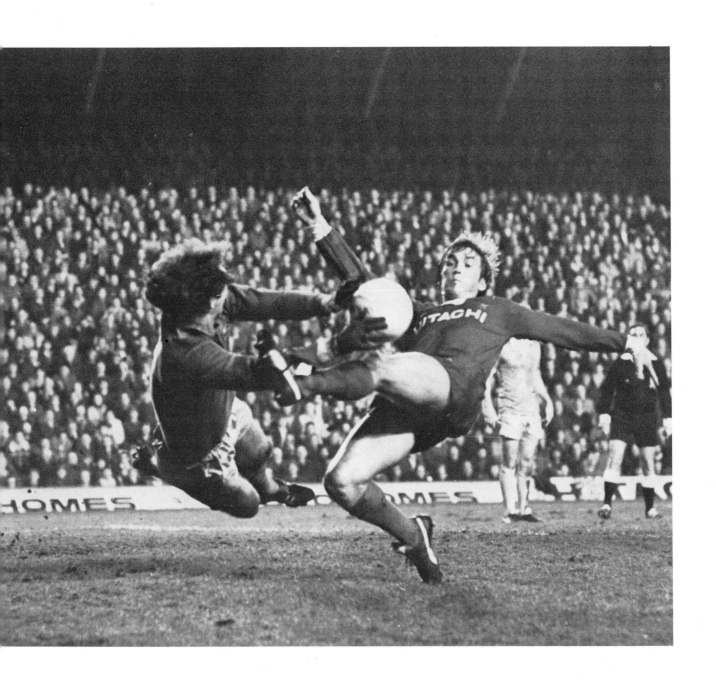

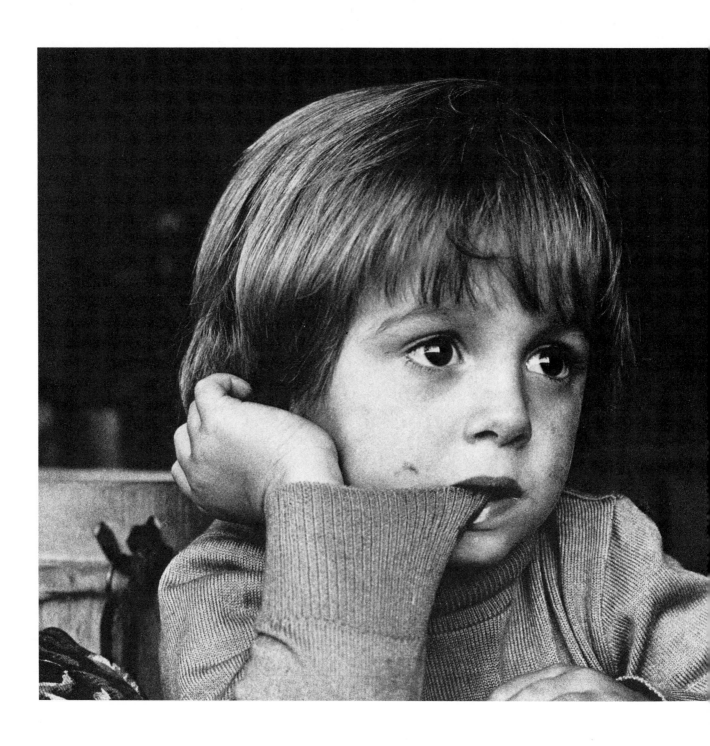

s Placido Lopez Caballero

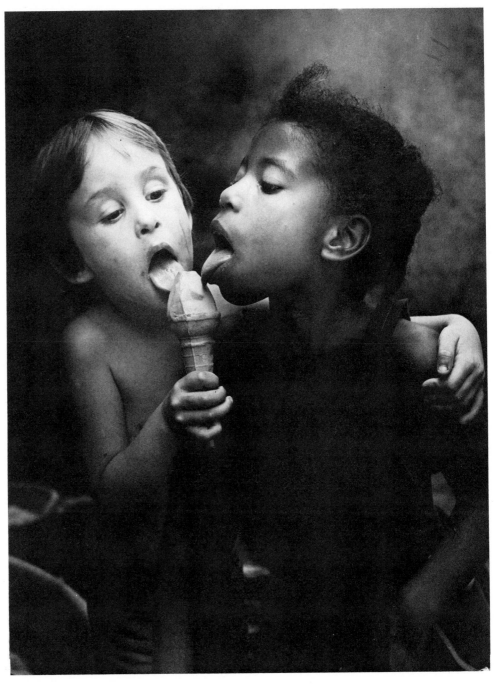

Pedro Luis Raota

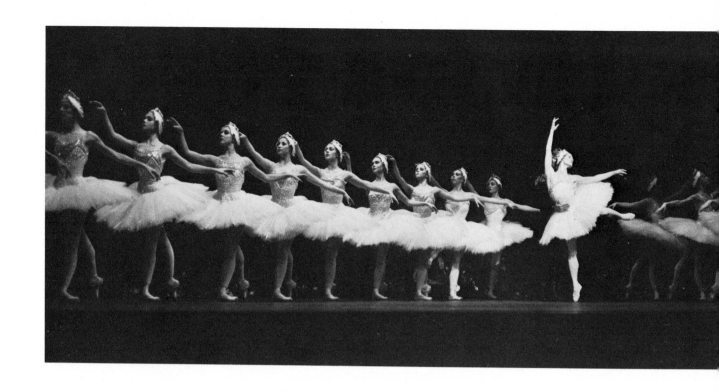

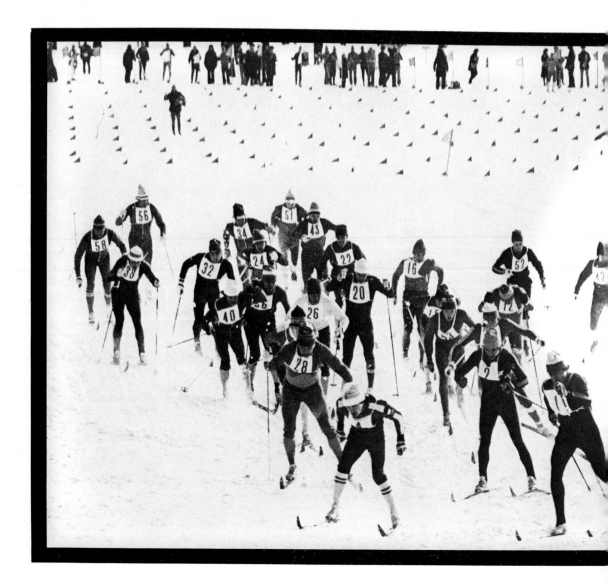

Denis Thorpe

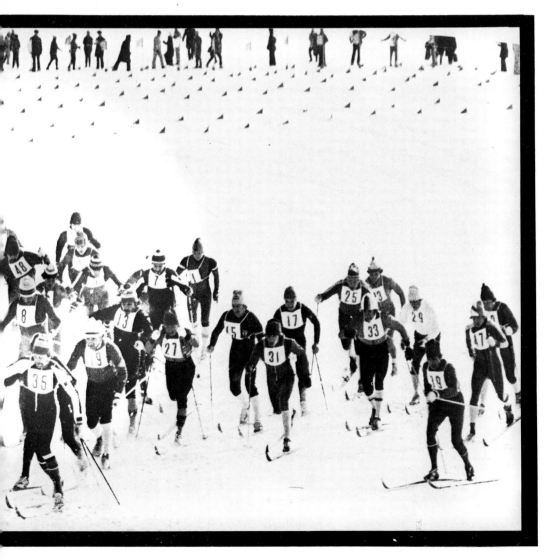

Stanislav Barkov 185

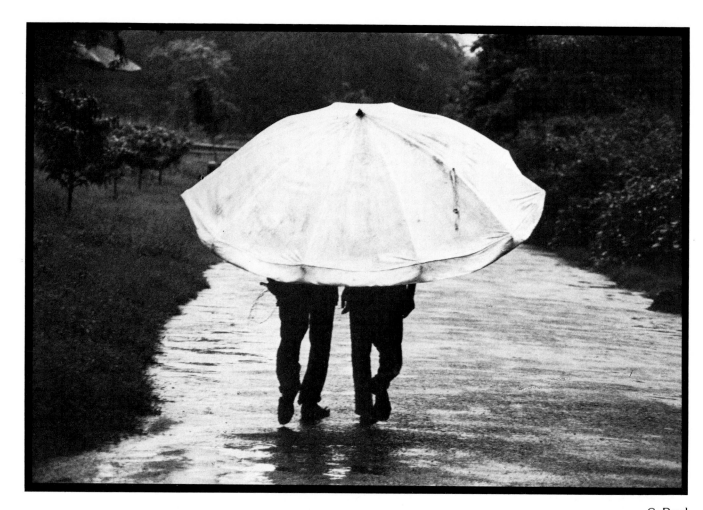

S. Paul

Erwin Kneidinger

Peter Hense

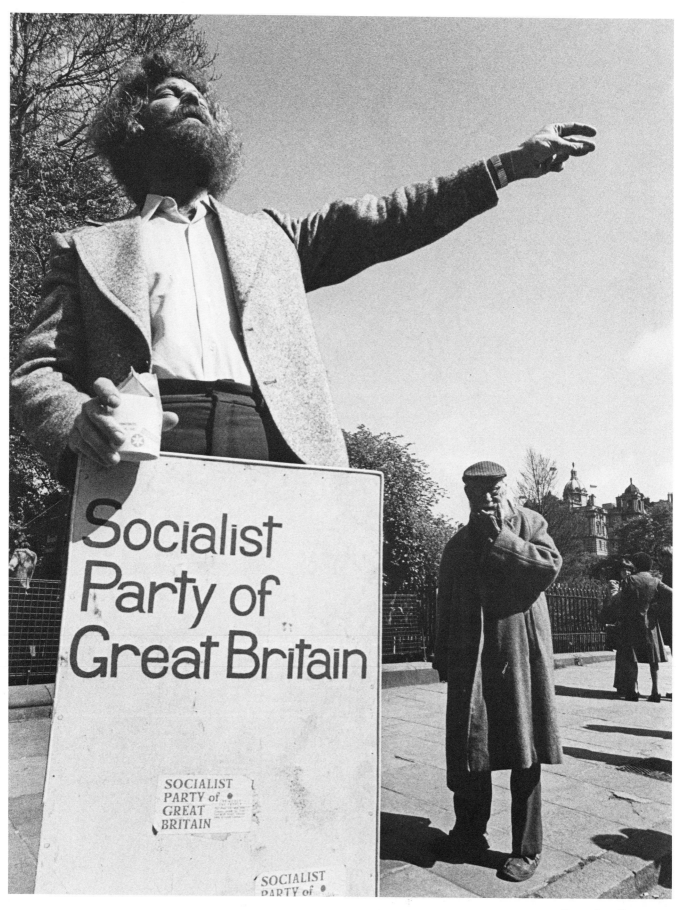

Douglas Corrance

Douglas Corrance

Denis Englefield

Howard Walker

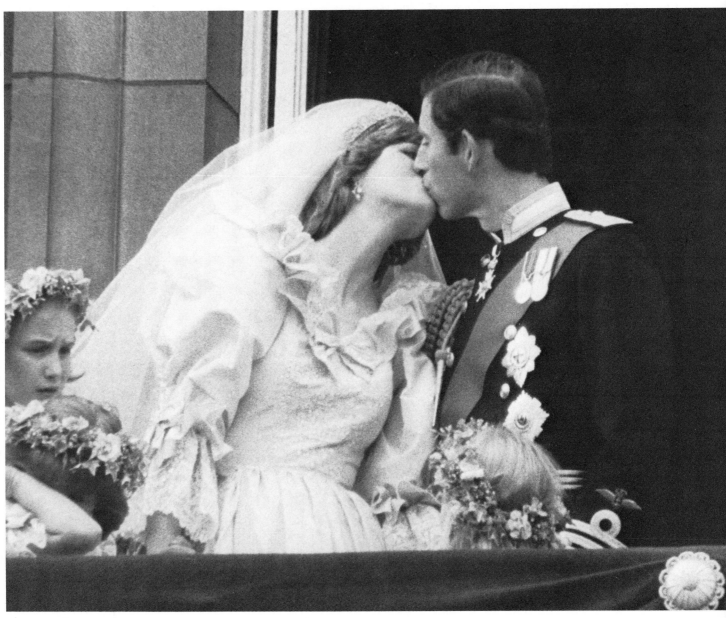

Ron Burton

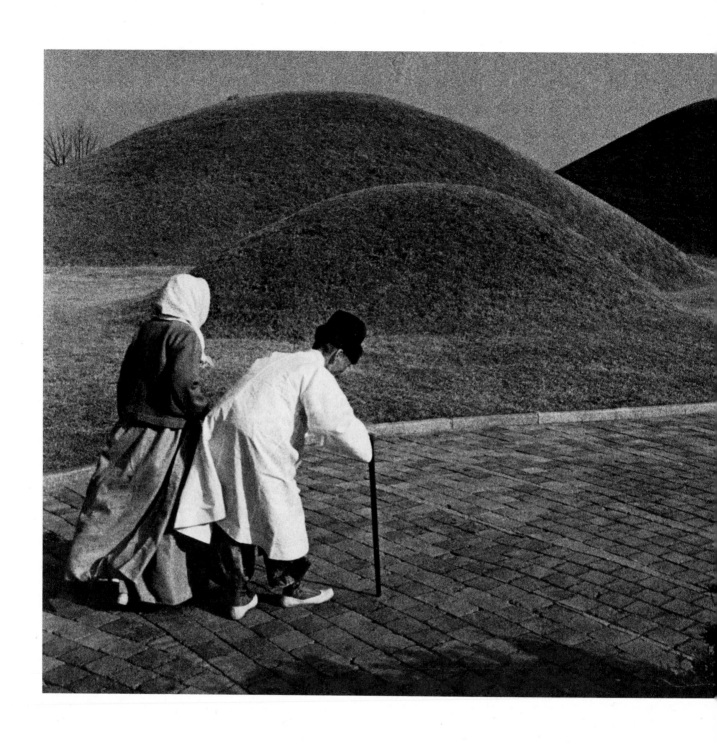

Boo Gil Choi

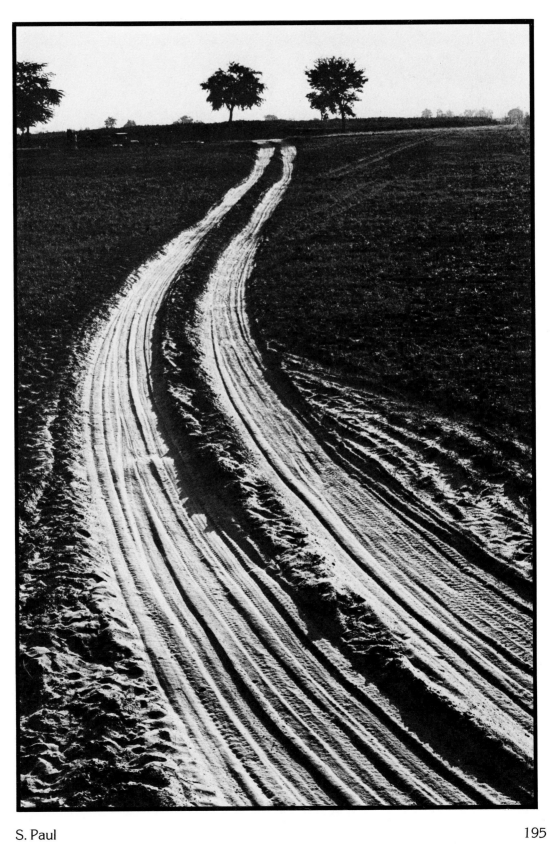

S. Paul

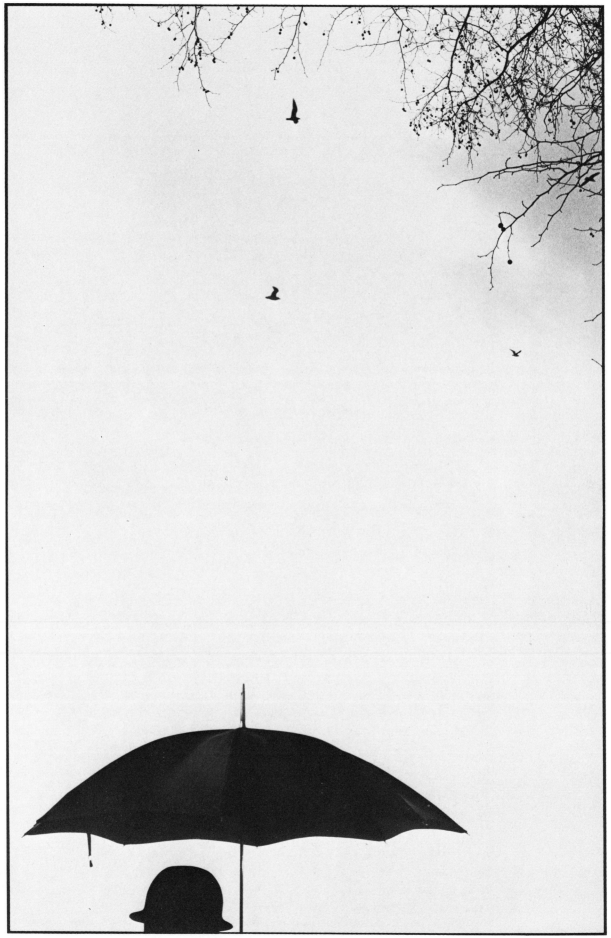

196

R.G. Curtis

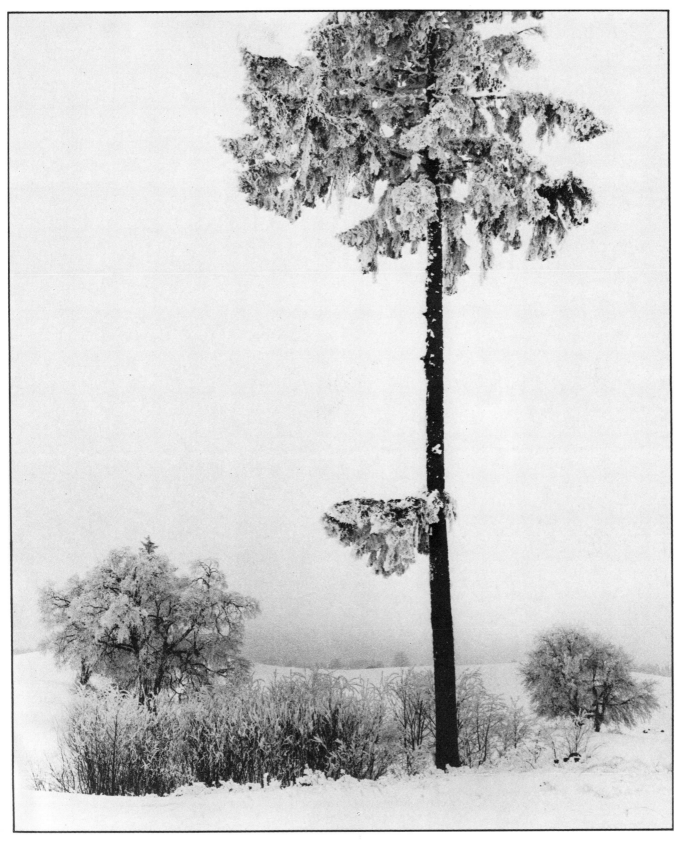

V. Stankevicius

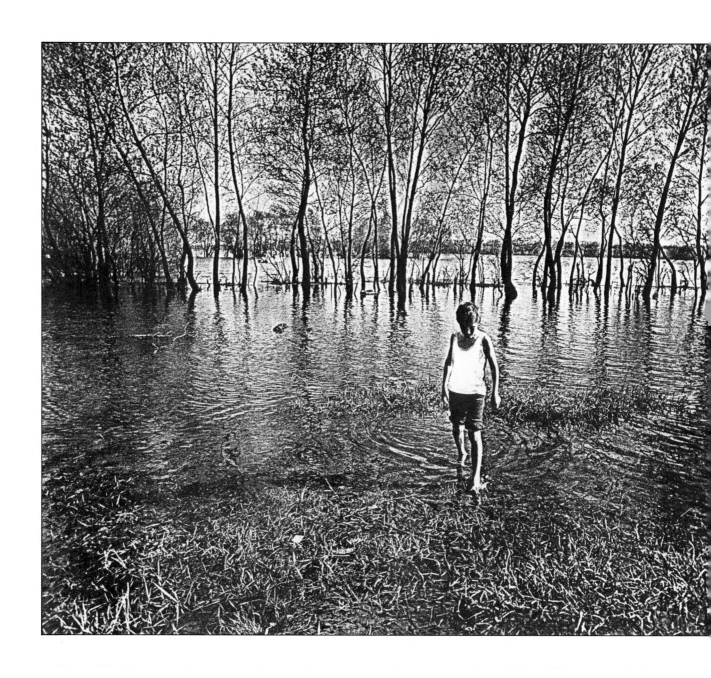

Vladimir Filonov

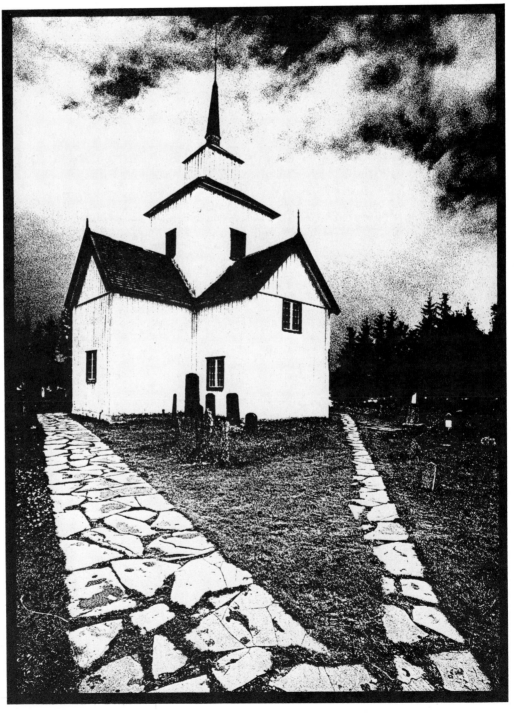

Jens O. Hagen

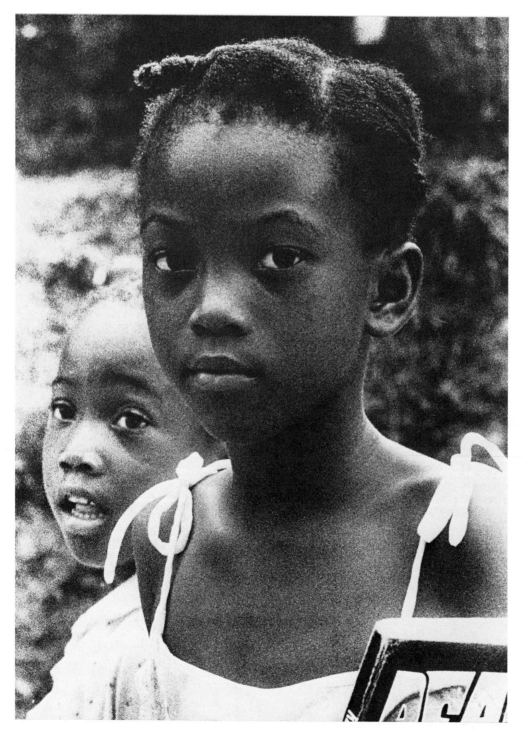

Veikko Wallström

T. Keeler

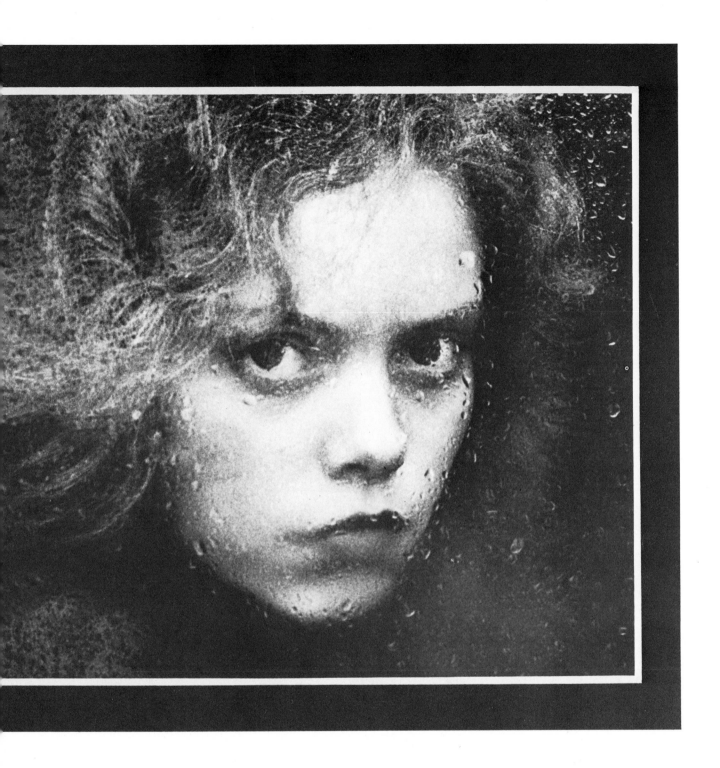

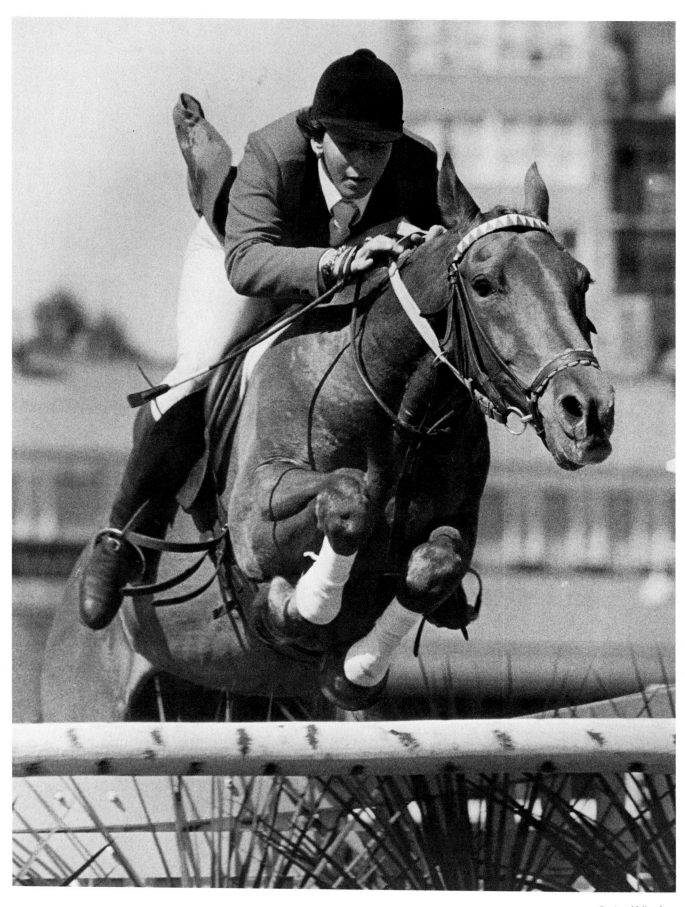

Colin Whelan

Margaret Salisbury

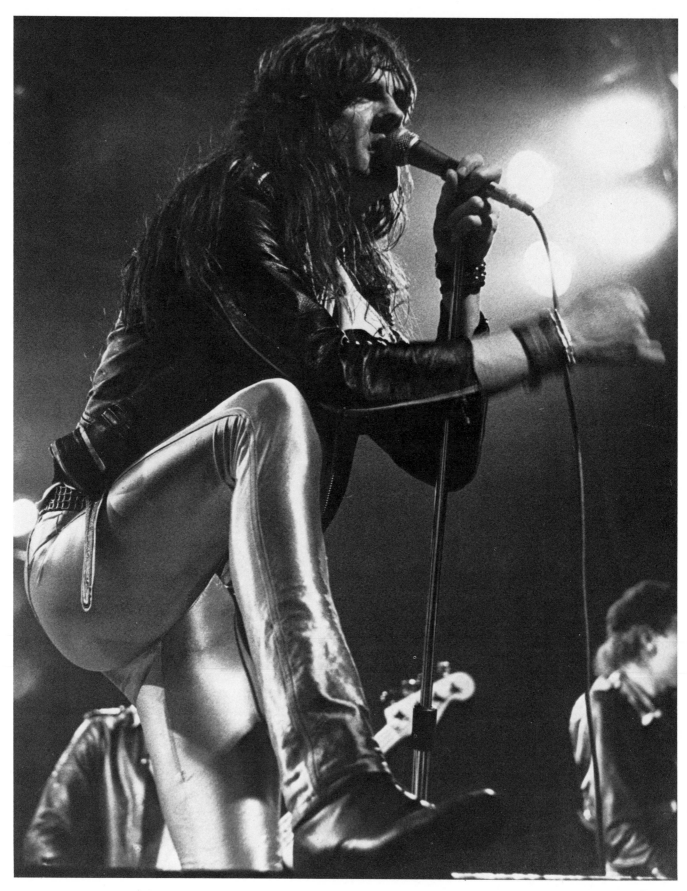

Stephen Power

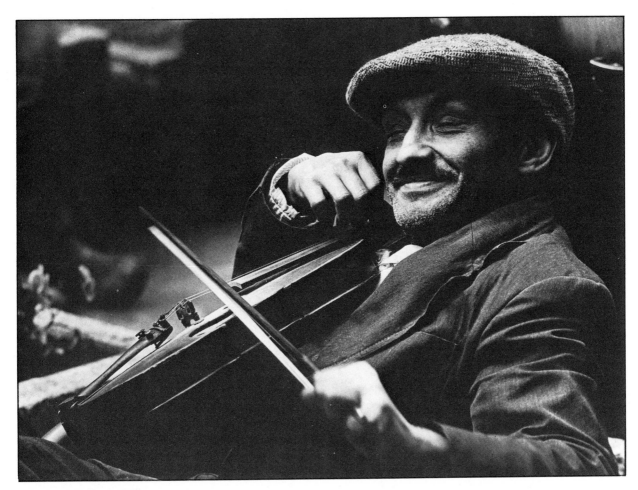

Zbigniew J. Podsiadlo

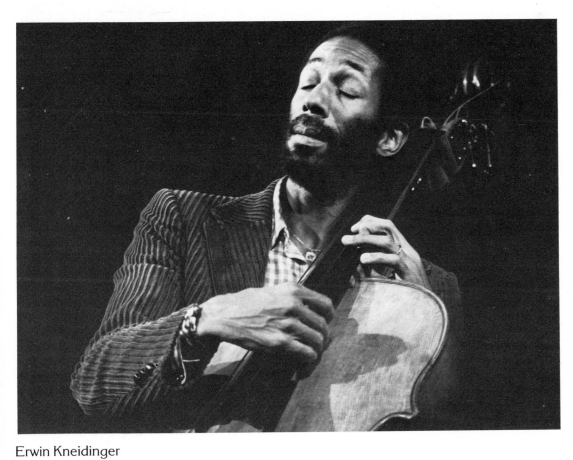

Erwin Kneidinger

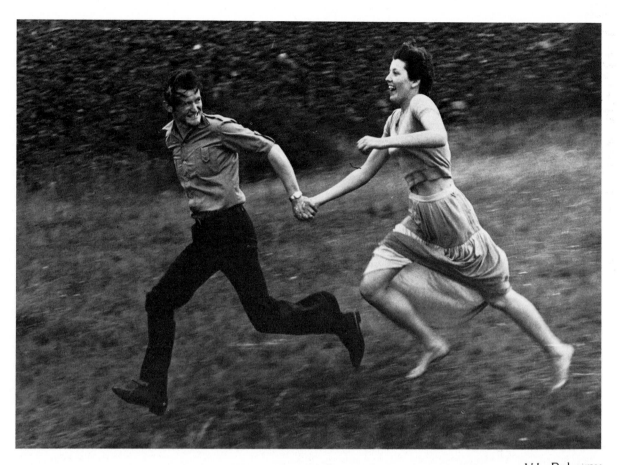

V.L. Pokorny

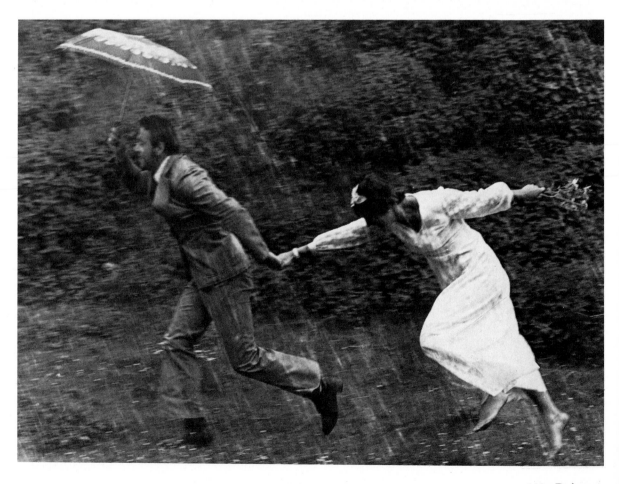

V.L. Pokorny

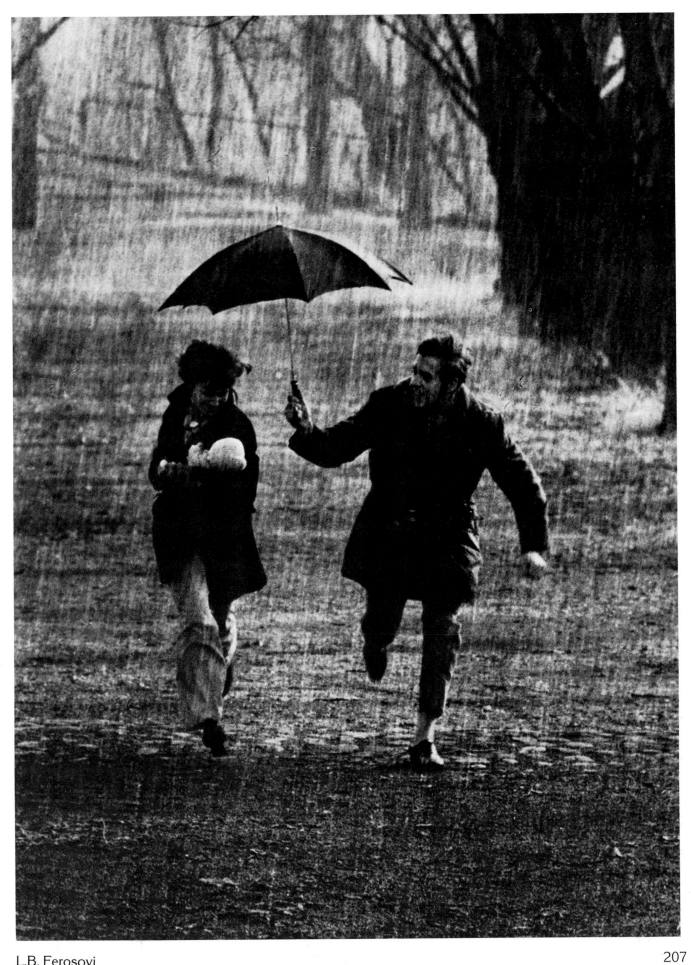

L.B. Ferosovi

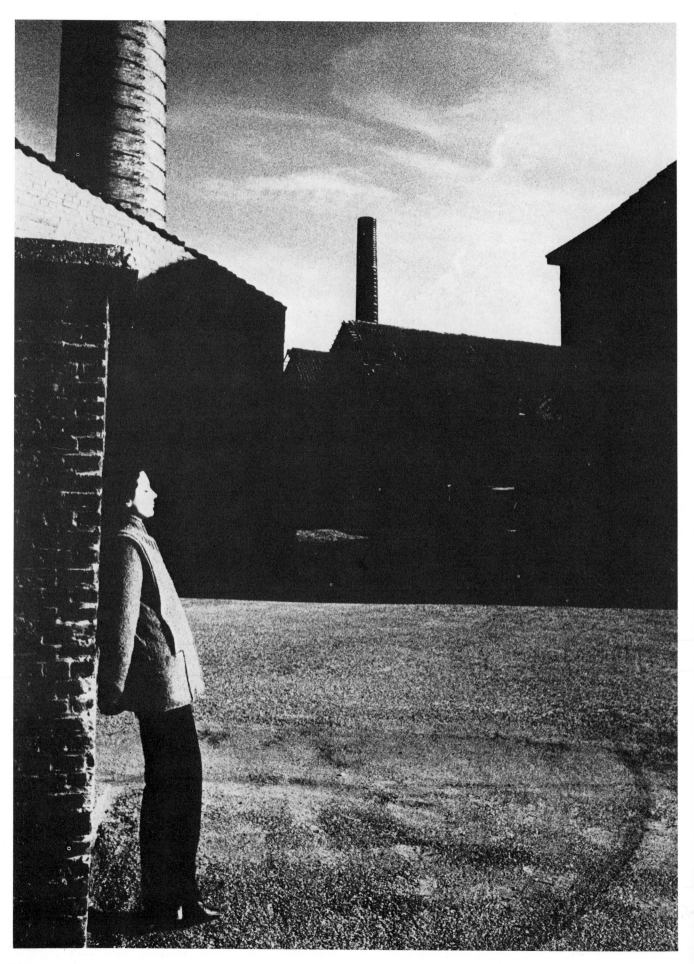

Frank Peeters

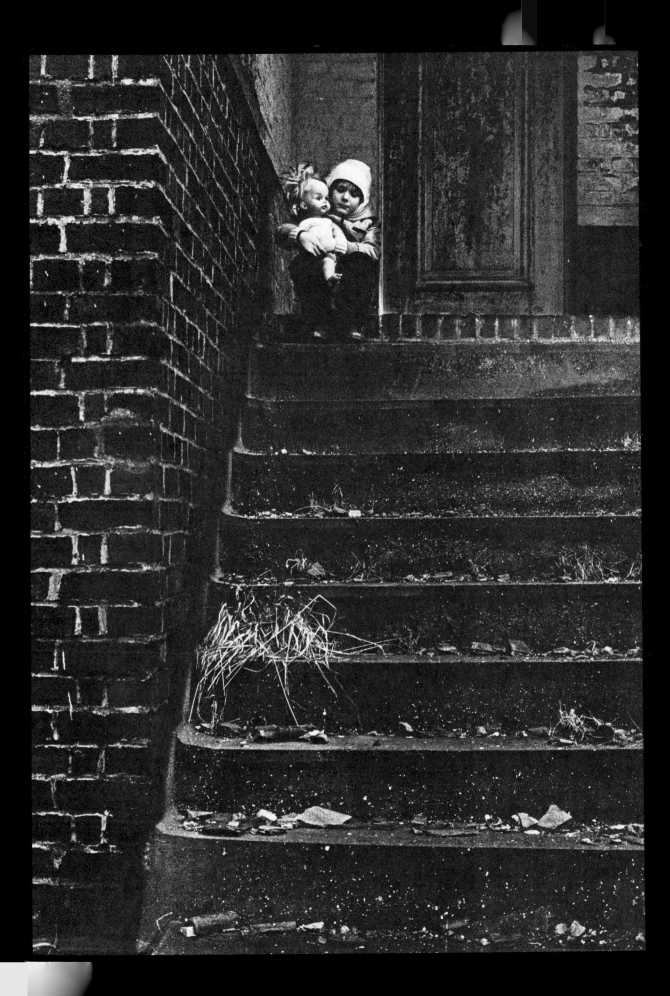

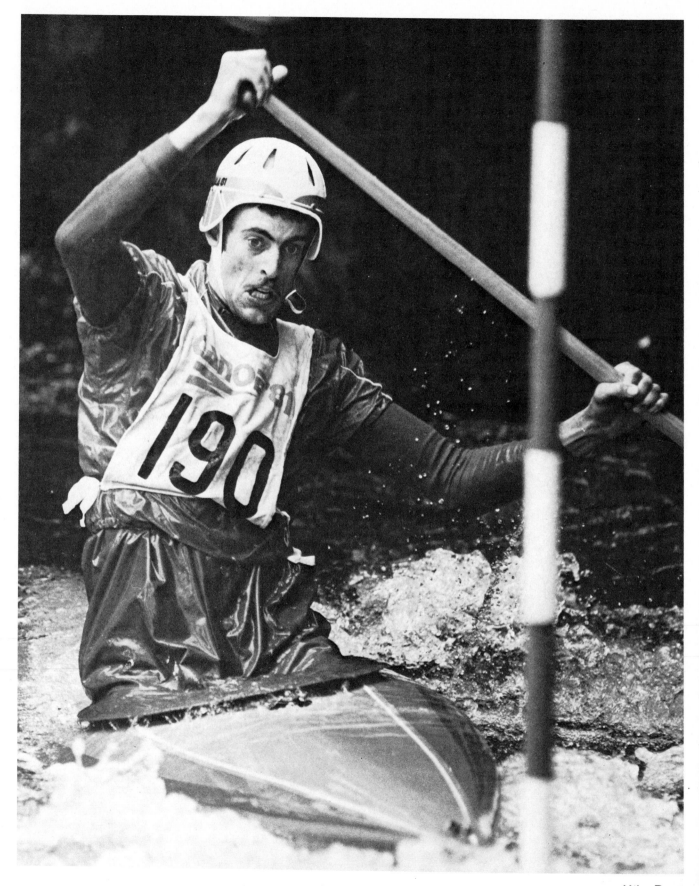

Mike Brett

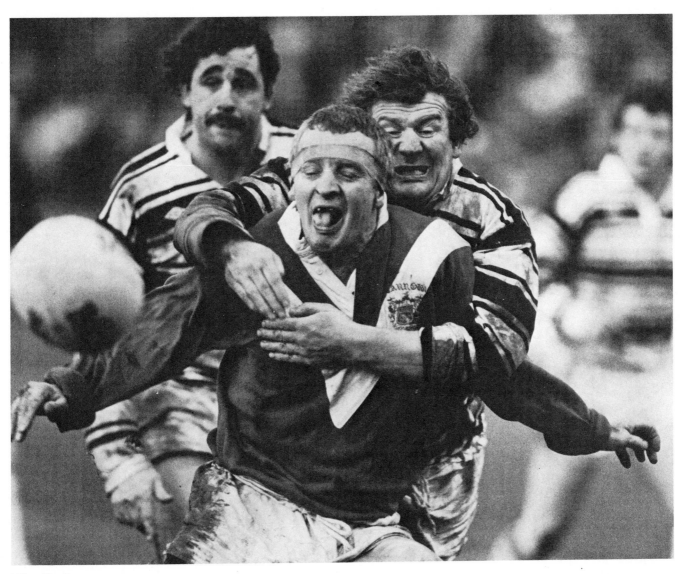

Mike Brett

Jenny Goodall

John Heywood

Oleg Burbowskij

Alejandro M. Gonzalez

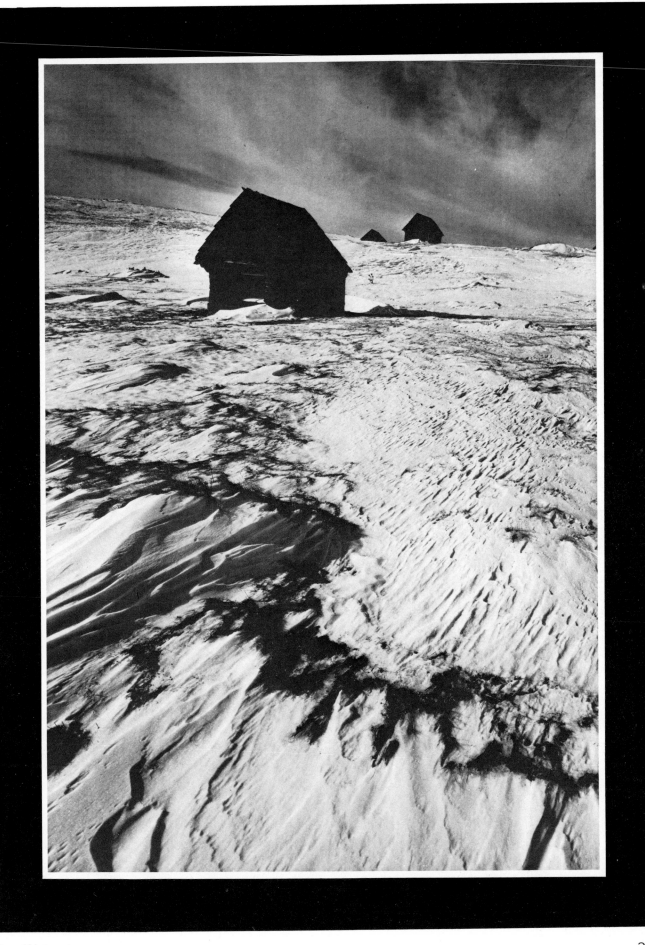

Vera Weinertova

John Davidson

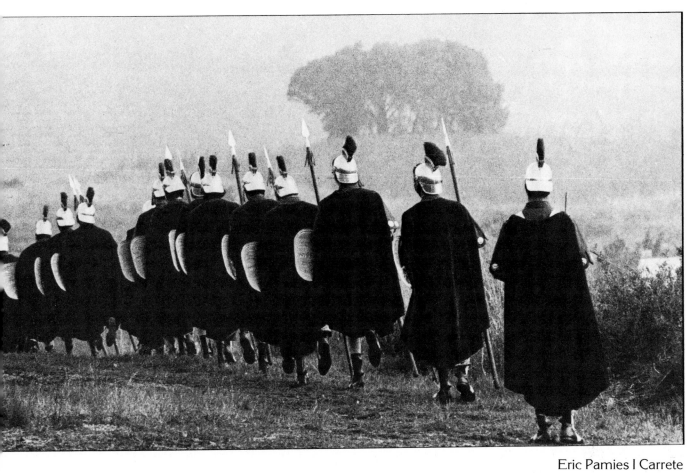

Eric Pamies I Carrete

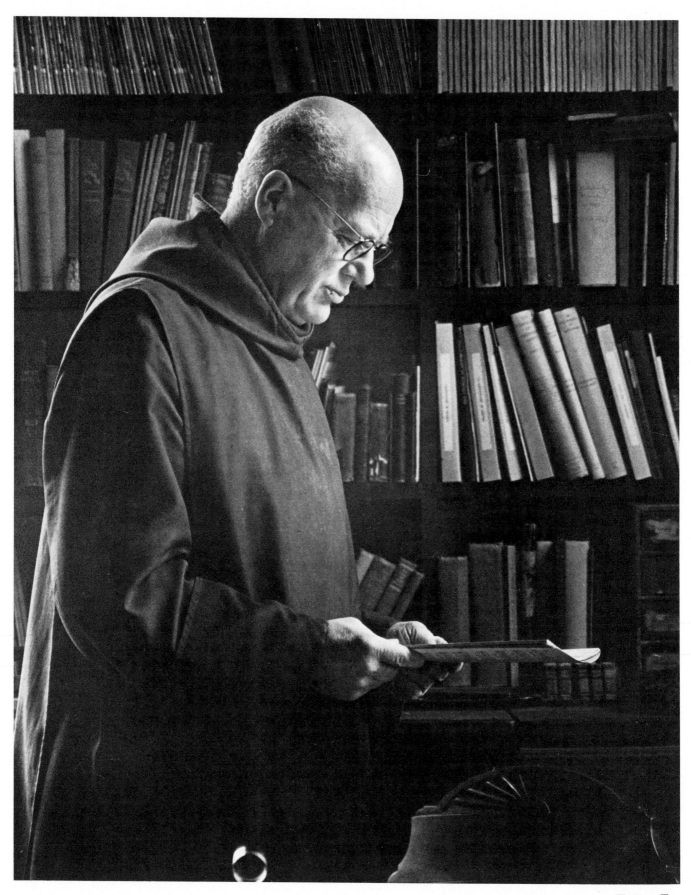

Trevor Fry

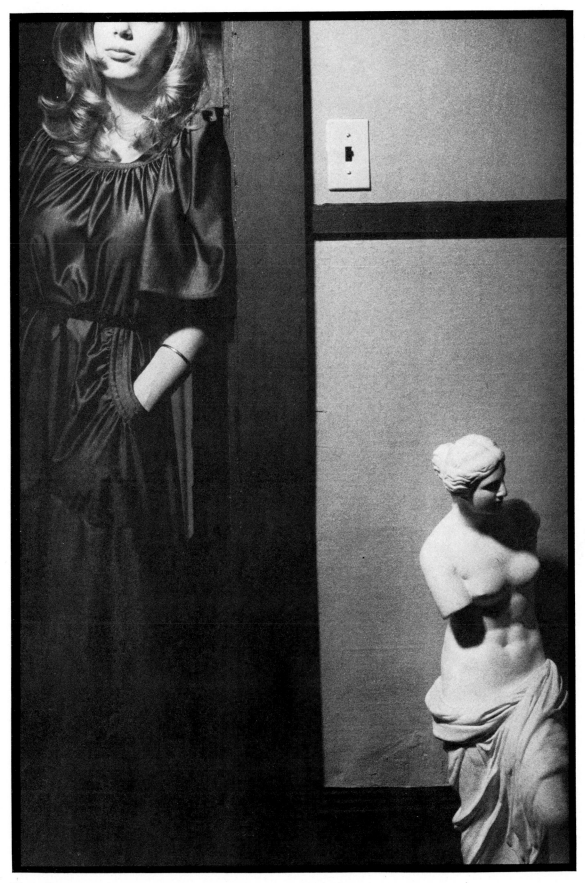

Tom Gore

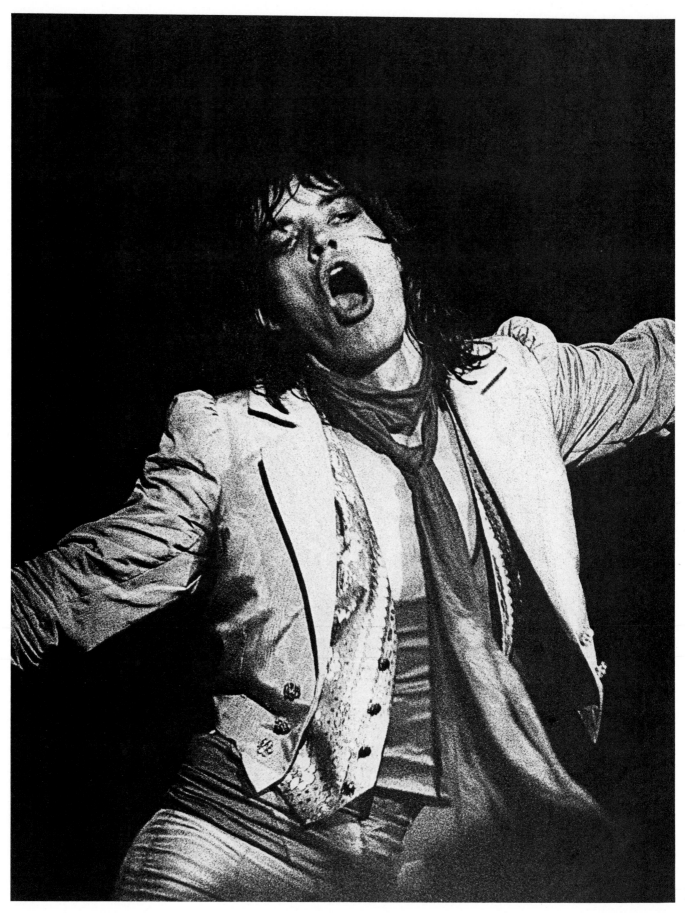

Felipe Iguiñiz

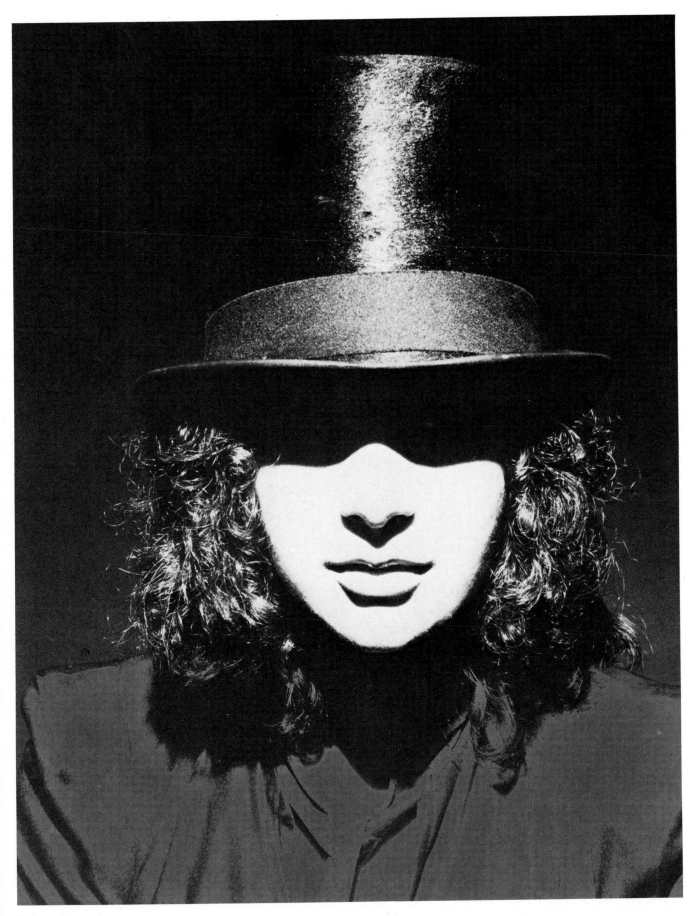

Robert Mason

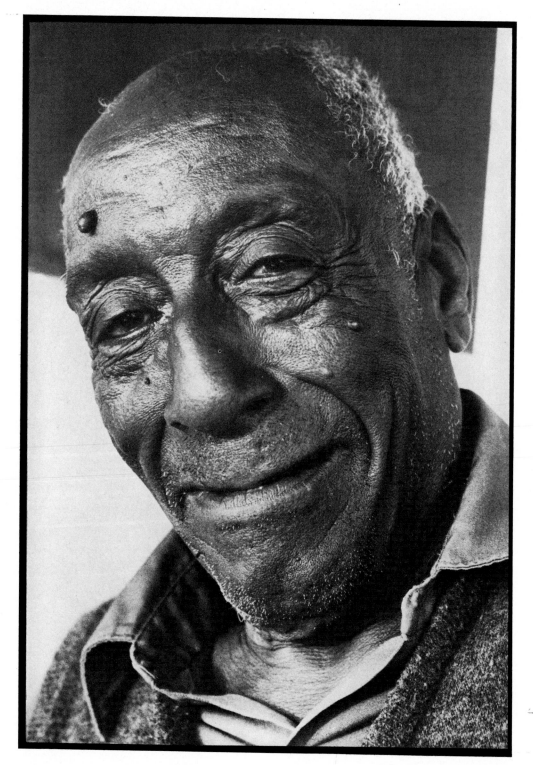

István Tóth

Denis Thorpe

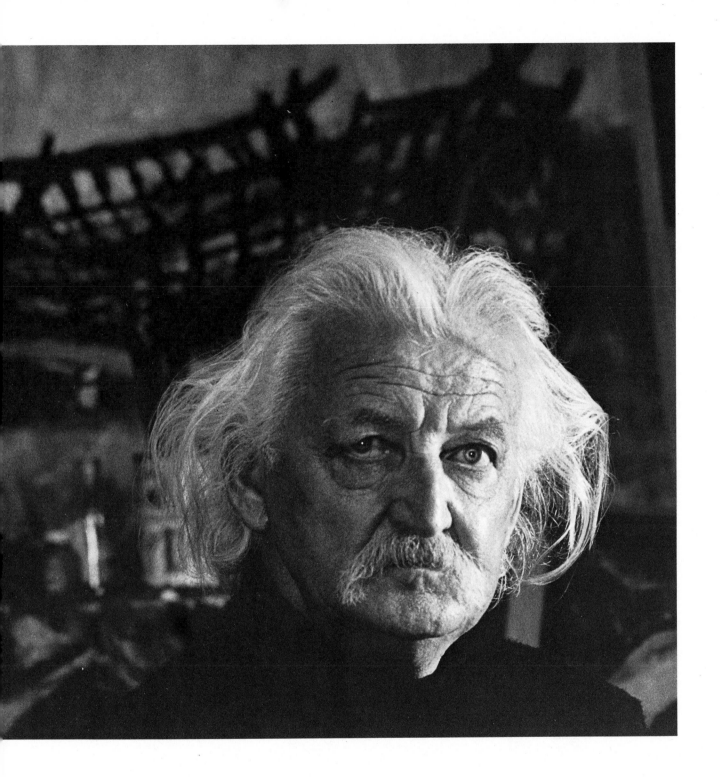

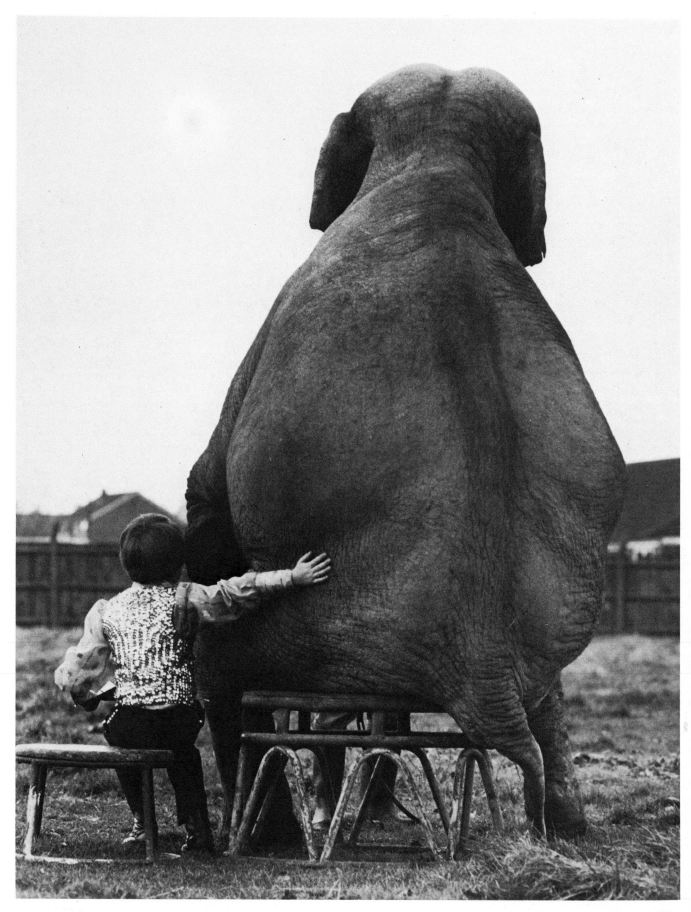

Mike Hollist

Technical Data

Jacket

Photographer Carol Anne Rimmer

A Polaroid picture by a student of the Blackpool and Fylde College which won first prize in the Portrait Section of a 1st Year student competition held by Polaroid (UK) Ltd.

Ein Polaroid-Bild von einem Studenten des Fylde College in Blackpool, der im Porträt-Teil eines Wettbewerbes für Studenten des 1. Jahres von Polaroid (UK) Ltd. den ersten Preis erhielt.

Een polaroid-opname van een student fotografie die hiermee de eerste prijs won in de categorie 'portretten' van een door Polaroid georganiseerde wedstrijd voor eerstejaars studenten fotografie.

Fotografía Polaroid, hecha por una estudiante del College de Blackpool y Fylde, que ganó el primer premio en la sección de retratos de un concurso que patrocinó la Polaroid (UK) Ltd. para los estudiantes de primer curso.

La photo a été prise avec un Polaroid par une étudiante du "Blackpool and Fylde College" et a obtenu le premier prix dans la catégorie "portrait" lors du concours pour étudiants de 1ère année, organisé par Polaroid (GB) Ltd.

Front Endpaper

Title	"Old Drum House"
Photographer	W Barry Evans
Camera	Leica M3
Lens	50mm Summicron
Film	Ilford Pan F

One of the best of the landscapes with a modern treatment shown in the Royal Photographic Society's Annual Exhibition. The low viewpoint, wide angle and contre-jour lighting give a lot of impact.

Eine der besten Landschaften in moderner Darstellung, die auf der Jahresausstellung der Royal Photographic Society gezeigt wurde. Der niedrige Blickpunkt, der breite Winkel und das Gegenlicht erzielen große Durchschlagskraft.

Een uitstekende landschapopname met een moderne benaderingswijze. Het lage standpunt, gebruik van een groothoekobjectief en het tegenlicht leiden tot een sterke beeldvoordracht.

Una de las mejores fotografías de paisajes con tratamiento moderno expuestas en la Exhibición Anual de la Royal Photographic Society. El punto de vista bajo, la amplitud y la iluminación a contraluz le proporcionan gran impacto.

L'un des meilleurs paysages de l'exposition annuelle de la "Royal Photographic Society". Le traitement est moderne, la prise de vue, le grand angle et le contre-jour créent un effet puissant.

13

Title	"Rudolf Nureyev off duty"
Photographer	Denis Thorpe
Camera	Leica M2
Lens	35mm Summilux
Film	HP5

Of the many portraits of this famous ballet star there are few which have projected character so well and the unusual composition is striking.

Unter den vielen Porträts dieses berühmten Ballettänzers gibt es wenige, die seinen Charakter so gut herausstellen. Die ungewöhnliche Komposition ist verblüffend.

Er zijn maar weinig portretten die van deze beroemde balletdanser zijn gemaakt, waarop het karakter zo goed naar voren komt; de ongewone compositie is frappant.

De todos los retratos que se han hecho a esta famosa estrella del ballet, pocos han logrado una buena caracterización, y es rara una composición tan sorprendente.

Parmi les nombreux portraits du célèbre danseur étoile, rares sont ceux qui ont autant de caractère, et cette composition inhabituelle est frappante.

14

Title	"The Riverside"
Photographer	Ha Won Bark
Camera	LeicaFlex SL
Lens	Elmarit – R 90mm f2.8 at f/11 1/500 sec
Film	Tri-X Microdol – X

A very unusual treatment sharing the classic "S" composition which gives and impression of depth while suppressing detail. The figures give scale without being obtrusive.

Eine sehr ungewöhnliche Darstellung mit der klassischen S-Komposition, die einen Eindruck von Tiefe vermittelt, während das Detail unterdrückt wird. Die Figuren vermitteln einen bestimmten Maßstab, ohne aufdringlich zu erscheinen.

De klassieke compositie met een S-vorm geeft een idee van diepte; door de opnametechniek worden details onderdrukt. De twee figuurtjes geven een idee van de schaal, zonder dat ze te sterk opvallen.

Un tratamiento especial de la clásica composición en "S" que proporciona profundidad, suprimiendo el detalle. Las figuras añaden proporción sin ser llamativas.

Un traitement très inhabituel avec composition classique en "S" qui donne une impression de profondeur tout en supprimant les détails. Les silhouettes mettent le paysage en valeur sans toutefois s'imposer.

15

Title	"Tao"
Photographer	Dr K L Kothary
Camera	Rolleicord
Lens	f3.5
Film	Panatomic X

A very artistic landscape which leads the eye around the picture to rest on the goatherd silhouetted against a dramatic sky.

Sehr künstlerische Landschaft, bei der das Auge um das Bild schweift und auf der Geißenherde zur Ruhe kommt, deren Silhouette mit dem interessanten Wolkenhimmel kontrastiert.

Een zeer artistieke landschapopname waarbij het oog over de hele foto wordt rondgeleid; de aandacht blijft uiteindelijk gevestigd op de geitenherder die als een silhouet afsteekt tegen een dramatische lucht.

Un panorama artístico que conduce al ojo a lo largo de la foto hasta llegar al rebaño de cabras, cuya silueta contrasta con el cielo dramático.

Un paysage très artistique où l'oeil peut se promener à son gré à travers l'image pour s'arrêter sur le troupeau de chèvres projeté en silhouette sur un ciel théâtral.

16

Title	"Prophetic Sign?"
Photographer	A Markey
Camera	Nikon F2
Lens	50mm
Film	HP5

A well seen shot of Mrs Shirley Williams MP shortly after she had joined the newly formed Social Democratic Party.

Eine gut gesehene Aufnahme von Shirley Williams, MP kurz nach ihrem Beitritt zur neu gebildeten Social Democratic Party.

Een treffer, deze foto van het Engelse parlementslid Shirley Williams, gemaakt kort nadat ze tot de nieuw opgerichte Sociaaldemocratische Partij was toegetreden.

Una buena toma de la señora Shirley Williams, miembro del Parlamento, un poco después de haberse integrado al recién formado Partido Social-Demócrata.

Une photo très bien observée de Mrs Shirley Williams MP, peu après son entrée au parti Social Démocrate nouvellement constitué.

17 (Upper)

Title	"One in the eye for Cyril Smith!"
Photographer	Don McPhee
Camera	Nikon F2
Lens	85mm Nikkor
Film	FP4

This well-known member of Parliament always makes news and especially with candid shots like this.

Dieses allgemein bekannte Parlamentsmitglied macht stets Schlagzeilen, besonders bei unverblümten Aufnahmen wie dieser.

Het bekende Engelse parlementslid Cyril Smith is altijd goed voor nieuws, zeker ook met candid opnamen als deze.

Todo lo que hace este conocido miembro del Parlamento hace noticia, especialmente fotos ingenuas como ésta.

Ce deputé très connu fait souvent parler de lui, surtout avec des photos prises sur le vif comme celle-ci.

17 (Lower)

Title	"Rt. Hon. Roy Jenkins"
Photographer	Mike Hollist
Camera	Nikon F2
Lens	105mm
Film	Tri-X

A famous politician caught off guard is always an intriguing subject, this time a happy one.

Ein berühmter Politiker im unbedachten Moment ist stets ein interessantes Bild, dieses Mal ein glückliches.

Het maken van foto's van beroemde politici als ze zich onbespied wanen kan intrigerende resultaten opleveren, en vrolijke, zoals hier.

Coger por sorpresa a los políticos famosos es un tema intrigante; en este caso, una toma oportuna.

Surprendre un célèbre homme politique donne toujours des résultats inattendus: pourquoi ce sourire?

18

Photographer	Andrej Lashkov
Camera	Pentax Spotmatic
Lens	20mm Flektogon
Film	KN3

Typical of much of the work we see from Russia – bold simplification and heavy blacks, but a romantic message.

Typisch für Arbeiten aus Rußland – kühle Vereinfachung und starke schwarze Bereiche, jedoch mit romantischer Aussage.

Typerend voor veel werk dat we uit Rusland ontvangen – een sterke vereenvoudiging en zware, zwarte partijen, met een romantische boodschap.

Típico de la mayoría de los trabajos que vienen de Rusia: atrevida utilización de los tonos negros para la transmisión de un mensaje romántico.

Photo assez représentative du travail que nous recevons de Russie – une simplification hardie et des ombres accentuées mais une touche romantique.

19

Title	"Summer"
Photographer	Vladimirovitch Shegelman

An almost stereoscopic impression of depth has been given by the interesting foreground against a high key background. The inclusion of the child is a nice touch.

Fast stereoskoper Tiefenausdruck durch interessanten Vordergrund mit scharfem Hintergrund. Der Einschluß des Kindes verfeinert das Detail.

Een bijna stereoscopische indruk van diepte is hier verkregen door de interessante voorgrond die afsteekt tegen een high key achtergrond. De plaatsing van het kind op de voorgrond geeft een interessant detail.

Por medio del interesante primer término, que contrasta con la claridad del fondo, casi se ha logrado una impresión estereoscópica de la profundidad. La presencia del niño es un buen detalle.

Une impression presque stéréoscopique de profondeur est donnée par le contraste du premier plan sur le lointain évocateur. La présence de l'enfant adoucit le paysage.

20

Title	"Parella"
Photographer	Domènec Bataller i Tortosa
Camera	Pentax SP 100
Lens	55mm Takumar
Film	Tri-X

The outline produced by backlighting and a simplified tone treatment has produced a powerful impact.

Starke Durchschlagskraft durch Gegenlicht-Umrisse und vereinfachte Tonbehandlung.

Deze indrukwekkende opname werd verkregen door gebruik te maken van de door tegenlicht veroorzaakte contour en een grafische omwerking die, doordat er veel details wegvallen, vereenvoudigend werkt.

El contorno producido por la luz posterior y la simplificación del tono produce un fuerte impacto.

Les silhouettes en contre-jour et le traitement simplifié des tons produisent une composition d'une puissance indiscutable.

21

Title	"Happy Old Man"
Photographer	Jochen Ehmke

The line treatment adopted here has made this a more interesting picture than usual with the highly detailed background giving the appearance of an etching.

Durch die hier übernommene Liniendarstellung entstand ein interessanteres Bild mit stark detailliertem Hintergrund, so daß es das Aussehen eines Kupferstiches erhält.

De hier toegepaste grafische bewerking heeft deze foto beslist interessanter gemaakt; door de sterk gedetailleerde achtergrond doet hij denken aan een ets.

El tratamiento de línea adoptado aquí ha aumentado el interés de la foto; y la densidad de detalle le da una apariencia de grabado.

Le traitement des lignes adoptées ici rend la photo plus intéressante, la netteté des détails du décor lui donnant l'aspect d'une eau-forte.

22

Photographer	Clive B Harrison
Camera	Olympus OM-1n
Lens	100mm Zuiko
Film	HP5

A delightfully candid and natural study of a child caught unaware of the camera.

Erfrischende, offene, natürliche Studie eines Kindes, das die Kamera nicht beachtet.

Een schitterende candid opname van een kind dat zich niet bewust was van de aanwezigheid van de fotograaf.

Un estudio natural e ingenuo de un niño que no ha percibido la cámara.

Une étude charmante et naturelle d'un enfant pris sur le vif.

23

Photographer	Jim Chambers
Camera	Nikon FM
Lens	75-100mm zoom
Film	HP5

A contemporary illustrative picture which will have historic value when the skinhead phase has passed.

Modernes, illustrierendes Bild, das historischen Wert erlangt, wenn die Punk-Phase vorbei ist.

Deze eigentijdse foto zal ooit historische waarde krijgen.

Una instantánea de la vida contemporánea que tendrá valor histórico cuando pase la moda de los "rapados".

Un reflet de notre époque qui aura une valeur historique quand la mode des skinheads sera dépassée.

24/25

Title	"Tommy Docherty"
Photographer	Brian Duff
Camera	Nikon F2
Lens	105mm
Film	FP4

A picture used to illustrate a centre spread when Docherty was hired by Queens Park Rangers for the third time.

Bild für die Aufschlagseite, als Docherty zum dritten Mal von Queens Park Rangers eingestellt wurde.

Deze foto werd gemaakt nadat Docherty voor de derde keer een managerscontract had gekregen voor de Engelse voetbalclub Queens Park Rangers.

Esta toma solía ser la ilustración cuando el Queens Park Rangers alquiló al Docherty por la tercera vez, la cual tomada la noche del Reading Gala Night of Sport hace justicia a la altura real de la acción.

Photo utilisée pour illustrer un article sur 2 pages quand Docherty a été loué par Queens Park Rangers pour la troisième fois.

26 (Upper)

Title	"Grahame Dangerfield"
Photographer	Mike Hollist
Camera	Nikon F2
Lens	180mm
Film	Tri-X

The famous naturalist is holding a miniature Ferrec Fox classed as a dangerous animal. He would like the law changed for these creatures.

Der berühmte Naturforscher hält einen als Schädling klassierten kleinen Ferrec-Fuchs. Er möchte das Gesetz für diese Tiere geändert sehen.

De beroemde natuurvorser houdt hier een kleine woestijnvos vast, die te boek staat als een gevaarlijk dier. Hij wil graag dat de wetten ten aanzien van deze dieren worden aangepast.

El famoso naturalista sostiene un diminuto zorro, considerado como animal peligroso. Le gustaría que cambiase la ley contra estas criaturas.

Le célèbre naturaliste tient un renard Ferrec miniature classé comme animal dangereux. Il voudrait que la loi soit changée pour ces animaux.

26 (Lower)

Title	"Triplets"
Photographer	Brian R Bricknell
Camera	Nikon FM
Lens	Vivitar 35-85 mm zoom
Film	FP4

A most unusual composition which produced one of the most widely discussed pictures in the London Salon Exhibition.

Eine äußerst ungewöhnliche Komposition, durch die eins der am meisten diskutierten Bilder auf der Londoner Salon Exhibition entstand.

Een bijzonder ongebruikelijke compositie, die veel discussie opriep op de Londense Fotosalon.

Una composición desacostumbrada que armó gran revuelo en las salas del London Salon Exhibition.

Une composition très inhabituelle qui a produit l'une des photos les plus largement commentées de l'exposition du salon de Londres.

The complete way to develop your photography.

27

Photographer	Pedro Luis Raota
Camera	Hasselblad
Lens	60mm f/5.6
Film	Kodak 400

A portrait which is also full of mood and which evokes a sympathetic response in the viewer. Its message is clear and the technique is impressive.

Ein Porträt mit Stimmung, die beim Beschauer Sympathie erweckt. Seine Aussage ist klar, die Technik eindrucksvoll.

Een stemmingsvol portret dat bij de toeschouwer gevoelens van sympathie oproept. De boodschap is duidelijk, de techniek is indrukwekkend.

Un retrato lleno de sentimiento que llega hasta el espectador. El mensaje es claro y la técnica impresionante.

Un portrait attachant et plein d'atmosphère qui éveille un sentiment de sympathie. Son message est clair et la technique est impressionnante.

28

Title	"Final"
Photographer	L Grubinskas

The light on the player's face, presumably held back when enlarging, has forcibly directed attention to his intense involvement and emphasised the drama of the action.

Das Licht auf dem Gesicht des Spielers, das wahrscheinlich beim Vergrößern zurückgehalten würde, lenkt die Aufmerksamkeit mit aller Kraft auf seine intensive Einbeziehung und unterstreicht die dramatische Tätigkeit.

Het licht op het gezicht van de speler, waarschijnlijk bij het vergroten wat tegengehouden, richt de aandacht dwingend op zijn concentratie en benadrukt het dramatische.

La luz en el rostro del jugador, posiblemente omitida al hacer la ampliación, dirige la atención con fuerza hacia el tema y aumenta el drama de la acción.

La lumière sur le visage du joueur, probablement intensifiée lors du développement, attire l'attention avec force sur l'effort de concentration et met l'accent sur le côté dramatique de la scène.

29

Title	"Hypnosis"
Photographer	Per-Anders Jörgensen
Camera	Canon A1
Lens	100mm
Film	Tri-X rated at 2,000ASA

The extended uprating has given this shot of a well known Swedish table tennis player, Ulf Carlsson, a dramatic impact.

Die erhöhte Steigerung hat dieser Aufnahme von Ulf Carlsson, einem allgemein bekannten schwedischen Tischtennisspieler, dramatische Durchschlagskraft verliehen.

Voor deze foto van de bekende Zweedse tennisspeler Ulf Carlsson werd de film sterk opgewaardeerd waardoor de dramatische indruk wordt vergroot.

La toma ha logrado dar un impacto dramático al conocido jugador de tenis de mesa Ulf Carlsson.

L'utilisation d'un film de très haute sensibilité donne à cette photo d'un célèbre joueur suédois de tennis de table, Ulf Carlsson, un effet théâtral.

30

Title	"Daley Thompson"
Photographer	George Herringshaw
Camera	Nikon
Lens	400mm
Film	XP1 rated at 400ASA

One of the most dramatic sports pictures of the year which is also a technical achievement.

Eines der dramatischsten Sportbilder des Jahres, das auch ein technischer Erfolg ist.

Een van de meest dramatische sportopnamen van dit jaar, tevens een technisch hoogstandje.

Una de las fotos deportivas más dramáticas del año, y también un logro técnico.

L'une des photos sportives les plus spectaculaires de l'année et qui est aussi un exploit technique.

31

Photographer	Denis Englefield
Camera	Olympus OM-1
Lens	135mm Zuiko
Film	HP5 rated at 650ASA

The actual height of the action was well prejudged in this fine shot of a pole vaulter taken at the Reading Gala Night of Sport.

Die Sprunghöhe wurde bei dieser feinen Aufnahme eines Stabhochspringers, die während der Gala Night of Sport, Reading aufgenommen wurde, gut geschätzt.

De uiteindelijke hoogte van de actie werd van tevoren goed gekozen voor deze fijne opname van een polsstokhoogspringer.

Esta fotografía, tomada la noche del Reading Gala Night of Sport, hace justicia a la altura real de la acción.

La hauteur réelle de l'action a été bien jugée dans cette excellente photo d'un sauteur à la perche prise à la soirée sportive de gala de Reading.

32

Title	"Vento sulla China"
Photographer	Giuseppe Balla
Camera	Canon F1
Lens	200mm
Film	Tri-X

One can almost feel the cold and experience the climber's struggle in this powerful composition beautifully emphasised by contre-jour lighting.

Man kann fast die Kälte und Erfahrungen beim Kampf des Bergsteigers in dieser starken Komposition mitfühlen, die durch Gegenlicht gekonnt unterstrichen wurde.

Je voelt de kou haast en je leeft mee met de worstelende bergbeklimmer bij deze krachtige compositie die schitterend wordt benadrukt door strijklicht.

Se puede sentir el frío y experimentar las dificultades del montañista, con esta bellísima composición tomada a contraluz.

Nous pouvons presque sentir le froid et partager la lutte acharnée de l'alpiniste dans cette puissante composition merveilleusement accentuée par le contre-jour.

33

Title	"Silky"
Photographer	Ozaki Kakuji
Camera	Mamiyaflex 330
Lens	55mm Sekor
Film	Ektachrome

A striking picture in contemporary style that seems to bring Japanese art up to date.

Verblüffendes Bild im modernen Stil, das die japanische Kunst auf den neuesten Stand bringt.

Een opvallende foto in moderne stijl die de Japanse kunst in de moderne tijd doet herleven.

Una sorprendente toma con estilo contemporáneo que pone al día al arte japonés.

Une photo frappante d'un style contemporain qui est évocatrice de l'art du Japon traditionnel.

34

Title	"Greyhounds at speed"
Photographer	Leo Mason
Camera	Nikon
Lens	800mm
Film	Kodachrome 64

An impressive action picture with tremendous impact due to the use of a very long focus lens.

Eindrucksvolles Bewegungsbild mit enormer Durchschlagskraft durch den Einsatz eines Fernobjektives.

Indrukwekkende actiefoto; hij is vooral ook zo bijzonder door het gebruik van een lange brandpuntsafstand.

El tremendo impacto de la acción se ha logrado mediante la utilización de un teleobjetivo.

Une photo remarquable dont l'effet saisissant a été obtenu au moyen d'un très long téléobjectif.

35

Title	"Agnes C"
Photographer	Joseph Cascio
Camera	Nikon FE
Lens	105mm Nikkor f/2.5
Film	Kodacolor II

Portraiture in a very modern vein with an intriguing pose and unusual background.

Sehr modernes Porträt mit interessanter Pose und ungewöhnlichem Hintergrund.

Een portretopname met een modern tintje door een intrigerende pose en een ongewone achtergrond.

Retrato muy moderno con postura intrigante y rodeado por un marco ambiental poco corriente.

Un portrait très moderne au décor inhabituel; la pose pique notre curiosité.

36 (Upper)

Title	"Flask Walk"
Photographer	Edward Bowman
Camera	Rolleiflex
Lens	f/3.5
Film	Vericolor
Print	Agfacolor

The subtle and delicate colour harmonies make even a snowstorm attractive.

Nikon

Colin Molyneux/ Image Bank.

When a moment becomes a memory there is only one thing preventing that memory being lost to time.

Not a date. A scent or a sound. But a photograph that has captured the sight, the aura and the emotion of that moment.

Appreciating a philosophy that embodies simplicity of design and optical supremacy, 80% of the world's professional photographers trust their Nikons to capture those moments of life.

Put your trust in a Nikon to capture those rare and special moments.

With the precision and flexibility of the Nikon FE. Part of the world's largest 35mm camera system.

The Nikon FE.
Choice of aperture-priority automatic or manual exposure control. Shutter speeds 1/1000–8 secs. Full viewfinder information. Interchangeable focusing screens. Multiple exposure facility. Depth-of-field preview. Exposure memory lock. Accepts most of the 60 legendary Nikkor lenses. Offers fully dedicated flash with Nikon Speedlight units. Complementary motor drive unit.

TRUST NIKON TO CAPTURE YOUR WORLD

NIKON UK LIMITED, 20 FULHAM BROADWAY, LONDON SW6 1BA. Tel: 01-381 1551.

Feine, zart Farbharmonien machen selbst eine Schneeschauer attraktiv.

De subtiele en delicate kleurenharmonie maakt zelfs een sneeuwstorm mooi.

La delicada armonía de colores transforma la tormenta de nieve en algo atractivo.

L'harmonie subtile et délicate des couleurs rend même une tempête de neige attrayante.

36 (Lower)

Photographer	Horst Kunert
Camera	Leica R3
Lens	Elmerit R f/2.8/28mm
Film	Ektachrome 400

An interesting picture of considerable documentary value as a record of a life style.

Interessantes Bild von wesentlichem dokumentarischem Wert als Zeugnis für die Lebensart.

Een interessante foto met een documentaire waarde, als een weergave van een manier van leven.

En esta interesante fotografía, que puede considerarse como un documento de referencia, se ha plasmado un estilo de vida.

Photo intéressante d'une valeur documentaire considérable comme témoignage d'un style de vie.

37

Title	"Las Hojas"
Photographer	Josep Maria Ribas I Prous
Camera	Nikon F
Lens	20mm
Film	Ektacolor

Showing the great value of reflections to bring out attractive but subdued colour harmonies.

Großer Reflektionswert zum Herausstellen von attraktiven, unterdrückten Farbharmonien.

Reflecties kunnen zeer waardevol zijn; ze dragen hier bij aan een mooie en bescheiden kleurenharmonie.

Sugiere el gran valor de los reflejos para destacar la atractiva, aunque un poco apagada, armonía de colores.

Les reflets rehaussent avec beaucoup de bonheur l'harmonie attrayante et délicate des couleurs.

38

Title	"Pregnant Donkey"
Photographer	Ursula Jeffree
Camera	Olympus OM1
Lens	Vivitar 300mm
Film	Ektachrome 200
Print	Cibachrome-A

A touch of humour and pathos emphasised by the rectangular format and soft background.

Ein Anflug Humor und Pathos, unterstützt durch ein Querformat und verschwommenen Hintergrund.

Beetje humor en pathos, benadrukt door het rechthoekige formaat en de zachte achtergrond.

El toque lastimoso de humor se ve aumentado por el formato rectángulo y el blando entorno.

Le côté à la fois humoristique et touchant de la photo est accentué par la format rectangulaire et le décor tout en douceur.

39

Title	"Smiling"
Photographer	Joachim Blanch
Camera	Nikon F2 Photomic
Lens	200mm
Film	Ektachrome 64

Yawning horses which look as though they are laughing are popular subjects but not often presented as well as this.

Gähnende Pferde, die aussehen, als wenn sie lachten, sind beliebt Themen, die jedoch nicht immer so gelingen wie dieses.

Als een paard gaapt lijkt het alsof het lacht; een redelijk populair onderwerp, maar zelden zo goed gepresenteerd als hier.

Temas populares, como el de los caballos que cuando bostezan parece que ríen, no suelen estar tan bien presentados como éste.

Les chevaux qui baillent tout en ayant l'air de rire sont des sujets fréquemment choisis mais rarement présentés aussi bien qu'ici.

40 (Upper)

Photographer	John Hillbom
Camera	Nikkormat FT
Lens	Nikkor 35mm f/2.8
Process	B/W negative copied on lith film and then onto color-key, sandwiched and re-copied on Ektachrome 64.

Showing what remarkable transformations can be achieved in the darkroom.

Dieses Bild zeigt, welche erstaunlichen Verwandlungen in der Dunkelkammer möglich sind.

U ziet dat er met donkerekamer-technieken opmerkelijke vervreemdingen mogelijk zijn.

Demuestra las increíbles transformaciones que se puede lograr en el cuarto oscuro.

Cette photo montre les transformations remarquables qui peuvent être obtenues en chambre noire.

40 (Lower)

Title	"Estuary Scene"
Photographer	Derek Gould
Camera	Olympus OM1
Film	Kodachrome 64

Reminiscent of a Dutch painting, this picture of a Thames barge will have historic value in time.

Das Bild eines Schiffes auf der Themse erinnert an ein holländisches Gemälde und dürfte mit der Zeit historischen Wert erlangen.

Deze foto van een Thamesbarge zal ooit historische waarde hebben. Hij doet denken aan werk van de Hollandse meesters.

Recuerda las pinturas holandesas. Con el tiempo, esta fotografía de una barca del Támesis tendrá valor histórico.

Cette photo d'une péniche de la Tamise évoque une peinture Hollandaise et aura plus tard une valeur historique

41

Title	"Snöfall"
Photographer	John Hillbom
Camera	Nikkormat FT
Process	Kodachrome copied onto Agfa Ortho film and the sandwich re-photographed on Kodachrome
Film	Agfachrome 50S

Another example of a popular subject improved by modern treatment.

Ein weiteres Beispiel für ein beliebts Thema, durch moderne Behandlung verbessert.

Alweer een voorbeeld van een populair onderwerp dat door een moderne behandeling werd verbeterd.

Otro ejemplo de un tema popular mejorado con un tratamiento moderno.

Autre exemple d'un sujet fréquemment choisi, mais amélioré ici par un traitement moderne.

42/43

Title	"Winter Bliss"
Photographer	Albert Bernhard
Camera	Leica R3
Lens	90 mm
Film	Kodacolor 400
Print	Agfacolor

A picture showing an exceptional appreciation of design which is almost daring.

Ein Bild mit ausgesprochener Würdigung der Form, das fast kühn zu nennen ist.

Deze foto toont een uitzonderlijke waardering voor compositie; het resultaat is nogal gedurfd.

La toma muestra una apreciación excepcional del diseño, casi llegando a lo atrevido.

Une photo témoignant d'un sens audacieux, presque téméraire, de la composition.

44

Title	"Crepaccia terminale"
Photographer	Giuseppe Balla
Camera	Canon F1
Lens	70-150mm Canon zoom
Film	Ektachrome Professional

An amazing feeling of depth created by a bold foreground and subdued background colours.

Ein erstaunliches Gefühl der Tiefe entsteht durch starken Vordergrund und verhaltene Hintergrundfarben.

Hier is een wonderbaarlijk gevoel van diepte verkregen door een krachtige voorgrond en tere achtergrondkleuren.

Increíble logro de profundidad creado con el atrevido marco frontal y los colores apagados.

La netteté du premier plan en contraste avec le décor estompé donne une incroyable impression de profondeur.

45

Photographer	Leo Mason
Camera	Nikon
Lens	50mm Nikkor
Film	Kodachrome 64

More From Fountain Press

PERFECT NUDE PHOTOGRAPHY
Michael Gnade
Following the success of People in My Camera by Michael Gnade comes a second book, this time on nude photography. His approach is based on the tradition of classical painting and sculpture, and he resists the temptation to follow modern trends and fashion which have so often tended to debase this difficult subject.
ISBN 0 85242 768 9 Casebound 270 x 210
208 pages Colour throughout £9.95

THE FOUR SEASONS OF NATURE PHOTOGRAPHY Fred Hazelhoff
A delightful and lavishly illustrated book concentrating on the various seasons and their photographic representations. The author, who had his last book named "book of the month" by the Dutch National Book Club, takes the reader through his own journeys and photographic experiences.
ISBN 0 85242 751 4 Casebound 210 x 295
176 pages Colour throughout £10.95

CREATIVE COLOUR TRANSPARENCIES
Wout Gilhuis
This book is lavishly illustrated with splendid full colour examples that will stimulate ideas and serve as a guide and reference for beginners and advanced photographers alike. The text is extremely practical and gives detailed instructions on all modern processes and applications for creative colour photography.
ISBN 0 85242 711 5 Casebound 240 x 185
160 pages £8.50

COMPOSITION IN COLOUR PHOTOGRAPHY W Nordhoek
The author, Wim Nordhoek, has brought the disciplines of a painter and graphic designer to bear on the medium of photography. His wide experience covers the subject in great depth and will be an eye opener to many photographers who use formal composition without realising it, and the beginner by teaching him how to see in photographic terms for the first time.
ISBN 085242 749 2 Casebound 240 x 185
176 pages Colour throughout £9.95

ESSENTIAL DARKROOM BOOK
Tom Grill and Mark Scanlon
This profusely illustrated book is a comprehensive, practical step-by-step guide to the essential film and print processing techniques. It clarifies the goals and techniques involved, explains how to set up a darkroom, helps the reader make informed decisions about which of the many available processes to use and shows exactly how to process a wide variety of material.
ISBN 0 85242 797 2 Casebound 210 x 280
176 pages £12.95

EXPOSURE MANUAL 4th edition
J F Dunn and G L Wakefield
This new and largely re-illustrated edition, with a considerably extended colour content, provides an invaluable guide to every photographer – the keen beginner as well as the advanced amateur and professional. It embraces solutions to almost any exposure problem arising in practical photography and shows how to get the best from your camera whether working in black and white or colour.
ISBN 0 85242 762 X Casebound 210 x 185
240 pages £9.95

FOUNTAIN PHOTOBOOKS
These useful pocket-books, well illustrated in both black and white and colour, offer an attractive instant guide to various aspects of photography.
B/W Negatives, their Exposure and Development – Hans Gotze
Creative Nude Photography – Peter Zeemeijer
Creative Portrait Photography – Peter Zeemeijer
Form and Line in Photography – Hans Gotze
Macrophotography – Dr W Kruyt
Photograms in B/W and Colour – G Spitzing
Photographic Retouching – Hans Gotze
Prints – Processing and Enlarging in B/W – Hans Gotze
Photographing with 400 ASA Film – Hans Gotze
200 Cine Tips – G Spitzing
200 Darkroom Tips – B/W – E Voogel/P Keyzer
200 Darkroom Tips – Colour – J Van Welzen
200 Filter and Lens Tips – E Voogel/P Keyzer
200 Flash Tips – E Voogel/P Keyzer
200 Photo Tips – G Spitzing
200 Slide Tips – E Voogel/P Keyzer
200 SLR Tips – E Voogel/P Keyzer
200 Interchangeable Lens Tips – E Voogel/P Keyzer
200 Macro Tips – G Spitzing.
116 x 180 mm Limp 96 pages
Profusely illustrated with line drawing and B/W and colour photographs. £2.50

FOUNTAIN PRESS LTD.
65 Victoria St. Windsor, Berkshire SL4 1EH

A fine technical achievement for an illustrative air-to-air shot in colour

Ein feiner technischer Erfolg für eine illustrierende Luftaufnahme in Farbe.

Deze air-to-air foto is een technisch meesterstuk.

Un fino logro técnico, buen ejemplo de foto en color hecha en el aire.

Un exploit technique pour une photo d'illustration en couleur.

46

Photographer	Rafael Valor Pascual
Camera	Nikon FTN
Lens	35mm Nikkor
Film	Agfapan 400

A most imaginative and expressive portrait with a modern treatment and original composition.

Phantasiereiches, ausrucksvolles Porträt in moderner Darstellung und origineller Komposition.

Een zeer suggestief en expressief portret met een moderne techniek en originele compositie.

Un retrato imaginativo y expresivo con tratamiento moderno y composición original.

Un portrait extrêmement imaginatif et expressif avec un traitement moderne et une composition originale.

47

Title	"Christine"
Photographer	Erwin Kneidinger
Camera	Nikon F
Lens	28mm Nikkor
Film	Ilford HP5

No photographer would have dared such an unusual subject arrangement twenty years ago, but it shows how 'rules' can be broken to striking effect. The colour balance is splendid.

Kein Fotograf hätte vor 20 Jahren eine derartig ungewöhnliche Themenanordnung gewagt. Es zeigt, wie "Regeln" mit interessanter Wirkung gebrochen werden können. Die Farbabstimmung ist glänzend.

Twintig jaar geleden zou er geen fotograaf aan een dergelijke plaatsing van het onderwerp hebben durven denken, maar deze foto toont hoe 'regels' kunnen worden gebroken voor een sterk effect. De kleurbalans is perfect.

Hace veinte años ningún fotógrafo se hubiera atrevido a tomar un tema tan especial. Se ve cómo el "romper con las reglas" puede dar un efecto impresionante. El equilibrio de colores es exquisito.

Aucun photographe n'aurait osé traiter son sujet de cette manière il y a 20 ans; la photo montre comment les "règles" peuvent être violées pour obtenir un effet saisissant. Une splendide symphonie de couleurs.

48

Title	"Mütter"
Photographer	Marlies Amling
Camera	Mamiya RB67
Lens	180mm Sekor
Film	Kodak VPS
Print	Ektacolor

One of the most expressive studies seen in the London Salon Exhibition. The age old theme has been beautifully presented in an artistic way.

Eine der eindruckvollsten Studien auf der Londoner Salon Exhibition. Das uralte Thema wurde in künstlerischer Weise herrlich dargestellt.

Een van de meest expressieve studies die op de Londense Fotosalon te zien waren. Het aloude thema is hier op een artistieke manier fraai gepresenteerd.

Uno de los estudios más expresivos que se han visto en la exhibición presentada en el London Salon. El tema de la vejez está presentado con gran belleza artística.

L'une des études les plus expressives de l'exposition du salon de Londres. Ce terme éternel est admirablement et artistiquement représenté

49

Title	"Ice Image"
Photographer	Peter M Rees
Camera	Olympus OM-1n
Lens	50mm Zuiko
Film	FP4

From an original negative deep frozen in a block of ice and then photographed by flash.

Von einem Originalnegativ, das in einem Eisblock tiefgekühlt und dann mit Blitzlicht fotografiert wurde.

Naar een origineel negatief dat in een blok ijs werd ingevroren en toen met flits werd gefotografeerd.

Viene de un negativo embebido en un bloque de hielo y luego fotografiado con flash.

D'après un négatif d'origine pris dans un bloc de glace puis photographié au flash.

50

Title	"Play"
Photographer	K Buchacek
Camera	Pentax Spotmatic
Lens	50mm
Film	Orwo

Plenty of action against an almost abstract background makes a striking picture.

Viel Bewegung auf einem fast abstrakten Hintergrund führt zu einem verblüffenden Bild.

Een en al actie tegen een vrijwel abstracte achtergrond. Een treffende foto.

Sorprendente resultado logrado oponiendo el dinamismo de la acción contra el entorno abstracto que le rodea.

Activité fiévreuse sur un fond presque abstrait: un contraste frappant.

51

Photographer	Eileen Langsley
Camera	Nikon F2SB
Lens	50mm f/1.4
Film	HP5 rated at 800ASA

Pictures which incorporate a number of faces, all with different expressions, invariably have a lot of appeal.

Bilder mit vielen Gesichtern, alle mit einem anderen Ausdruck, sind immer ansprechend.

Alle foto's waarop een aantal gezichten is te zien die allemaal een andere expressie vertonen, hebben een grote aantrekkingskracht.

Las tomas de varios rostros con expresiones diferentes siempre tienen grandes atractivos.

Les photos qui comprennent un grand nombre de visages, tous avec des expressions différentes, ont invariablement beaucoup d'attrait.

52

Title	"Hands"
Photographer	U E Baukus
Camera	Olympus OM-2
Lens	75-150mm zoom
Film	FP4

A deeply moving picture that will stimulate many different ideas of its meaning.

Ein stark bewegendes Bild, das zu seiner Deutung viele verschiedene Ideen zulassen sollte.

Een indrukwekkende foto waarvan de bedoeling door velen op verschillende wijze zal worden geïnterpreteerd.

Una conmovedora fotografía capaz de estimular muchas interpretaciones.

Une photo très émouvante qui suscite des interprétations différentes.

53

Title	"Meg Littlewood"
Photographer	Mervyn Rees
Camera	Nikon F3
Lens	300mm
Film	Tri-X

The British women's shot putt record holder caught in a dramatic moment. The original was on Ektachrome 64.

Die britische Kugelstoßerin in einem dramatischen Moment. Original auf Ektachrome 64.

De Britse kogelstootster vastgelegd op een dramatisch moment. Het origineel werd gemaakt op Ektachrome 64.

Dramática actuación durante la competición femenina de Gran Bretaña.

La recordwoman du lancer du poids saisie dans un moment spectaculaire. L'original était sur Ektachrome 64.

54

Title	"My Child"
Photographer	Veikko Wallström
Camera	Nikon F
Lens	105mm Nikkor
Film	Tri-X

A very modern treatment of the eternal theme that is sentimental but far from 'sugary'.

Eine sehr moderne Darstellung des ewigen Themas, die sentimental aber nicht "süß" ist.

Een moderne uitwerking van een oud thema dat beslist niet suikerzoet aandoet.

Un tema sentimental eterno, que con el tratamiento moderno, dista mucho de ser "empalagoso"

Un traitement très moderne d'un thème éternel, sentimental sans être mièvre.

55

Title	"Monday Morning"
Photographer	Alan Millward
Camera	Pentax Spotmatic
Lens	55mm Takumar
Film	Tri-X

Documentary photography at its best — well presented and with a bold design.

Dokumentarfoto bester Qualität, gut dargestelt und in kühner Form.

Documentaire fotografie op haar best — fraai naar voren gebracht in een krachtige compositie.

Una fotografía documental, bien presentada y de atrevido diseño.

Une excellente photo documentaire — une disposition heureuse, des personnages et des lignes hardies.

56

Title	"Seagull in flight"
Photographer	Santokh Kochar
Camera	Minolta 102
Film	Kodachrome Panatomic-X

From an original shot on 35mm Kodachrome copied on to black and white film.

Von einer Originalaufnahme auf 35mm Kodachrome, auf Schwarz-Weiß-Film kopiert.

Naar een originele opname op Kodachrome, omgekopieerd op zwartwitfilm.

Toma hecha sobre un Kodachrome 35mm y copiada en una película blanco y negro.

A partir d'une photo d'origine sur Kodachrome 35mm copiée sur film noir et blanc.

57

Title	"Fairford Church"
Photographer	Stephen Whitfield-Almond
Camera	Canon AE1
Lens	28mm
Film	FP4

Stark contrasts of both tones and subject matter have given this picture enormous impact.

Starke Kontraste im Ton und Thema verleihen diesem Bild seine enorme Durchschlagskraft.

Zowel de onderwerpen als de toonwaarden zijn in groot contrast, waardoor een zeer sterke beeldvoordracht wordt gegeven.

El enorme impacto de esta foto proviene del gran contraste entre el tono y el tema.

Le contraste marqué entre les couleurs et le sujet donne à la photo sa force et son originalité.

58

Title	"Retrato Antiguo"
Photographer	Josep Maria Ribas I Prous
Camera	Nikon F
Lens	105mm Nikkor
Film	Tri-X

Typical of the frank and erotic approach to figure photography that is popular with Spanish photographers today.

Typisch für die freie, erotische Lösung in der Aktfotografie, die heute bei spanischen Fotografen so beliebt ist.

Typerend voor de openhartige en erotische benadering van de figuurstudie, zoals die bij de Spaanse fotografen populair is.

Típico del planteamiento franco y erótico que caracteriza la fotografía española actual.

Un nu érotique et sans fard; l'approche est caractéristique des photographes espagnols contemporains.

59

Title	"Study"
Photographer	Alena Vykulilova
Camera	Yashica 6 x 6cm
Lens	80mm
Film	Orwo NP20 (tungsten)

Another picture, like the one opposite, which ignores traditional rules of composition. The powerful tone scheme and dramatic lighting also help.

Ein weiteres Bild wie auf der gegenüberliegenden Seite, das die herkömmlichen Kompositionsregeln unbeachtet läßt. Das kräftige Tonsystem und die dramatische Beleuchtung unterstreichen dies.

Nog een foto die net als de tegenoverstaande, niet volgens de traditionele compositieregels is opgebouwd. De krachtige toonwaarden en de dramatische verlichting versterken de indruk.

Otra de las tomas, al igual que la opuesta, donde se han ignorado las reglas tradicionales de composición. La fuerza la proporcionan los tonos y las luces.

Comme la photo ci-contre, elle fait fi des règles traditionnelles de la composition. La gamme des tons et l'éclairage concourent à créer l'effet produit.

60

Photographer	Gary Browne
Camera	Canon F1
Lens	50mm
Film	Tri-X

H.R.H. Prince Philip at the opening of the first World Driving Championship and very nicely framed.

Seine Königliche Hoheit Prinz Philip bei der Eröffnung der First World Driving Championship, sehr hübsch umrahmt.

Z.K.H. Prins Philip tijdens de opening van de eerste World Driving Championship; interessante beeldopbouw.

Su Alteza Real el Príncipe Felipe en la apertura de la Primera Carrera Automovilística. Un encuadramiento óptimo.

Sa Majesté le Prince Philip très bien encadré sur cette photo prise à l'ouverture du premier championnat mondial de driving.

61

Title	"A Royal Smile"
Photographer	Steve Hartley
Camera	Nikon F2
Lens	400 mm
Film	HP5

The Queen looking happy at the Royal Windsor Horse Show typical of the candid approach acceptable today.

Die lachende englische Königin bei der Royal Windsor Horse Show ist typisch für die offene Einstellung von heute.

Een vrolijke koningin Elizabeth tijdens de Royal Windsor Horse Show; typerend voor de hedendaagse stijl van candid fotografie.

La actitud ingenua que prima hoy en día se ve tipificada en esta toma de la reina, alegre durante la Exhibición de Equitación del Royal Windsor.

La Reine a l'air heureuse au concours hippique Royal de Windsor; cette approche décontractée est désormais admise.

62

Photographer	C Churchill
Camera	Pentax SPF
Lens	80-200mm zoom
Film	Kodachrome

Made by an inter-negative forced to give a grain effect which complements the bold design.

Herstellung mit einem Zwischennegativ, das zur Erzielung eines körnigen Effekts forciert wurde, der die starke Form ergänzt.

Tot stand gekomen via een tussennegatief waarbij door geforceerde ontwikkeling een korreleffect werd verkregen dat de sterke beeldvoordracht benadrukt.

El internegativo proporciona un efecto de grano que complementa el atrevido diseño.

L'apparence grenue, complément de la pose hardie, est obtenue au moyen d'un négatif intercalé.

63

Title	"Couple"
Photographer	Veikko Wallström
Camera	Nikon F
Lens	105mm Nikkor
Film	Tri-X

A posed portrait given a natural look by the unconventional outdoor dress and bold tone contrasts.

Gestelltes Porträt, das durch die unkonventionelle Oberbekleidung und die kühnen Tonkontraste ein natürliches Aussehen erhält.

Een geposeerd portret; ondanks dat (of juist doordat) de kleding nogal ongewoon was en het contrast nogal pittig, wordt hier een natuurlijk aanzien verkregen.

El aspecto natural de este retrato en pose está logrado por medio del vestido callejero y los atrevidos contrastes de tonalidad.

La pose des personnages conserve son naturel grâce à leur tenue décontractée et au contraste accentué des couleurs.

64

Title	"Giuseppe Lund"
Photographer	Denis Thorpe
Camera	Nikon F2
Lens	28mm Nikkor
Film	FP4

An expressive portrait of a blacksmith sculptor at work in Ironbridge, Shropshire.

Ausdrucksvolles Porträt eines Kunstschmiedes bei der Arbeit in Ironbridge, Shropshire.

Expressief portret van een siersmid aan het werk in Ironbridge, Shropshire.

Expresivo retrato de un artista forjador trabajando en Ironbridge, Shropshire.

Un portrait expressif d'un sculpteur forgeron au travail à Ironbridge, Shropshire.

65

Title	"A giant of steam"
Photographer	John Davidson
Camera	Nikon F
Lens	28mm Nikkor
Film	Tri-X rated at 800ASA

A marvellous genre portrait with contrast in subject and tones with an unmistakable message.

Interessantes Genre-Porträt mit Kontrast in Thema und Ton und deutlicher Aussage.

Een prachtig genreportret met contrasten in het onderwerp en in de toonwaarden en met een duidelijke boodschap.

Un hermosísimo retrato que contrasta el tema y la tonalidad con el inconfundible mensaje.

Un merveilleux portrait de genre avec contrastes de sujet et de tons et un message évident.

66

Photographer	Brian Duff
Camera	Nikon F2
Lens	105mm
Film	FP4

There is a lot of humour in the contrast of the donkey with the rider's dress even though it was obviously posed.

Im Kontrast des Esels mit der Kleidung des Reiters liegt viel Humor, obgleich das Foto offensichtlich gestellt ist.

Een grappig contrast tussen de ezel en de donkere kleding van de man; de foto is duidelijk geposeerd.

El sentido del humor se ha logrado contrastando al burro con la ropa del jinete, que obviamente había posado.

Beaucoup d'humour dans le contraste entre l'âne et les vêtements du cavalier même s'il est évident qu'ils ont posé pour la photo.

67

Title	"Orator"
Photographer	Neale Davison
Camera	Pentax SP2
Lens	135mm Soligor
Film	Tri-X

A well known 'tub thumper' at Speakers' Corner in Hyde Park is caught in full flight.

Ein allgemein bekannter "Seifenkistenredner" an der Speakers' Corner im Hyde Park.

Een bekende 'tub thumper' van Speakers' Corner in Hyde Park, Londen, gefotografeerd in het heetst van de strijd.

Un conocido orador del Hyde Park en plena "lucha".

Un harangueur bien connu de Speakers' Corner dans Hyde Park surpris en pleine envolée oratoire.

68 (Upper)

Photographer	Mel Digiacomo
Camera	Nikon
Lens	300mm
Film	Tri-X

The fantastic speed of a game of polo is well projected here with the leading horse's head sharp enough to justify the movement in all the rest.

Die phantastische Geschwindigkeit des Polospiels kommt hier deutlich zutage. Der Kopf des ersten Pferdes ist scharf genug, um die Bewegung bei aller Ruhe zu rechtfertigen.

De fantastische snelheid van het polospel wordt hier goed tot uitdrukking gebracht; de scherpe afbeelding van het voorste paard geeft voldoende rechtvaardiging voor de onscherpe beweging in de rest van het beeld.

La fantástica velocidad de los juegos de polo se ve bien proyectada por la cabeza del caballo delantero, lo suficientemente visible para justificar el movimiento de los demás.

La vitesse fantastique de jeu de Polo est bien projetée ici; le premier cheval se détache avec suffisamment de netteté pour justifier l'impression de mouvement donnée par le reste de la photo.

68 (Lower)

Title	"Pony Race"
Photographer	C Scheurweg
Camera	Pentax MX
Lens	80-200mm zoom
Film	Tri-X at 800ASA

A very well balanced design which helps the impression of movement and atmosphere.

Gut ausgeglichener Aufbau, der den Eindruck von Bewegung und Atmosphäre unterstreicht.

Prachtig uitgewogen beeldopbouw die de sfeer en de indruk van beweging doet versterken.

Un diseño bien equilibrado en el que destacan la impresión de movimiento y el ambiente.

Une composition très bien équilibrée qui contribue à donner l'impression de mouvement et d'atmosphère.

69

Photographer	Jan Anděl
Camera	Pentacon Six
Lens	300mm Sonnar
Film	Formapan 200

A photograph of superb print quality which shows an attractive rhythm in its design.

Eine Aufnahme mit ausgezeichneter Druckqualität, die interessanten Rhythmus im Aufbau zeigt.

Deze foto, met een schitterende afdrukkwaliteit, geeft in de beeldopbouw een aantrekkelijk ritme te zien.

La suprema calidad de la impresión refleja un diseño de atractivo ritmo.

Une photo d'une superbe qualité d'impression et d'un rythme séduisant.

70

Title	"Sue Barker"
Photographer	Mervyn Rees
Camera	Nikon F2
Lens	300mm Nikkor
Film	Tri-X

A dynamic shot of Sue Barker, the famous tennis player hitting hard for the championship.

Dynamische Aufnahme von Sue Barker, der berühmten Tennisspielerin, während sie um die Meisterschaft kämpft.

Een dynamische foto van Sue Barker, bekend tennisspeelster.

Una dinámica foto de la famosa tenista Sue Barker durante un campeonato.

Une photo dynamique de Sue Barker, la célèbre joueuse de tennis n'épargnant pas ses peines pour gagner le championnat.

71

Photographer	Mel Digiacomo
Camera	Nikon F2
Lens	500mm
Film	Tri-X

A prize winning picture taken at a dramatic moment in a rugby match from a well chosen low viewpoint.

Preisgekrönte Aufnahme eines dramatischen Momentes bei einem Rugby-Spiel aus gut gewähltem, niedrigem Gesichtspunkt.

Deze foto werd gemaakt op een dramatisch moment in een rugbywedstrijd; het lage standpunt is goed gekozen. Met deze foto heeft de fotograaf een prijs in de wacht gesleept.

Merecedora de premio, esta foto muestra un momento dramático durante un partido de rugby. Se tomó desde un punto de vista bajo.

Cette photo qui a reçu un prix a été prise à un moment crucial d'un match de rugby, à la hauteur idéale.

72

Title	"Lindisfarne"
Photographer	Geoffrey J Jefferson
Camera	Rolleicord V
Lens	80mm
Film	FP4

A beautifully composed landscape in which the eye is forced to follow a path to the principal object.

Herrlich komponierte Landschaft, bei der das Auge gezwungen wird, dem Weg zum wichtigsten Gegenstand zu folgen.

Een prachtig gecomponeerde landschapopname waarin het oog wordt gedwongen het pad naar het hoofdonderwerp te volgen.

En la composición de esta toma panorámica el ojo sigue un camino trazado hasta que llega al sujeto.

Un paysage très bien composé dans lequel l'oeil est forcé de suivre le chemin qui mène à l'objet principal.

73

Title	"Vigie"
Photographer	M L Brehant
Camera	Canon F
Lens	28mm
Film	Tri-X

An interesting comparison with the picture opposite. Both are of similar subjects but seen through different eyes.

Interessanter Vergleich zum gegenüberliegenden Bild. Ähnliche Themen, jedoch ganz anders gesehen.

Een interessante vergelijking met de foto op de tegenoverliggende bladzijde. Vergelijkbare onderwerpen door verschillende ogen gezien.

Se puede hacer una interesante comparación con esta toma y la opuesta; aunque los temas son similares, están vistos por ojos diferentes.

Une comparaison intéressante avec la photo ci-contre. Le sujet est semblable mais perçu d'un point de vue différent.

74

Photographer	Guillermo Proaño Moreno
Camera	Rolleicord
Lens	80mm
Film	Verichrome Pan
Lighting	Two photofloods

A conventional pose but lifted out of the ordinary by the dramatic lighting.

Konventionelle Pose, jedoch durch dramatische Beleuchtung aus der normalen Betrachtung gehoben.

Een conventionele pose die er toch uitspringt door de dramatische verlichting.

Una pose convencional, destacada mayormente por la iluminación dramática.

Une pose classique mais sortie de l'ordinaire par l'éclairage dramatique.

75

Title	"In the Waves"
Photographer	R Dichavičius

Less conventional than the figure study opposite, but the candid treatment and strong tones make it dynamic.

Nicht so konventionell wie die Aktstudie auf der gegenüberliegenden Seite, wird jedoch durch die offene Darstellung und starke Töne dynamisch.

Minder conventioneel dan de voorgaande foto; de actie en de krachtige tonen geven de foto dramatiek.

Menos convencional que el estudio opuesto, pero el tratamiento cándido y la fuerte tonalidad le confieren dinamismo.

Moins conventionnel que l'étude de nu ci-contre, mais la candeur et ses tons contrastés lui donne son dynamisme.

76

Title	"Night Study"
Photographer	Oleg Burbowskij
Camera	Pentacon Six
Lens	Normal
Film	Foto

Natural history subjects used for pictorial studies can be most effective and this combines a very satisfying design with a powerful treatment.

Naturgeschichtliche Themen für Bildstudien können äußerst wirksam sein. Bei diesen wird eine sehr lohnende Struktur mit kraftvoller Darstellung verbunden.

Natuurlijk-historische onderwerpen kunnen ook voor fotografische studies zeer goed dienst doen; hier zien we een fraaie compositie met een krachtige aanpak.

Un diseño vigoroso logrado por la combinación de temas de historia natural utilizados para realizar estudios pictóricos.

La nature est parfois une source d'inspiration privilégiée; la photo allie une composition judicieuse à un traitement ferme.

77

Title	"End of Summer"
Photographer	Pavel Tischkovski
Camera	Lubitel-2
Lens	80mm T-22
Film	Foto 65

An unmistakable message presented in a most creative and imaginative context.

Eine deutliche Aussage in äußerst kreativem, phantasiereichem Zusammenhang.

Een duidelijke boodschap, zeer creatief en met veel verbeeldingskracht uitgewerkt.

Un mensaje inconfundible presentado dentro del contexto más creativo e imaginativo.

Un message clair présenté dans un contexte très créatif et plein d'imagination.

78 (Upper)

Title	"Rilsky Monastery"
Photographer	Jiri Bartos
Camera	Pentax SP1000
Lens	20mm Flektogon
Film	HP5

The subject has a striking intrinsic appearance and the viewpoint has been well chosen to show it to advantage.

Das Thema hat ein interessantes eigenes Aussehen, jedoch wurde der Gesichtspunkt gut gewählt, um es vorteilhaft darzustellen.

Dank zij een juiste toepassing van brandpuntsafstand en standpunt komt dit gebouw uit zijn omgeving los.

Se ha escogido un buen punto de vista para presentar este tema de sorprendente apariencia intrínseca.

Le sujet a en lui-même un aspect frappant et a été photographié sous un angle qui le met en valeur.

78 (Lower)

Photographer	Peter Hense
Camera	Nikon F2A
Lens	24mm Nikkor
Film	Tri-X

A cleverly chosen viewpoint shows both the old and the new market halls in Paris; or is it a multiple print?

Ein klug gewählter Gesichtspunkt zeigt die alten und neuen Markthallen in Paris, oder handelt es sich um mehrere Aufnahmen?

Dit slim gekozen standpunt toont de oude en de nieuwe hallen van Parijs; of is het een montage?

¿Se trata de un punto de vista inteligentemente escogido para tomar el antiguo y nuevo mercado de París o de una impresión múltiple?

Vue de l'ancien et du nouvel édifice; ou s'agit-il d'un montage adroit?

79

Title	"Vilnius"
Photographer	A M Cerniauskai

One of many examples of architectural subject given emphasis to their design by simplified tone treatment and a heavy border.

Eines von vielen Beispielen für architektonische Themen, bei dem die Form durch vereinfachte Tonbehandlung und starken Rand unterstrichen wird.

Een voorbeeld van de manier waarop een architectuuropname wat extra's krijgt door grafische vereenvoudigingstechniek en een zware omlijsting.

Uno de los muchos ejemplos de tema arquitectónico, en el que se acentúa el diseño por medio del tratamiento de la tonalidad y los bordes oscuros.

L'un des nombreux exemples de sujet architectural dont la composition a été soulignée par un traitement simplifié des tons et un encadrement bien marqué.

80

Title	"Erica Roe"
Photographer	Mike Brett
Camera	Nikon F2
Lens	300mm
Film	XP-1 uprated

One of the most published pictures of the year which demonstrates the author's alertness and technical skill.

Eines der am meisten veröffentlichten Bilder des Jahres, das zeigt, wie wachsam und technisch erfahren der Fotograf ist.

Een van de meest geplaatste foto's van 1982 in Engeland; complimenten voor de snelle reactie van de fotograaf en zijn technische bekwaamheid.

Una de las fotos más publicadas este año; confirma la técnica y la actitud de alerta de su autor.

L'une des photos les plus publiées de l'année qui témoignent de la vivacité et de la compétence technique de l'auteur.

81

Title	"Der Lauf Om Die Wette"
Photographer	V L Pokorny
Camera	Pentacon Six
Lens	120mm
Film	Orwo 20

Back views can sometimes be funnier than the front and the author chose his moment to shoot with deadly accuracy!

Rückblicke können häufig komischer sein als der Blick nach vorn. Der Fotograf wählte diesen Moment, um mit tödlicher Genauigkeit auszulösen!

Deze fotograaf schoot zijn foto met een akelig praktische timing.

A veces las tomas de espalda son más cómicas que las que se toman de frente. El momento de disparar se escogió cuidadosamente.

Les vues de dos sont parfois plus amusantes que celles de face et l'auteur a choisi son moment pour prendre la photo avec une extrême précision!

82

Title	"Albert"
Photographer	Cori Pedrola
Camera	Topcon Super DM
Lens	100mm
Film	Valca F22

A contemporary treatment of a contemporary subject which will have value in years to come.

Moderne Darstellung eines zeitgenössischen Themas, das mit den Jahren Wert erhalten sollte.

Een eigentijdse aanpak van een eigentijds onderwerp: een beeld van deze tijd.

Un tratamiento contemporáneo de un tema contemporáneo que tendrá aún más valor en los años venideros.

Un traitement et un sujet contemporains pour une photo qui aura plus tard de la valeur.

WHEN YOU DEMAND THE VERY BEST YOUR CHOICE IS SOMEWHAT LIMITED

LEICA R4
Single Lens Reflex Camera

In 35mm. cameras this is especially true. The best made 35mm. camera in the world is, and always has been, the legendary LEICA Indisputably. And understandably. Because when LEITZ built their first LEICA (and in so doing introduced the technique of 35mm. photography)

they had already been making some of the world's finest microscopes for close on a hundred years. Today, as well as LEICA cameras LEITZ also make projectors, enlargers, binoculars and of course microscopes and other advanced optical instruments. Each is the best of its kind the world has to offer.

LEICA R4
Single Lens Reflex
with Motor Drive

LEITZ Pradovit C
Slide Projector.

LEICA M4 P
Rangefinder
Camera
with Motor
Winder.

LEITZ
Trinovid
Binoculars

LEITZ Focomat V35
Autofocus Enlarger

LEITZ
Trinovid
Compact
Binoculars

Available from specialist dealers throughout the U.K.
E. Leitz (Instruments) Ltd., 48 Park Street, Luton, Beds. Tel: Luton 413811.

Leitz means precision. Worldwide.

83

Title	"Iolanda"
Photographer	Cori Pedrola
Camera	Topcon Super DM
Lens	100mm
Film	Valca F22

An example of the natural effect of lighting from a window, allied to strong tonal contrasts.

Beispiel für den natürlichen Lichteffekt von einem Fenster, verbunden mit starken Tonkontrasten.

Een voorbeeld van het natuurlijke effect dat wordt verkregen met direct door een raam invallend licht, waardoor sterk contrasterende toonwaarden ontstaan.

Un ejemplo del efecto natural que se consigue con la luz desde una ventana unida a un fuerte contraste de tonalidad.

Un exemple de l'effet naturel de la lumière pénétrant par la fenêtre avec de forts contrastes de tons.

84

Title	"Ausfahrt"
Photographer	Willy Hengl
Camera	Minolta XD7
Film	Agfa

The simplified line treatment, once so popular, has a touch of freshness when revived by such an excellent design.

Die vereinfachte Liniendatstellung, die früher einmal beliebt war, hat einen Hauch von Frische bei Belebung durch eine derartig ausgezeichnete Form.

De vereenvoudigende grafische contour-behandeling, die ooit erg populair was, krijgt toch weer iets verfrissends als het zo treffend wordt toegepast.

El simplificado tratamiento de la línea, que había sido tan popular, adquiere un toque refrescante gracias al excelente diseño.

Les lignes pures, autrefois très populaires acquièrent une fraîcheur nouvelle grâce à la composition de tout premier ordre.

85

Photographer	Pavel Tishkovski
Camera	Zenith-E
Lens	43mm Helios
Film	Foto 65

A popular subject well arranged and given artistic emphasis by the tone separation and heavy black border.

Ein beliebtes Thema in guter Anordnung und mit künstlerischer Betonung durch Tontrennung und starken schwarzen Rand.

Goed gezien en fraai gecomponeerd; door de toonscheiding en de zwarte rand wordt dit alles nog benadrukt.

Este popular tema ha recibido un énfasis artístico por medio de la separación de tonalidades y el borde oscuro.

Un sujet populaire bien disposé et dans lequel l'aspect artistique est souligné par la séparation des tons et l'encadrement noir très accentué.

86

Title	"Gillespie"
Photographer	Giuseppe Balla
Camera	Canon F
Lens	200mm
Film	Tri-X

The character of a trumpeter in concert could not have been projected with more drama than this.

Der Charakter eines Trompeters beim Konzert könnte nicht dramatischer als hier dargestellt werden.

Een betere karakteristiek van deze jazz-trompettist is er niet te geven dan deze foto, die tijdens een concert werd gemaakt.

No esperar que el carácter de un trompetista en un concierto quede mejor proyectado que aquí.

Le visage d'un trompettiste en concert ne pourrait pas être plus expressif qu'ici.

87

Title	"Yusef Lateef"
Photographer	Erwin Kneidinger

Although there is little detail in the background the atmosphere of a concert hall or night club is well portrayed by the lighting.

Obgleich der Hintergrund wenig Detail aufweist, tritt die Atmosphäre einer Konzerthalle oder eines Nachtklubs durch die Beleuchtung gut zutage.

Hoewel er weinig details op de achtergrond zijn te herkennen wordt door de verlichting de atmosfeer van een concertzaal of een nachtclub goed overgebracht.

Aunque hay poco detalle ambiental evidente, la atmósfera de un salón de conciertos está bien conseguida por medio de la iluminación.

Bien qu'il y ait peu de détail dans le fond, l'atmosphère d'une salle de concert ou d'un Night Club est bien rendue par l'éclairage.

88/89

Title	"A good game"
Photographer	Lew Gelderman
Camera	Kiev
Lens	65mm
Film	A-12

The unusual treatment seen here is very effective with moving subjects in semi-silhouette. This is a beautiful example.

Die hier zu sehende, ungewöhnliche Darstellung ist durch die sich bewegenden Gestalten in Halbsilhouette sehr wirksam. Ein sehr schönes Beispiel.

Een bijzonder fraaie uitwerking van een foto met bewegende onderwerpen in halfsilhouet.

Este es un hermoso ejemplo del tratamiento especial logrado con la semisilueta de los chicos que juegan.

Le traitement inhabituel que nous voyons ici est très efficace avec des sujets en mouvement en semi-silhouette. Bel exemple.

90

Photographer	Jiri Bartos
Camera	Pentax SP1000
Lens	Flektogon 35mm
Film	Orwo NP 20

Sometimes it is not easy to see the message in modern figure photographs but this is intriguing and well presented.

Manchmal ist es nicht leicht, eine Aussage in modernen Aktfotografien zu sehen. Diese ist jedoch faszinierend und gut dargestellt.

Het is soms moeilijk om de boodschap te doorgronden bij de moderne naaktfotografie maar deze is intrigerend en goed gepresenteerd.

Con frecuencia no es fácil leer el mensaje que contienen las fotografías de creación moderna; pero ésta, además de intrigante, está bien presentada.

Parfois il n'est pas facile de voir le message dans les photos modernes mais celui-ci intrigue et est bien présenté.

91

Photographer	Guillermo Proaño Moreno
Camera	Ricohflex
Lens	50mm
Film	Verichrome Pan
Lighting	One photoflood for fill-in

A more conventional figure shot than the one opposite but well executed and a good study of form.

Eine konventionellere Aktaufnahme als die auf der gegenüberliegenden Seite, jedoch gut ausgeführt und eine gute Formstudie.

Een wat conventionelere figuurstudie dan de vorige; de techniek is erg goed en de opname is een goede vormstudie.

Una toma más convencional que la opuesta, pero bien ejecutada y digna de un detenido estudio.

Une photo plus conventionnelle que la précédente mais la technique est bonne et la silhouette est bien étudiée.

92

Title	"Lake in Winter"
Photographer	Z Bulgakovas

A landscape that one feels is typical of the country and which has caught the bleakness of the winter scene, aided by the simplified treatment.

Eine Landschaft, die man für das Land für typisch hält, und die die Trostlosigkeit der Winterszene einfängt, unterstützt durch die vereinfachte Darstellung.

Men voelt dat dit landschap typisch Russisch is; de kilheid van dit winterse tafereel wordt versterkt door de grafische omwerking.

Una vista típica del país que ha captado el frío de la escena invernal, ayudada por la sencillez-del tratamiento.

Un paysage d'hiver desólé comme on se les imagine dans le pays; l'effet est renforcé par la pureté des lignes.

93

Title	"Winter"
Photographer	Pavel Tishkovski
Camera	Zenith-E
Lens	43mm Helios
Film	Foto 65

There is an appeal of sadness and loneliness in this picture which shows imagination in the combination of subjects.

The Photography Year Book Has Moved To Windsor.

All enquiries and material for the 1984 edition should be sent to the Editor of Photography Year Book, Fountain Press Limited, 65 Victoria Street, Windsor, Berks. SL4 1EH, England. Telephone Windsor 56959.

Dieses Bild hat einen Anklang von Traurigkeit und Alleinsein, was Vorstellungskraft bei der Kombination der Gegenstände zeigt.

Deze foto geeft een gevoel van triestheid en eenzaamheid; de combinatie van de onderwerpen wijst op een grote fantasie van de fotograaf.

La combinación de los sujetos muestra un llamamiento a la tristeza y la soledad.

Il y a un attrait de tristesse et de solitude dans cette photo qui fait preuve d'imagination dans la combinaison des sujets.

94

Title	"Hats"
Photographer	Oleg Burbowskij
Camera	Kiev 6S
Lens	Vega
Film	Soviet KN-3

A touch of humour is produced by the men ignoring the girl and there is originality in the presentation, especially the close-up view concentrating on the figure alone.

Ein Anflug von Humor entsteht, weil die Männer das Mädchen nicht beachten. Die Präsentation ist originell, besonders, da sich die Nahaufnahme nur auf den Akt konzentriert.

Er zit een vleugje humor in deze foto met de twee mannen die aan het meisje geen aandacht besteden; de presentatie is erg origineel.

Un toque de humor cuando los hombres ignoran a la chica. La toma de cerca de la chica sola constituye una presentación muy original.

Une note d'humour est produite par les hommes ne faisant pas attention à la fille, et la présentation est originale, surtout la vue en gros plan du personnage féminin.

95

Title	"Corte-I"
Photographer	Julio Alvarez Yague
Camera	Nikon F2
Lens	35mm Nikkor
Film	Tri-X

Mainly a design picture but very striking in its simplicity. It demonstrates the alertness of the author.

Hauptsächlich ein strukturelles Bild, jedoch verblüffend in seiner Einfachheit. Es zeigt, wie aufmerksam der Fotograf ist.

Deze compositiefoto valt op door zijn eenvoud. Hij illustreert de visie en de alertheid van de fotograaf.

En el fondo se trata de un diseño, pero muy atrayente debido a su simplicidad. Demuestra el estado de alerta del autor.

C'est surtout la composition qui importe, frappante par sa simplicité même. Elle témoigne de l'acuité de la perception du photographe.

96

Photographer	Shabbir Dossaji
Camera	4" x 5" for egg
	35mm for model
Film	FP4

An original portrait made by printing two negatives separately onto Kodak paper.

Originalporträt, das durch getrennten Abzug von zwei Negativen auf Kodakpapier entstand.

Een origineel portret dat verkregen werd door twee negatieven na elkaar af te drukken op een vel Kodak-papier.

Un retrato original conseguido al positivar dos negativos, por separado, en papel Kodak.

Un portrait original, réalisé par le tirage séparé de deux négatifs sur papier Kodak.

97

Title	"Virgin"
Photographer	Jules Copus
Camera	Mamiya RB67
Lens	127mm
Film	Kodak Vericolor II

A candid studio portrait of remarkably good technique and colour rendering.

Ein offenes Studio-Porträt mit bemerkenswert guter Technik und Farbwiedergabe.

Een candid studio-opname met een goede techniek en kleurweergave.

Un ingenuo estudio de retrato con buena técnica y combinación de colores.

Un portrait plein de candeur, exécuté en studio. La technique est excellente et les couleurs sont remarquablement bien rendues.

98 (Upper)

Title	"Sacred Ibis and the Sun"
Photographer	Dr M D Constable
Camera	Canon FTB
Lens	80-250 zoom
Film	High speed Ektachrome

A striking montage of a semi-silhouette with a screen pattern which concentrates the eye on the subject.

Überraschende Montage einer Halbsilhouette mit grünem Muster, die das Auge auf den Gegenstand lenkt.

Een treffende montage van een halfsilhouet met een lijnpatroon dat het oog naar het onderwerp leidt.

Un montaje sorprendente de una semisilueta en un entorno de dibujos que invitan al ojo a que se concentre en el sujeto.

Montage frappant d'une semi-silhouette avec un écran qui concentre l'oeil sur le sujet.

98 (Lower)

Photographer	Steve Powell
Camera	Nikon F2
Lens	300mm Nikkor
Film	Kodachrome 64

A picture which demonstrates how a semi-silhouette can heighten the impression of movement.

Ein Bild, das beweist, daß eine Halbsilhouette den Eindruck der Bewegung unterstreichen kann.

Deze foto toont hoe een halfsilhouet de indruk van beweging kan verhogen.

Viene a demostrar cómo una semisilueta realza la impresión de movimiento.

Une photo qui montre comment une demi-silhouette peut accentuer l'impression de mouvement.

99

Photographer	John M Vijlbrief
Camera	Nikon FM
Lens	50mm
Film	Ilford HP5

A simplified tone treatment has produced an original and modern effect in a romantic subject which could have been too sentimental.

Vereinfachte Tondarstellung, die einen originellen, modernen Effekt bei einem romantischen Gegenstand erzielt hat, der zu sentimental hätte werden können.

Deze foto van de Haagse fotograaf John M. Vijlbrief toont een origineel en modern effect in een romantisch onderwerp, dat gemakkelijk te sentimenteel zou kunnen zijn.

Se ha evitado que este romántico tema quedase demasiado sentimental por medio del tratamiento simplificado de tonos.

Le traitement simplifié des tons a produit un effet original et moderne dans un sujet romantique qui aurait pu être trop sentimental.

100

Title	"Cheer Squad"
Photographer	Lee I-Hsung
Camera	Nikon FE
Lens	80-200mm zoom
Film	Fuji F11
Print	Ektacolor

Repetition of forms in opposition has given rhythm and vitality and the leader holds them together which prevents monotony.

Die Wiederholung von umgekehrten Formen hat dem Bild Rhythmus und Vitalität verliehen, und der Leiter hält sie zusammen, was Monotonie verhütet.

Een herhaling van tegengestelde vormen waardoor de foto ritme en vitaliteit vertoont. De houding van de leidster, die de meisjes bij elkaar schijnt te houden voorkomt eentonigheid.

La repetición de formas opuestas da ritmo y vitalidad a la imagen, la presencia del jefe rompe la monotonía.

La répétition des formes en opposition donne du rythme et de la vitalité à l'image; la présence du chef rompt la monotonie.

101

Title	"Sneeuw Mannetje"
Photographer	Etienne Desmet
Camera	Hasselblad
Lens	150mm
Film	Agfa

A good theatrical type of portrait which shows a colour contrast that suits the subject.

Ein gutes Theaterporträt, das einen Farbkontrast zeigt, der zum Thema paßt.

Een goed portret dat een kleurcontrast vertoont dat geheel bij het onderwerp past.

Un retrato de tipo teatral que muestra el contraste de color apropiado para el sujeto.

Un bon type de portrait théâtral avec un contraste de couleurs qui convient au sujet.

102

Title	"Water Canon"
Photographer	Robert Martin
Camera	Nikon FE
Lens	300mm
Film	Kodachrome 64

Action and texture have combined to produce a well-composed and interesting as well as amusing sports picture.

Bewegung und Struktur wurden miteinander verbunden, um ein komponiertes, interessantes und amüsantes Sportbild zu erzielen.

Actie en uitdrukking werden gecombineerd om een goed gecomponeerde, interessante en amusante sportfoto te verkrijgen.

Se ha fundido la acción con los materiales para lograr esta interesante y atrayente fotografía deportiva.

L'action et la texture sont combinés pour donner une photo sportive bien composée, intéressante et amusante.

103

Photographer	Steve Powell
Camera	Nikon F2
Lens	24mm
Film	Kodachrome 64

An incredible amount of action has been captured and the low viewpoint emphasises the excitement.

Dieses Bild fängt unglaublich viel Bewegung ein, und der niedrige Gesichtspunkt unterstreicht die Aufregung.

Een enorme hoeveelheid actie, in één foto gevangen. Door het lage standpunt wordt de spanning vergroot.

La cantidad de acción que se ha captado es increíble; el punto de vista acentúa la emoción.

Le photographe a capturé une débauche d'action sous un angle qui met en évidence l'excitation du moment.

104 (Upper)

Title	"Nude"
Photographer	Lee I-Hsung
Camera	Nikon FE
Lens	35mm
Film	Sakuracolor-11
Paper	Kodak Ektacolor

An excellent example of the technique of zooming during exposure that produces maximum concentration on the subject.

Ausgezeichnetes Beispiel für die Zoom-Technik bei der Belichtung, wodurch sich eine maximale Konzentration auf den Gegenstand ergibt.

Een excellent voorbeeld van de zoomtechniek waarbij tijdens de verlichting de brandpuntsafstand wordt versteld; zo wordt een maximale concentratie op het onderwerp verkregen.

La técnica del zoom produce máxima concentración en el sujeto, de lo que esta foto es un buen ejemplo.

Un excellent exemple de la technique du zooming pendant l'exposition qui produit une concentration maximum sur le sujet.

104 (Lower)

Title	"Sunset Clouds"
Photographer	Jenn-Shyong Lee
Camera	Minolta XD
Lens	35mm
Film	Sakura-100

A very happy shot, full of vitality, in which the sky formation directs the eye unfailingly towards the dancer.

Eine sehr lustige Aufnahme, voller Vitalität, wobei die Wolkenbildung das Auge unfehlbar direkt auf die Tänzerin richtet.

Een vrolijke opname vol vitaliteit waarin de wolkenformaties de aandacht van het oog direct naar de danseres leiden.

Una instantánea llena de vitalidad. La formación del cielo conduce el ojo hacia la bailarina.

Une photo très heureuse, pleine de vitalité, dans laquelle la formation du ciel dirige l'oeil inexorablement sur la danseuse.

105

Title	"Summer Solitude"
Photographer	Peter M Rees
Camera	Olympus OM1-N
Lens	28mm Zuiko
Film	Kodachrome-25

An unusual figure study in which the contrast between voluptuous curves and rugged rock is evocative.

Eine ungewöhnliche Aktstudie, bei der der Kontrast zwischen den üppigen Kurven und dem zerklüfteten Gestein beschwörend wirkt.

Een ongebruikelijke figuurstudie, waarin vooral het contrast tussen de weelderige vormen en de ruwe rots opvalt.

Un estudio fuera de lo corriente en el que se contrasta de forma evocativa la voluptuosidad de las curvas y la aspereza de la roca.

Une étude inhabituelle dans laquelle le contraste entre les courbes voluptueuses et les rochers déchiquetés est évocateur.

106 (Upper)

Title	"Buzzard and Giant Turtle, Galapagos"
Photographer	Fritz Pölking
Camera	Olympus OM-2
Lens	200mm
Film	Kodachrome 64

The author must have been very much on the alert to catch such an unusual incident as this with superb technique as well.

Der Fotograf muß sehr wachsam gewesen sein, um diesen ungewöhnlichen Vorfall aufnehmen zu können, wobei die Aufnahme ebenfalls mit ausgezeichneter Technik erfolgte.

De fotograaf moet bijzonder op zijn hoede zijn geweest om een dergelijke ongebruikelijke gebeurtenis met een zo hoge graad van perfectie te kunnen vastleggen.

El autor tiene que haber estado muy alerta para captar un incidente tan especial, y además con una técnica tan buena.

L'auteur a vraiment dû être sur le qui-vive pour saisir un incident aussi inhabituel avec en plus une technique superbe.

106 (Lower)

Title	"Hyalophora cecropia mating"
Photographer	Santokh Kochar
Camera	Minolta SRT 102
Lens	Vivitar Series-1 90mm Macro
Film	Kodachrome

An excellent example of natural history showing the specimens in their environment.

Ein ausgezeichnetes Beispiel für Naturgeschichte mit Schmetterlingen in ihrer Umgebung.

Deze prachtige natuuropname toont vlinders in hun natuurlijke omgeving. Dank zij het gebruik van een 90 mm objectief kon de fotograaf op een dusdanige afstand van zijn onderwerp blijven, dat de vlinders niet op de vlucht gingen.

Un excelente ejemplo de historia natural mostrando unos especímenes en su propio medio.

Un excellent exemple d'histoire naturelle montrant les spécimens dans leur environnement.

107

Title	"Baby Antics – Orang-utan"
Photographer	Peter W Tryuk
Camera	Canon A1
Lens	300mm
Film	Ektachrome 400ASA

A picture with human appeal as well as zoological interest and more than a little humour.

Ein Bild, das den Menschen anspricht und von zoologischem Interesse ist und das überdurchschnittlichen Humor aufweist.

Bij dergelijke foto's is een vergelijking met mensen onontkoombaar; deze opname is niet alleen interessant als dierenfoto, maar ook vanwege het humoristische tafereel.

Tiene atracción humana, al mismo tiempo que interés animal y bastante humor.

Une photo d'un attrait humain ainsi que d'un intérêt zoologique non sans une pointe d'humour.

108

Title	"Larry Holmes (World Heavy-Weight Champion"
Photographer	Steve Powell
Camera	Nikon F2 with M/D
Lens	85mm f/2 Nikkor
Film	Kodachrome 64ASA

The muscular strength associated with this athlete is given added emphasis by a powerful presentation.

Die mit diesem Athleten verbundene Muskelstärke wird durch die kraftvolle Präsentation noch unterstrichen.

De pittige presentatie van deze foto versterkt de indruk van spierkracht die hij als totaal overbrengt.

La impresionante presentación acentúa la fuerza muscular asociada con este atleta.

La force musculaire de cet athlète est soulignée ici par une puissante présentation.

109

Title	"Water Babe"
Photographer	Tony Duffy
Camera	Nikon F2
Lens	200mm
Film	Kodachrome 64

A popular subject well presented with just the right amount of movement.

Ein beliebtes Thema, das mit genau der richtigen Bewegung gut präsentiert wurde.

Een populair onderwerp, goed gefotografeerd met precies de juiste hoeveelheid beweging.

Tema popular presentado con la correcta cantidad de movimiento.

Un sujet populaire, bien présenté, avec juste ce qu'il faut de mouvement.

110 (Upper)

Title	"Exploring an inflatable"
Photographer	Clive B Harrison
Camera	Olympus OM-1
Lens	28mm Zuiko
Film	Ektachrome 200
	Combination print in
	Cibachrome

Not many people would see the possibilities of a child's play tunnel and capture it as well as this.

Nicht jeder würde die Möglichkeiten eines Kinder-Spieltunnels sehen und das Bild so gut wie hier einfangen.

Er zijn maar weinig mensen die de mogelijkheid om een speeltunnel voor kinderen op deze manier uit te beelden, zouden zien.

Pocos verían las posibilidades de un túnel de juguete y sabrían, además, captarlo tan bien.

Rares sont ceux qui se rendraient compte des potentialités d'un tunnel gonflable et songeraient à les capturer de cette manière.

110 (Lower)

Title	"Merry-go-Round"
Photographer	Philippe Massenat
Camera	Olympus OM-2
Lens	100mm Zuiko
Film	Kodachrome 64

Movement well captured has presented the atmosphere of a carousel to perfection.

Gut eingefangene Bewegung in der Atmosphäre eines Karussells, in voller Perfektion.

De goed gevangen beweging leidt tot een perfecte uitbeelding van de atmosfeer die men in een draaimolen ondergaat.

Tanto el movimiento como la atmósfera de los caballitos se han captado a la perfección.

Le mouvement bien saisi présente à la perfection l'atmosphère d'un manège.

111

Title	"Adolescent"
Photographer	Joachim Blanch
Camera	Nikon F2
Lens	55mm f/2.8 Micro Nikkor
Film	Ektachrome 64

A delightful study in romantic vein which seems to project the wonder of childhood emerging into teenage.

Eine entzückende Studie mit romantischem Anstrich, die das Wunder der Kindheit beim Übergang in das Teenager-Alter zu projizieren scheint.

Een fijne studie in romantische sfeer die het wonder van de eerste stappen op weg naar de volwassenheid tot uiting brengt.

Un estudio delicioso de carácter romántico, que evoca la sorprendente transformación del niño en adolescente.

Une étude charmante teintée de romantisme et évoquant l'étonnante transformation de l'enfant en adolescent.

112

Title	"A Fight in Flying"
Photographer	Seok-Joon Huh
Camera	Nikomat
Lens	Nikkor 200mm
Film	Kodak 100ASA

An extremely well caught shot which even shows one bird's wounds although in mid-air. It proves the wisdom of keeping a camera always at the ready.

Eine äußerst gut gelungene Aufnahme, die sogar die Wunden des Vogels beim Flug zeigt. Sie beweist, daß es sich lohnt, die Kamera stets schußbereit zu halten.

Een uitermate goed getroffen opname waarop zelfs de wonden van een der vogels te zien zijn. Zo blijkt maar weer dat het verstandig is om altijd een camera paraat te hebben.

Una instantánea de estupenda calidad, que incluso muestra las heridas de uno de los pájaros en vuelo. No hace más que reafirmar la importancia de tener la cámara siempre a punto.

Une photo extrêmement bien prise qui montre même les blessures de l'un des oiseaux bien qu'il soit en plein vol. Comme quoi il est sage d'avoir toujours son appareil sous la main.

113

Title	"Lyudmila"
Photographer	Oleg Burbowskij
Camera	Kiev 6
Lens	Vega
Film	Foto 130

An original approach to a glamorous subject that also projects a little air of mystery by 'sinking' into a black background. The biting definition concedes nothing to glamour.

Originelle Lösung eines glänzenden Themas, das auch ein gewisses Geheimnis projiziert, indem es in den schwarzen Hintergrund "versinkt". Die scharfe Definition ist kein Zugeständnis an die Schönheit.

Een originele benadering van een glamour-achtig onderwerp die een vleugje geheimzinnig-heid krijgt doordat het gezicht in een donkere achtergrond verdwijnt. De genadeloos scherpe weergave van alle details laat zich niet door glamour onderdrukken.

Una forma original de presentar un tema exuberante, que también proyecta un poco de misterio al "hundirse" en la distancia.

Une approche originale et un sujet fascinant que le fond noir auréole d'un certain mystère. La précision ne cède en rien au charme.

114

Title	"Happiness in a silent world"
Photographer	Denis Thorpe
Camera	Leica M2
Lens	35mm Summilux
Film	FP4

A documentary type of photograph intended to show how deaf children can be helped with modern technology. No one could ignore the message so well conveyed here.

Ein Dokumentarfoto, das zeigen soll, wie tauben Kindern durch moderne Tecknik geholfen werden kann. Keiner kann ignorieren, was hier so gut dargestellt wird.

Een documentaire foto waarop te zien is hoe dove kinderen met behulp van de moderne technologie kunnen worden geholpen. Niemand zal de boodschap van deze foto ontgaan.

Un tipo de fotografía documental para sugerir cómo la nueva tecnología puede ayudar a los niños sordos. A nadie puede escapársele el mensaje que transmite.

Une photo de type documentaire qui vise à montrer comment les enfants sourds peuvent être aidés par la technologie moderne. Personne ne pourrait être insensible à un message si bien transmis.

115

Title	"Let me do it"
Photographer	Dev Raj Agarwal
Camera	Rolleicord
Lens	Xenon 80mm
Film	INDU 125

A picture which captures the happiness of childhood in a candid way, emphasised by differential focus.

Ein Bild, das das Glück der Kindheit offen einfängt, unterstrichen durch unterschiedliche Schärfe.

De blijdschap van dit kind, ongedwongen gefotografeerd, wordt benadrukt door de selectieve scherpstelling, die de achtergrond doet vervagen.

Ha captado la felicidad ingenua de la niñez, acentuada por medio del enfoque selectivo.

Le bonheur de l'enfance saisi avec une candeur accentuée par le flou de l'image.

116

Title	"The Spies"
Photographer	Pedro Luis Raota
Camera	Hasselblad
Lens	80mm
Film	Tri-X

Humour in photography which is obtained by natural and not contrived situations is always acceptable, especially when as funny as this.

Humor in der Fotografie durch natürliche, nicht herbeigeführte Situationen ist immer akzeptabel, besonders, wenn er so komisch ist wie hier.

In de fotografie wordt humor, als hij voortkomt uit natuurlijke, dus niet voor de foto gecreëerde situaties, altijd geaccepteerd.

El humor en la fotografía siempre se acepta bien si es natural, sobre todo si es tan graciosa como ésta.

En Photographie, l'humour qui est obtenu par des situations naturelles est toujours acceptable, surtout quand c'est aussi amusant qu'ici.

117

Title	"Kupo"
Photographer	John Doidge
Camera	Nikon F2A
Lens	200mm Nikkor
Film	FP4

A 5 year old Orang-utan at Twycross Zoo caught with an almost human expression in a pose of despair.

Ein 5 jähriger Orang-utan im Twycross-Zoo, hier mit einem fast menschlichen Ausdruck und in entmutigter Pose eingefangen.

Een vijf jaar oude orang-oetang in de Engelse Twycross dierentuin met een welhaast menselijke uitdrukking en een houding die wanhoop uitdrukt.

Un orangután de cinco años del Twycross Zoo muestra una expresión de desesperanza casi humana.

Un orang-outan de 5 ans au zoo de Twycross surpris avec une expression presque humaine et dans une attitude de désespoir.

118

Photographer	Larry Bartlett
Camera	Mamiya C33
Lens	80mm
Film	HP4

To keep a fast moving car as sharp as this while panning and pre-judging the exact moment to fire the shutter is a tremendous technical achievement.

Um einen schnell fahrenden Wagen so scharf wie diesen zu halten, während man den genauen Moment zum Abdrücken plant und beurteilt, ist ein enormer technischer Erfolg.

Het scherp vastleggen van een snel rijdende auto door de camera mee te bewegen en van tevoren het moment van afdrukken te bepalen mag gerust een staaltje van technisch vakmanschap worden genoemd.

El mantener al coche moviéndose a gran velocidad y calcular con éxito el momento justo para disparar es el resultado de un tremendo logro técnico.

Obtenir une image aussi nette d'une voiture roulant à grande vitesse tout en panoramiquant et en déterminant le moment exact auquel déclencher l'obturateur, est un exploit technique remarquable.

119

Photographer	Chas Thompson
Camera	Rolleiflex SL 35
Lens	400mm
Film	HP5

A tremendous impression of speed and determination shown by catching competitors in action side by side.

Ein enormer Eindruck von Geschwindigkeit und Entschlossenheit zeigt sich hier durch Einfangen der Rennfahrer im Einsatz Seite an Seite.

De indruk van snelheid wordt hier verkregen door de enorme detailrijkdom van de foto, waaruit actie en spanning goed te herkennen zijn.

Una demostración de velocidad y determinación cuando se captan los competidores uno al lado del otro.

Une fantastique impression de vitesse et de détermination obtenue en montrant les concurrents côte à côte dans le vif de l'action.

120

Title	"Cycle Chain"
Photographer	Pavel Tishkovski
Camera	Zenith-E
Lens	43mm Helios
Film	Foto 65

A treatment achieved in the darkroom, by moving the paper under the enlarger, effectively increases the impression of speed.

Eine in der Dunkelkammer erzielte Darstellung, indem das Papier unter dem Vergrö-ßerungsgerät bewegt wird. Dies steigert wirksam den Eindruck von Geschwindigkeit.

Dit effect berust op een dokatruc: bij iedere nieuwe belichting werd het papier iets verschoven; de eerste belichting duurde duidelijk het langst. Door dit effect wordt een idee van snelheid gecreëerd.

Para incrementar la impresión de velocidad se movió lateralmente el papel bajo el haz luminoso de la ampliadora, en el cuarto oscuro.

Traitement obtenu en chambre noire, en déplaçant le papier sous l'agrandisseur, un procédé efficace pour augmenter l'impression de vitesse.

121

Title	"The River Neris"
Photographer	S Žvirgždas

This looks like a right/left montage but is, in fact, a panoramic or 'fish-eye' shot and the author deserves a lot of credit for seeing the possibilities in the subject.

Das Foto sieht aus wie eine rechts/links Montage, ist aber eine Panorama – oder Fish-eye – Aufnahme. Der Fotograf hatte den richtigen ßlick für die Möglichkeiten des Objektes.

Door de symmetrische opbouw zou men eerst haast denken dat we hier met een fotomontage te doen hebben waarvan links en rechts (gespiegeld ten opzichte van elkaar) gelijk zijn. Deze opname is echter met een panorama-macamera gemaakt. Door de horizon niet in het midden te houden en de camera iets omlaag te richten werd de bolle horizon verkregen.

Esta fotografía parece un montaje, pero en realidad es una panorámica hecha con un objetivo "ojo de pez". El autor se merece una felicitación por ver las posibilidades del tema.

Ceci paraît être un montage symetrique mais c'est en fait une photo panoramique ou à lentille sphérique, et l'auteur a le grand mérite d'avoir vu les possibilités du sujet.

122

Photographer	Howard Walker
Camera	Nikon F2
Lens	80-200mm zoom
Film	Tri-X

A "well seen" shot by a photographer with his eyes open to spot a humorous juxtaposition of subjects which can also have a topical message.

Eine "gut beobachtete" Aufnahme von einem Fotografen, der seine Augen offen hatte, um eine humorvolle Nebeneinanderstellung von Personen zu sehen, die auch interessante Bedeutung haben kann.

Goed gezien! Alleen een fotograaf die zijn ogen goed de kost geeft is in staat zo'n opname te maken, die niet alleen een humoristische tegenstrijdigheid bevat maar ook een actueel tintje heeft.

Una foto "bien vista" hecha por un fotógrafo lo suficientemente alerta como para notar la cómica yuxtaposición de objetos, que además trasmiten un mensaje tópico.

Un instantané "bien observé": le photographe a su déceler l'humour de la situation et transmettre un message par la même occasion.

123

Photographer	Mike Hollist
Camera	Nikon F2
Lens	180mm
Film	Tri-X

A very happy picture which is a pleasant counter to the attacks so often made on the police.

Ein sehr fröhliches Bild, eine angenehme Variation der Angriffe, die so häufig auf die Polizei gemacht werden.

Een vrolijk tafereel dat een aardige afwisseling vormt op de vele aanvallen die de politie te verduren heeft.

Esta grata fotografía representa una acogedora variante a los ataques que generalmente se dirigen contra la policía.

Une photo très gaie qui change agréablement des attaques auxquelles la police est souvent en butte.

124

Photographer	Gerry Lockley
Camera	Canon F1
Lens	50mm
Film	FP4
Lighting	Flash

A charming picture which was probably staged but is none the worse for that, and the arrangement of subjects has produced a most attractive design.

Ein charmantes Bild, das wahrscheinlich gestellt, aber trotzdem gut ist. Durch die Anordnung der Gegenstände wurde eine sehr attraktive Form erzielt.

Een aantrekkelijke opname, die waarschijnlijk werd gearrangeerd; dat hoeft beslist niet tot een negatief oordeel te leiden. Het resultaat is hier een aantrekkelijke compositie.

Una deliciosa fotografía, sin duda alguna preparada – lo cual no es óbice para su efecto–. La disposición de los temas ha resultado en un diseño de lo más atractivo.

Une photo charmante qui a été probablement mise en scène mais qui n'en est pas plus mauvaise, et la disposition des sujets a produit une composition très agréable.

125

Title	"Furious"
Photographer	Kishore Joshi
Camera	Ashahi Pentax MX
Lens	Vivitar 80-200mm zoom
	(at 200mm setting)
Film	Orwo NP 55 125ASA
	(rated 100ASA)

Lions when yawning can look very fierce in the camera but one could easily interpret this one as laughing, just as a yawning horse looks as though it is laughing.

Wenn Löwen gähnen, kann das mit der Kamera sehr bedrohlich aussehen. Man könnte diese Geste jedoch auch als Lachen auslegen, genau wie bei einem gähnenden Pferd.

Een geeuwende leeuw kan er vervaarlijk uitzien op een foto, hoewel men van deze ook zou kunnen denken dat hij schaterlacht.

Cuando los leones bostezan parecen muy enojados, aunque podría interpretarse como si rieran, de la misma forma que parecía seíz el caballo que bostezaba.

Quand ils baillent, les lions peuvent paraître très féroces sur la photo mais on pourrait ici facilement prendre ce baillement pour un rire, comme pour un cheval qui baille.

126

Photographer	Denis Thorpe
Camera	Leica M2
Lens	35mm
Film	HP5

A well caught picture of Willie Gaines, the jazz tap dancer, at the height of his leap and clear of the other subjects.
Ein gut aufgenommenes Bild von Willie Gaines, dem Jazz-Stepptänzer beim Sprung, bei dem er sich von anderen Gegenständen abhebt.

Een precies op het juiste moment genomen foto van Willie Gaines, jazz tapdanser, op het hoogste punt van zijn sprong en los van de andere personen op de foto.

Se le ha hecho una buena foto a Willie Gaines, bailarín de jazz zapateado, en el punto más alto de su salto y libre de toda obstrucción.

Une photo bien prise de Willie Gaines, le danseur de claquettes de jazz, au sommet de son saut et bien distinct par rapport aux autres personnages.

127

Photographer	John Doidge
Camera	Rolleiflex
Lens	80mm
Film	HP5
Lighting	Flash

Malcolm Hudson, World Champion karate black belt in dynamic action presented with technical perfection.
Malcolm Hudson, Weltmeister im Karate-Sport mit schwarzem Gürtel in einer dynamischen Bewegung, die hier mit technischer Perfektion aufgenommen wurde.

Wereldkampioen karate Malcolm Hudson is hier op technisch perfecte wijze 'bevroren' in een dynamische actie door de korte belichtingsduur van een elektronenflitser.

Con gran perfección técnica se presenta al campeón mundial de karate, categoría "cinturón negro", Malcolm Hudson.

Malcolm Hudson, champion du monde de karaté ceinture noire dans une action dynamique présentée avec une technique parfaite.

128

Photographer	Aloke Mitra
Camera	Nikon F
Lens	105mm
Film	Plus X

A documentary or illustrative type of portrait of an Indian peasant which has social overtones but is also very artistic in its interpretation.
Ein Dokumentar- oder illustrierendes Porträt einer indischen Bauernfrau mit sozialen Assoziationen, jedoch auch sehr künstlerisch in der Interpretation.

Een documentair of illustratief portret van een bewoonster van het Indische platteland waarin een sociale context doorklinkt; de foto valt op door zijn artistieke interpretatie.

Un tipo de retrato documental de la vida del campo en la India; aunque recoge cierta sugestión tipo social, la interpretación es bastante artística.

Un portrait documentaire ou illustratif d'une paysanne indienne avec un nuance sociale tout en étant d'une interprétation très artistique.

129

Title	"The Hair"
Photographer	Veikko Wallström
Camera	Nikon F
Lens	105mm Nikkor
Film	Tri-X

Portraits lit by light through lattice windows, once popular, are not often seen today but this is an original revival.

Porträts, die mit Licht, das durch Gitterfenster fällt, beleuchtet werden, waren früher einmal beliebt. Heute sind sie nicht häufig zu sehen. Hier handelt es sich um eine originelle Wiederbelebung.

Foto's, gemaakt bij het door jaloezieën invallende licht, waren eens populair; deze mag als een interessante heropleving worden gezien.

Una grata y original resurrección de lo que fue anteriormente la popular costumbre de utilizar la luz que atravesaba.

Les portraits pris à la lumière filtrant par des persiennes étaient autrefois populaires mais sont devenus rares. Un exemple original.

130

Title	"On the evening tide"
Photographer	David Herrod
Camera	Mamiya 645-1000S
Lens	110mm Sekor
Film	FP4

The splended "wet look" achieved by a comparatively slow shutter speed has made this an outstanding seascape in modern vein.

Durch den ausgezeichneten "Wassereffekt", der durch eine verhältnismäßig niedrige Belichtungsgeschwindigkeit erzielt wurde, erhielt dieses ausgezeichnete Seebild eine moderne Nuance.

De 'natheid' van het water wordt hier bereikt door een vergelijkenderwijs trage sluitersnelheid die dit schitterende zeegezicht een modern tintje geeft.

Un espléndido paisaje marino logrado con obturación lenta y tratamiento moderno.

La vitesse d'obturation relativement lente crée la splendide impression de "mouillé" qui fait de cette photo un paysage marin remarquable et tout à fait moderne.

131 (Upper)

Title	"Sculptor"
Photographer	A Macijauskas

A contemporary treatment of a genre subject aided by an attractive sky which provides strong contrast in tone as well as between the components, sky, man and rock.

Moderne Darstellung eines Genre-Themas, unterstützt durch einen attraktiven Himmel mit starkem Tonkontrast sowie Kontrast zwischen den Bestandteilen Himmel, Mensch und Fels.

Een eigentijdse benadering van de genrefotografie, die wordt ondersteund door de prachtige lucht die niet alleen een contrast oplevert met betrekking tot de toonwaarden, maar ook tussen licht, man en steen.

Un tratamiento contemporáneo armonizado por el atractivo cielo, lleno de contrastes, y la tonalidad del resto de los componentes: el hombre, la roca.

Un traitement contemporain d'un sujet de genre aidé par un ciel intéressant qui fournit un puissant contraste aussi bien entre les tons que les composants, le ciel, l'homme et la pierre.

131 (Lower)

Photographer	Tony Ward
Camera	Nikon FM plus motor drive
Lens	500mm mirror
Film	Tri-X

The mood of a raging storm on the sea shore is given meaning and added interest by the excellent placing of the bird taking off.

Die Stimmung eines rasenden Sturms an der Küste erhält Bedeutung und zusätzliches Interesse durch die ausgezeichnete Position des abfliegenden Vogels.

De stemming van een op de kust beukende storm wordt hier zinvol en interessant naar voren gebracht door de perfecte plaatsing van de wegvliegende vogel.

Se ha captado la emoción de un día tormentoso de playa y añadido interés con la colocación afortunada de un pájaro tomando vuelo.

L'atmosphère d'une forte tempête sur le rivage reçoit une signification et un intérêt accrus par l'excellent positionnement de l'oiseau prenant son vol.

132

Title	"Morecambe and Wise"
Photographer	Steve Templeman
Camera	Nikon FM
Lens	50mm Nikkor
Film	HP5

Although obviously posed for the photographer this shot is so typical of the popular comedians that it is acceptable and pleasing, as well as showing a good character likeness.

Obgleich diese Aufnahme offensichtlich eine Pose für den Fotografen war, ist sie so typisch für diese beliebten Komiker, daß sie annehmbar und angenehm ist und eine gute Ähnlichkeit im Charakter zeigt.

Het feit dat er voor deze foto duidelijk werd geposeerd is acceptabel doordat de foto deze twee in Engeland populaire komieken op een zeer typerende wijze weergeeft terwijl ook de karaktereigenschappen juist overkomen.

Aunque es evidente que han posado para el fotógrafo, esta fotografía de los populares comicos se acepta y gusta por la gran semejanza que muestra el carácter de los personajes.

Bien que les deux comédiens aient visiblement posé pour la photo, elle est si typique qu'elle parvient à plaire; en outre la ressemblance est bonne.

133

Title	"Quentin Crisp"
Photographer	Jim Miller
Camera	Nikon F2
Lens	50mm
Film	HP5 rated at 650ASA

A formal portrait which has managed to look relaxed and not too obviously posed, aided by the unusual background.

Ein offizielles Porträt, das entspannt und nicht zu stark posiert aussieht, unterstützt durch den ungewöhnlichen Hintergrund.

Een formeel portret dat er toch ontspannen uitziet en niet al te geposeerd, mede dank zij de ongebruikelijke achtergrond.

El extraño entorno ha servido para que este retrato formal mueste naturalidad y menos pose.

Un portrait conventionnel mais qui ne manque toutefois pas de naturel ni de décontraction, en partie grâce au décor inhabituel.

134

Photographer	Peter Stickler
Camera	Nikon FE
Lens	55mm
Film	Tri-X

This is reminiscent of many photographs exhibited in the 1930's and it is a refreshing revival in a more modern idiom.

Dies erinnert an viele Fotos aus den 30er Jahren und ist eine erfrischende Wiederbelebung in moderner Form.

Deze opname doet ons denken aan foto's uit de jaren dertig; de fotograaf heeft echter een verfrissende nieuwe kijk op dit thema.

Reminiscencia de las fotos de los años treinta, refrescante tema con tratamiento moderno.

Ceci rappelle de nombreuses photos exposées dans les années 1930 mais il s'agit toutefois d'un cliché original, bien d'aujourd'hui.

135

Title	"Puppy Love"
Photographer	M J O'Neill
Camera	Yashica FR-1
Lens	35mm
Film	HP5

The age old theme of young lovers snatching a moment of privacy becomes a sociological message.

Das uralte Thema der jungen Liebenden, die einen Moment des Alleinseins nutzen, wird zur soziologischen Aussage.

Het eeuwenoude thema van jonge geliefden die zich op een rustig plaatsje afzonderen krijgt hier sociologische bijbetekenis.

Los jóvenes que buscan un momento para estar solos convierten el tema eterno en un mensaje sociológico.

Le thème éternel des jeunes amoureux profitant d'un moment de solitude devient un message sociologique.

136

Title	"The Sunshine of your smile"
Photographer	Stephen Shakeshaft
Camera	Nikon F2
Lens	50mm Nikkor
Film	Tri-X

A very happy and pleasing candid executed with technical perfection and beautiful print quality.

Ein sehr glückliches, angenehm offen ausgeführtes Foto mit technischer Perfektion und ausgezeichneter Abzugqualität.

Een leuke, vrolijke candid opname, technisch perfect uitgevoerd en fraai afgedrukt.

Una foto espontánea muy bien ejecutada, con perfección técnica y estupenda calidad de impresión.

Une photo sur le vif très belle et très gaie avec une technique parfaite et une belle qualité de tirage.

137

Title	"The Neighbourhood"
Photographer	John Doyle
Camera	Pentax K1000
Lens	50mm Takumar
Film	Tri-X

A "framed" picture of the lonely cyclist in silhouette has projected a scene that most have experienced and the "contre-jour" light has made it very attractive in atmosphere.

Ein "gerahmtes" Bild eines einzelnen Radfahrers als Silhouette projiziert eine Szene, die die meisten schon einmal gesehen haben. Durch das "Gegenlicht" wird es sehr attraktiv in der Stimmung.

Een omkaderde opname van een eenzame fietser, afgebeeld in silhouet. Velen zullen de sfeer duidelijk herkennen, die wordt versterkt door het tegenlichteffect.

Una foto "encuadrada". La silueta del ciclista solitario se proyecta sobre una escena que cualquiera ha experimentado; el contraluz le ha proporcionado una atmósfera atractiva.

La silhouette "encadrée" du cycliste solitaire est une image familière à beaucoup d'entre nous, le contre-jour crée une atmosphère séduisante.

138

Photographer	Steve Hartley
Camera	Nikon F2
Lens	200mm Nikkor
Film	HP5

No doubt a number of press photographers could have caught this happy picture of Chris Lloyd after winning the Ladies Singles Championship at Wimbledon, but this is outstanding because of the technique which shows the plate in exceptional detail.

Zweifellos könnten viele Pressefotografen dieses fröhliche Bild von Chris Lloyd aufgenommen haben, nachdem sie in Wimbledon Meisterin im Dameneinzel wurde. Dieses Foto ist jedoch darum so ausgezeichnet, weil seine Technik den Teller in ausgesprochen gutem Detail zeigt.

Ongetwijfeld hadden veel fotografen deze vrolijke foto van Chris Lloyd kunnen maken, nadat zij het dames-enkel-kampioenschap op Wimbledon had gewonnen, maar deze is bijzonder omdat het bord met een enorme detailrijkdom wordt weergegeven.

Que duda cabe que cualquier fotógrafo de prensa hubiera logrado esta agraciada fotografía de la campeona de los Singles de Wimbledon, Chris Lloyd, pero la excelencia de la foto le viene de la técnica utilizada para la exquisita captación de la placa.

Il est évident qu'un grand nombre de photographes de presse auraient pu prendre cette photo heureuse de Chris Lloyd après sa victoire au simple dames de Wimbledon, mais cette photo est remarquable à cause de la technique qui montre la coupe avec une netteté exceptionnelle.

139

Title	"Inspiration"
Photographer	Zinovi Shegelman
Camera	Zenith-E
Lens	50mm
Film	KN3

Backlighting has given an artistic touch to a lively portrait with an unusual pose and viewpoint.

Durch Gegenlicht verleiht diese Aufnahme einen lebendigen künstlerischen Anstrich, wobei Pose und Blickpunkt ungewöhnlich sind.

Het tegenlicht heeft aan dit levendig portret met een ongebruikelijke pose en standpunt een artistiek tintje meegegeven.

La iluminación a contraluz del retrato aumenta el toque artístico de esta pose y punto de vista poco frecuentes.

L'éclairage à contre-jour donne une note artistique à un portrait plein de vie dont la pose et l'angle sont inhabituels.

140 (Upper)

Title	"Chanctonbury Ring"
Photographer	Chris Peet
Camera	Exakta
Lens	20mm Flektogon
Film	FP4 in D76
	Orange filter

A straightforward "no frills" landscape in which a very wide angle lens has been used to advantage. The unconventional composition is pleasing and the shading around the trees is, in this case, acceptable.

Unkomplizierte Landschaft, bei der ein starkes Weitwinkelobjektiv vorteilhaft benutzt wurde. Die unkonventionelle Komposition ist angenehm, und die Schattierung um die Bäume ist in diesem Fall annehmbar.

Een rechttoe-rechtaan landschapopname waarbij succesvol gebruik werd gemaakt van een extreem groothoekobjectief. De onconventionele compositie doet het goed en het duidelijk tegenhouden van de bomenpartij bij het afdrukken in de donkerekamer is geheel acceptabel.

Un paisaje directo "sin adornos", en el cual el amplio ángulo aporta ventajas. Una composición fuera de lo corriente en la que se acepta bien el oscurecimiento que rodea a los árboles.

Un paysage direct et sans fioritures pour lequel un objectif à très grand angle a été utilisé avantageusement. La composition inhabituelle est agréable et les ombres autour des arbres sont acceptables dans ce cas.

140 (Lower)

Title	"Road to Hope"
Photographer	Andreas Markiewicz
Camera	Mamiya
Lens	80mm
Film	FP4

A landscape which is striking because of its simplicity of design and the great impression of depth created by the road vanishing into the distance.

Eine Landschaft, die darum verblüffend ist, weil sie eine einfache Form hat und den Eindruck großer Tiefe vermittelt, die durch die Straße entsteht, die in der Ferne verschwindet.

Dit landschap is boeiend door de eenvoud en de enorme indruk van diepte die wordt gecreëerd door de in de verte verdwijnende weg.

La impresión de profundidad está creada por la carretera que se pierde en la distancia. Un diseño sorprendente por su sencillez.

Un paysage frappant par la simplicité de sa composition et une impression de grande profondeur créée par la route qui disparaît dans le lointain.

141

Title	"Park Impressions"
Photographer	Rudolf Bieri
Camera	Leicaflex SL2
Lens	24mm Elmarit
Film	Kodak HS Infra-red
	Red filter

Showing an intelligent use of infra-red film to give strength and unusual tone values to a well composed landscape.

Der Beweis für den intelligenten Einsatz von Infrarotfilm zur Erzielung von Stärke und ungewöhnlichen Tonwerten bei einer gut komponierten Landschaft.

Deze foto toont een intelligent gebruik van infra-roodfilm om aan een goed gecomponeerd landschap extra zeggingskracht te geven.

Demuestra cómo se puede utilizar la película infrarroja para añadir fuerza y tonalidades a una vista bien enfocada.

Cette photo montre un emploi intelligent de la pellicule infrarouge pour donner de la force et des tons inhabituels à un paysage bien composé.

142

Title	"Aftermath"
Photographer	Alasdair Foster
Camera	Mamiya 67
Lens	90mm
Film	HP5

A problem picture that will intrigue the viewer's curiosity about its meaning, but artistically presented.

Problembild, das beim Betrachter Fragen über seine Bedeutung weckt, jedoch artistisch dargestellt ist.

Een probleemfoto die de nieuwsgierigheid van de toeschouwer zal opwekken, en die zich kenmerkt door een artistieke presentatie.

Una fotografía intrigante que capta la curiosidad del espectador sobre su significado, aunque artísticamente presentada.

Une photo problème qui intrigue l'observateur quant à sa signification, tout en étant artistiquement présentée.

143

Photographer	Ladislav Formánek
Camera	Pentacon Six/Horizont
Lens	Sonnar 2.8/180
	Flektogon 4/50
Film	Fomapan 21 N
	Montage of four negatives.

A decidedly unusual combination print in which the author has made the most of contrasting elements presented in a creative design.

Ein entschieden ungewöhnlicher Kombinationsabzug, bei dem der Fotograf das beste aus kontrastierenden Elementen in kreativer Form gemacht hat.

Een bepaald ongebruikelijke combinatiedruk waarin de fotograaf contrasterende elementen juist heeft toegepast in een creatief ontwerp.

Un diseño muy creativo, en el que el autor ha contrastado los elementos para crear esta extraordinaria combinación.

Une épreuve combinée vraiment inhabituelle dans laquelle l'auteur a tiré le maximum des éléments contrastants présentés dans une composition créatrice.

144

Photographer	Brian Duff
Camera	Nikon F
Lens	50mm
Film	Tri-X

Humour presented in a not unkindly way due to the situation depicted. The subject is Cyril Smith, a Liberal member of parliament.

Humor in nicht unfreundlicher Weise, bedingt durch die dargestellt Situation. Das Thema ist Cyril Smith, ein liberaler Parlamentsabgeordneter.

Zuivere humor, in de gegeven situatie zeker niet kwetsend. Cyril Smith is een liberaal lid van het Engelse parlement.

El modelo es el parlamentario Cyril Smith, del Partido Liberal. Humor y buena intención en la situación que representa.

Humour présenté sans méchanceté à cause de la situation. Le sujet est Cyril Smith, député Libéral.

145

Title	"Fat School Teacher"
Photographer	Arch White
Camera	Olympus OM2n
Lens	Tamron 70-210mm zoom
Film	FP4

Although rather posed this shows a touch of humour well executed.

Obgleich es sich eher um eine Pose handelt, ist das Bild humorvoll und gut ausgeführt.

Ook deze geposeerde foto bevat een flinke dosis humor.

Aunque obviamente en pose, tiene un toque de buen humor.

Bien que le personnage ait visiblement posé, cette photo montre une note d'humour bien exécutée.

146 (Upper)

Title	"Panic"
Photographer	Colin Hutchby
Camera	Minolta SRT 101
Lens	28mm Rokkor
Film	Pan F

A pleasing action picture in the modern idiom with the directional lines of the grass opposing those of the figure to enhance the movement.

Angenehmes Bewegungsbild in moderner Form mit den Richtungslinien von Gras im Gegensatz zur Person, um die Bewegung zu verbessern.

Een fraaie actiefoto in een modern idioom, waarbij de richting van de gebogen grassprieten en die van de rennende figuur de beweging versterken.

Atractiva fotografía en la que la acción está expresada con lenguaje moderno; las líneas de dirección de la hierba se oponen a las de la figura y refuerzan la sensación de movimiento.

Une agréable photo en mouvement prise de façon moderne, avec les tiges d'herbe orientées dans le sens opposé aux personnages pour accroître le mouvement.

146 (Lower)

Photographer	Brian Duff
Camera	Nikon F
Lens	50mm
Film	Tri-X

A famous comedy actress, Thora Hird, receiving a practical demonstration from her producer.

Die berühmt Komödiendarstellerin, Thora Hird, die eine praktische Vorführung vom Produzenten erhält.

Thora Hird, een beroemde blijspelactrice, krijgt hier een praktische demonstratie van haar producer.

Thora Hird, la famosa actriz de comedias, recibiendo una demostración práctica de su productor.

Une célèbre actrice de comédie, Thora Hird, recevant une démonstration pratique de son réalisateur.

147

Title	"Last day at school"
Photographer	Vaclovas Straukas

Graduation day in a Russian school is marked by the presenting of a flower and these two students are suitably portrayed in the school corridor.

In einer russischen Schule wird das Abitur durch Überreichen einer Blume gekennzeichnet. Diese beiden Schüler werden entsprechend im Schulkorridor abgebildet.

Op de examendag wordt in Rusland aan de studenten een bloem aangeboden. Deze studenten zijn treffend geportretteerd in de gangen van hun school.

El día de graduación en esta escuela rusa está marcado por la presentación de una flor. Se ha realizado un buen retrato de estos dos alumnos en el corredor del colegio.

Le jour de la remise des diplômes est marqué dans les écoles russes, par l'offre d'une fleur et la photo de ces deux étudiants a été prise, comme il se doit, dans le couloir de l'école.

148

Title	"Dream of Childhood"
Photographer	Vladimir Vitow
Camera	Praktica
Lens	135mm
Film	Foto 130

A thought-provoking picture which has something of the symbolism seen in church frescos. It shows combination printing to good advantage.

Ein zu Gedanken anregendes Bild, das den Symbolismus von Kirchenfresken trägt. Es zeigt einen vorteilhaften Kombinationsabzug.

Een foto die beslist gedachten oproept en die enige gelijkenis vertoont met de symboliek die we in sommige kerkfresco's zien. De combinatiedruk is hier met succes toegepast.

Esta fotografía nos recuerda los grabados de las iglesias y sus simbolismos. Está bien combinada.

Une photo qui donne matière à réflexion et au symbolisme comparable à celui des fresques d'église.

149

Title	"Kathreen"
Photographer	Sjur Roald
Camera	Nikon F Photomic
Lens	105mm Nikkor
Film	Kodak Tri-X

The author has given a touch of originality to a conventional child portrait by employing a close-up in an oblong format and emphasising grain.

Der Fotograf hat einem konventionellen Kinderporträt Originalität verliehen, indem er eine Nahaufnahme im Längsformat vornahm, bei der die Körnung betont wurde.

De fotograaf heeft een op zich conventioneel kinderportret hier op originele wijze aangepakt door de close-up in een liggend formaat te nemen en een grove korrel toe te passen.

Tiene gran originalidad en este retrato convencional de una niña aumentada por el formato rectangular y por la granulación.

L'auteur a donné une note d'originalité à un portrait conventionnel d'enfant en employant un gros plan dans un format rectangulaire et en accentuant le grain.

150

Title	"Blonde"
Photographer	Zinovi Shegelman
Camera	Zenith-E
Lens	133mm
Film	Svema-65

Dramatic contrasts are fashionable today and the idea of a high key face against low keyed backs was very imaginative. The one face turned around justifies all that background.

Drastische Kontraste sind heute modern. Die Idee des hellen Gesichts gegen den dunklen Hintergrund war sehr phantasiereich. Das eine umgedrehte Gesicht rechtfertigt den ganzen Hintergrund.

Dramatische contrasten zijn tegenwoordig erg populair en het idee van een high-key portret tegen een achtergrond van low-key ruggen getuigt van veel fantasie.
Het ene naar de camera toegekeerde gezicht rechtvaardigt de verhoudingsgewijs ruime achtergrond.

Dramático contraste de la moda actual. La idea de destacar la cara por medio de la luz es muy imaginativa. El rostro vuelto justifica todo el entorno posterior.

Les contrastes frappants sont de mode aujourd'hui et l'idée d'un visage expressif se détachant sur l'anonymité des dos était très imaginative. Ce visage tourné vers nous est suffisant pour justifier le décor.

151

Photographer	Guillermo Proaño Moreno
Camera	Pentax SP
Lens	35mm Takumar
Film	FP4

Reversed pictures are rarely satisfactory because of low contrast, but the author has printed this to produce a powerful impact.

Umgekehrt Bilder sind wegen ihres geringen Kontrasts selten zufriedenstellend. Der Fotograf hat dieses jedoch so abgezogen, daß ein starker Eindruck entstand.

Omgekopieerde afdrukken zijn zelden fraai vanwege het lage contrast, maar hier is de fotograaf er toch in geslaagd een sterke beeldwerking te verkrijgen.

Rara vez las fotos invertidas son satisfactorias a causa del débil contraste, pero el autor en esta fotografía ha conseguido un potente efecto.

Les photos inversées sont rarement satisfaisantes à cause du faible contraste, mais l'auteur a tiré celle-ci de façon à produire un puissant effet.

152

Title	"On a Summer's Day"
Photographer	M L Brehant
Camera	Canon F1
Lens	50mm
Film	Tri-X

The solarisation in this picture has produced an effect of winter snow rather than summer sun but it is nevertheless a fine composition well suited to the treatment.

Durch die Sonnenbestrahlung auf diesem Bild entsteht der Effekt von Schnee anstatt von Sommersonne. Es handelt sich trotzdem um eine gute Komposition, die für diese Darstellung sehr geeignet ist.

De solarisatie van deze opname heeft voor een effect gezorgd dat eerder aan sneeuw in de winter dan aan zon in de zomer doet denken; de compositie sluit echter mooi aan op de wijze van afdrukken.

La solarización de esta fotografía ha producido un sol de nieve invernal, en lugar de uno de verano. La composición, no obstante, es adecuada al tratamiento.

La solarisation de cette photo a produit un effet de neige plutôt que de soleil d'été mais c'est néanmoins une excellente composition bien adaptée au traitement.

153

Title	"Der Baum"
Photographer	Wilhelm Hagenberger

The dynamic contrast produced by a stark silhouette against a high key background is very attractive and projects well the atmosphere of winter scenery in the mountains.

Der dynamische Kontrast, der durch eine kräftige Silhouette auf hellem Hintergrund entsteht, ist sehr attraktiv und spiegelt die Atmosphäre von Winterszenen in den Bergen wider.

Het dynamische contrast, dat het resultaat is van een pittig silhouet tegen een high-key achtergrond is bijzonder fraai en brengt de atmosfeer van een winterlandschap in de bergen goed over.

Contraste dinámico, lleno de belleza, entre la fuerte silueta y el entorno invernal de montañas.

Le contraste dynamique produit par une silhouette accentuée sur un fond suggestif est très attrayante et rend bien l'atmosphère des paysages d'hiver en montagne.

154

Title	"Orator"
Photographer	Neale Davison
Camera	Pentax SP2
Lens	200mm Soligor
Film	Tri-X

An action portrait showing imaginative treatment in shading so that viewing is concentrated on the expressive face and the pointing hand.

Bewegungsporträt mit einfallsreicher Darstellung in der Schattierung, so daß sich der Blick auf das ausdrucksvolle Gesicht und die zeigende Hand konzentriert.

Een actieportret waarbij tijdens het afdrukken stevig en met fantasie is doorgedrukt zodat de aandacht van de toeschouwer automatisch gericht wordt op het expressieve gezicht en de wijzende hand.

Para este retrato se ha utilizado un tratamiento muy creativo de las sombras, que obliga a concentrar la vista en la expresión de la cara y la señal que hace la mano.

Un portrait d'action montrant un traitement imaginatif des ombres de façon à concentrer le regard sur le visage expressif et le doigt tendu.

155

Title	"A peasant woman in Cyprus"
Photographer	W O Turnbull
Camera	Leicaflex SL2
Lens	60mm Elmarit-R
Film	FP4

A face with so much intrinsic character that the author only had to apply good technique to make a thought–provoking picture.

Ein Gesicht mit so viel eigenem Charakter, daß der Fotograf nur mit guter Technik arbeiten mußte, um ein gedankenvolles Bild zu erzielen.

Bij deze foto hoefde de fotograaf slechts te zorgen voor een technisch goede opname om de zeggingskracht te kunnen overbrengen.

Tiene esta cara tanta personalidad intrínseca, que el autor sólo ha tenido que utilizar una táscnica buena para obtener una fotografía que invita a la reflexión.

Un visage qui a tant de caractère en lui-même que l'auteur n'a eu qu'à appliquer une bonne technique pour produire une photo qui fait réfléchir.

156

Title	"Nagie"
Photographer	Frank Peeters
Camera	Nikon F2A
Lens	20mm
Film	Tir-X

An original treatment of a portrait made even more striking by the severe though appropriate, background.

Originaldarstellung eines Porträts, die durch den gleichmäßigen und doch zutreffenden Hintergrund noch interessanter wird.

Een originele benadering van de portret-fotografie, mede door de harde en toch niet onjuiste achtergrond.

Aunque apropiado, el severo entorno de esta retrato se ve aumentado por el tratamiento que se le ha aplicado.

Traitement original d'un portrait rendu encore plus frappant par le fond sévère mais approprié.

157

Photographer	Steve Templeman
Camera	Nikon FM
Lens	70-210mm Vivitar zoom
Film	HP5

Champion Olympic swimmer Duncan Goodhew, pictured in action and from a viewpoint which has produced an attractive composition and heightened the sense of movement and effort.

Olympia-Sieger Duncan Goodhew, hier beim Schwimmen und aus einer Sicht abgebildet, durch die eine attraktive Komposition entstand, unterstrichen durch ein Gefühl von Bewegung und Anstrengung.

Olympisch zwemkampioen Duncan Goodhew, in volle actie gefotografeerd vanaf een standpunt dat tot deze aantrekkelijke compositie leidde en dat belangrijk was voor het verkrijgen van het juiste gevoel van beweging en inspanning.

Duncan Goodhew campeón Olímpico de Natación, fotografiado en acción y desde un punto de vista que crea una atractiva composición y aumenta el sentido de movimiento y esfuerzo.

Le champion olympique de natation Duncan Goodhew, pris dans l'action et sous un angle qui a produit une composition agréable et augmenté l'impression de mouvement et d'effort.

158

Title	"Daddy's Toes"
Photographer	Marko Moisio
Camera	Canon A-1
Lens	35mm FD
Film	Tri-X

Typical of much of the modern approach to portraiture adopted by the leading Finnish photographers. There is no question of "waiting for a smile".

Typisch für die moderne Einstellung zu Porträts bei führenden finnischen Fotografen. Auf ein Lächeln wird nicht mehr gewartet.

Deze foto is typerend voor de moderne benadering die door de vooraanstaande Finse fotografen bij portretwerk wordt gehanteerd. 'Wachten op een glimlach' is er niet bij.

Típico de la forma moderna que se ha adoptado para hacer retratos en Finlandia. Un hay por qué "esperar una sonrisa".

Typique de la démarche moderne adoptée vis-à-vis du portrait par les grands photographes Finlandais. Il n'est pas question d' "attendre un sourire".

159

Photographer	Stanley Matchett
Camera	Nikon FE
Lens	80-200mm zoom
Film	HP5

Television's Mr Balloon – Trevor Little who tips the scales at 22 stone shows a local child how to keep fit in Belfast.

Trevor Little, der aus dem Fernsehen bekannte Herr Ballon, der fast drei Zentner auf die Waage bringt, zeigt einem Kind in Belfast, wie man sich fit hält.

Mr. Balloon, bekend van de Engelse televisie (Trevor Little), gewicht 140 kilo, toont een meisje in Belfast hoe je fit moet blijven.

El señor Globo de la televisión. Trevor Little, que casi pesa 140 kilos, está enseñando a una niña de Belfast cómo mantenerse en forma.

(La vedette de télévision Mr Balloon – Trevor Little qui fait passer l'aiguille de la balance à 140 kilos montre à un enfant local comment garder la forme à Belfast).

160

Photographer	Pedro Luis Raota
Camera	Hasselblad
Film	Kodak 400

A happy interpretation of a subject once 'taboo' and the remarkably attractive lighting within as well as through the window is very artistic. The birds add to a very evocative message.

Glückliche Interpretation eines Themas, das früher tabu war. Die bemerkenswert attraktive Beleuchtung im Fenster und durch das Fenster ist sehr künstlerisch. Die Vögel verstärken eine Aussage mit starkem Erinnerungswert.

Een vrolijke interpretatie van een onderwerp dat eens taboe was; de verlichting is bijzonder fraai. De aanwezigheid van de vogels verleent de foto een extra boodschap.

Una buena interpretación de un tema que se consideraba "tabú". Tanto la bellísima luz del interior como la que atraviesa la ventana son muy artísticas. Los pájaros le añaden un mensaje evocador.

Une interprétation heureuse d'un sujet autrefois "tabou" et l'éclairage extrêmement agréable aussi bien à l'intérieur qu'à travers la fenêtre est très artistique. Les oiseaux contribuent à donner un message très évocateur.

161

Title	"Strip"
Photographer	Henning Skytte
Camera	Hasselblad
Lens	80mm
Film	Kodak

A touch of humour in a promotional (?) shot beautifully executed and original in presentation.

Eine Werbeaufnahme (?) mit Humor, gut ausgeführt und originell in der Darstellung.

Een beetje humor in een reclamefoto (?), prachtig uitgevoerd en origineel gepresenteerd.

¿Un toque de humor en una foto de promoción? La presentación es muy original.

Une note d'humour dans une photo promotionnelle (?) merveilleusement exécutée et de présentation originale.

162 (Upper)

Title	"Virginia and Desiree"
Photographer	Peter Dainty
Camera	Zenith EM
Lens	44mm Helios
Film	Kodacolor II 100ASA

Happy childhood executed with immaculate technique and a good composition.

Glückliche Kinder, in ausgezeichneter Technik und guter Komposition ausgeführt.

Een vrolijke kinderfoto, technisch onberispelijk uitgevoerd, met een goede compositie.

La belleza de la niñez. La técnica es inmaculada y la composición muy buena.

Photo de l'enfance heureuse exécutée avec une technique parfaite et une bonne composition.

162 (Lower)

Photographer	Ramon Riu Martinez
Camera	Konika T3
Lens	35-100mm zoom
Film	Fujicolor F11 400ASA

There is such a variety of expressions on these faces that the picture demands a long look and the teacher provides the focal point.

Diese Gesichter sind so ausdrucksvoll, daß man sich das Bild lange ansehen muß. Die Lehrerin sitzt im Brennpunkt.

Op deze foto is een zo groot aantal gezichtsuitdrukkingen te zien dat je er lang naar blijft kijken; de onderwijzeres vormt het hoogtepunt van de aandacht.

Es tal la variedad de expresiones en las caras, que se la ha de mirar largamente. La maestra constituye el centro de interés.

Il y a une telle diversité d'expressions sur ces visages que la photo exige qu'on s'y arrête et la maîtresse fournit le point de convergence.

163

Title	"A pink"
Photographer	Veikko Wallström
Camera	Nikon FE
Lens	Nikkor 43-86mm zoom
Film	Ektachrome 64

A very dramatic portrait study full of meaning and given life by the carnation.

Dramatische Porträtstudie voller Bedeutung, die durch die Nelke Leben erhält.

Een zeer dramatische portretstudie, verlevendigd door de bloem.

Un retrato dramático de un estudio lleno de significado, al que el clavel le da vida.

Un portrait très théâtral plein de sens et rendu vivant par l'oeillet.

164

Title	"Harvest Man!"
Photographer	Ron Lovesey
Camera	Pentax
Lens	50mm
Film	Kodachrome 25 and Fujichrome sandwiched.

A multiple image picture which is almost horrific but carrying an important message.

Ein aus mehreren Aufnahmen bestehendes Bild, das fast erschreckend ist, jedoch eine wichtige Aussage hat.

Een combinatie van twee dia's die nogal beangstigend aandoet en een belangrijke boodschap bevat.

Una fotografía de imagen múltiple, de efecto horripilante, pero portadora de un importante mensaje.

Un photo composée de plusieurs images qui est presque horrible mais porteuse d'un message important.

165 (Upper)

Photographer	Erik Steen
Camera	Nikon F2
Lens	35mm
Film	Kodak Ektacolor

An artistically composed picture showing a good choice of viewpoint and an attractive colour composition.

Ein künstlerisch komponiertes Bild aus einem gut gewählten Blickpunkt, in attraktiver Farbkomposition.

Een artistiek gecomponeerde opname, met een goede standpuntkeuze en een aantrekkelijke kleurcompositie.

Una fotografía artísticamente compuesta, con un punto de vista bien escogido y una atractiva composición de colores.

Une photo artistiquement composée qui montre un bon choix de l'angle et une agréable composition des couleurs.

165 (Lower)

Title	"Caramelos de Coco"
Photographer	Domingo Batista
Camera	Canon F1
Lens	135mm
Film	Ektachrome 64

Wide angle lenses and low viewpoints invariably add drama to a landscape and this is a good example.

Weitwinkelobjektive und niedrige Blickpunkte verleihen einer Landschaft zweifellos Interesse. Dies ist ein gutes Beispiel.

Door het gebruik van een groothoekobjectief en het innemen van een laag standpunt maakt men landschapopnamen vrijwel automatisch dramatischer: hier ziet u een sterk voorbeeld.

Un buen ejemplo del dramatismo que confiere la utilización de objetivos gran angulares y de puntos de vista bajos para las fotografías de paisajes.

Les objectifs grand angle et les angles bas rendent invariablement les paysages spectaculaires et ceci en est un bon exemple.

166

Photographer	Kevin Peschke
Camera	Olympus OM1
Lens	17mm Tamron
Film	Kodacolor 400

A photograph with a very harmonious colour composition and a remarkable impression of depth due to the wide angle lens employed.

Ein Foto mit sehr harmonischer Farbkomposition und eindrucksvollem Eindruck von Tiefe durch das verwendete Weitwinkelobjektiv.

Een opname met een zeer harmonieuze kleurcompositie en een opmerkelijke diepteindruk, dank zij het gebruik van een groothoeklens.

Fotografía con una armoniosa composición de color. El uso de un objetivo gran angular incrementa la sensación de profundidad.

Photographie d'une composition des couleurs très harmonieuse et d'une impression de profondeur remarquable qui a été obtenue par l'objectif grand angle.

167

Title	"Nepal Landscape"
Photographer	Dr Leo K K Wong
Camera	Hasselblad
Lens	120mm
Film	Kodacolor II

Plane separation by layers of mist gives this beautiful landscape a touch of Oriental art.

Die Trennung verschiedener Ebenen durch Nebelschichten verleiht dieser herrlichen Landschaft einen Anstrich orientalischer Kunst.

De luchtperspectief, veroorzaakt door de verschillende mistlagen, geeft dit prachtige landschap een oosters trekje.

La separación de los planos por medio de la niebla da a este hermosísimo paisaje un toque del arte oriental.

La séparation des plans par des couches de brume donne à ce beau paysage une note d'art oriental.

168 (Upper)

Title	"Rosie Casals"
Photographer	Steve Yarnell
Camera	Nikon FM
Lens	135mm
Film	Kodak Ektachrome-200 Professional

A dramatic action picture with an expression that tells all. The background is well held.

Dramatisches Bewegungsbild mit einem Ausdruck, der alles besagt. Der Hintergrund ist gut gehalten.

Een dramatische actiefoto: de expressie op het gezicht van de speelster is een verhaal op zich. De achtergrond is precies goed.

Toda la acción dramática de esta fotografía está contenida en la expresión. El entorno está bien elegido.

Une photo d'action spectaculaire avec une expression qui dit tout. Le fond est bien soutenu.

168 (Lower)

Photographer	Paul McMullin
Camera	Hasselblad
Lens	150mm
Film	Kodacolor 400

Action becomes artistry when there is so much movement that only the idea is expressed.

Bewegung wird zur Kunst, wenn so viel vorhanden ist, daß nur eine Idee zum Ausdruck kommt.

Actie wordt kunst als er zoveel beweging in een opname zit dat er vooral een idee wordt overgebracht.

La acción se convierte en una obra artística cuando existe tanto movimiento que sólo se expresa la idea.

L'action devient un artifice: le mouvement est tel que seule l'idée est exprimée.

169

Photographer	Duncan Raban
Camera	Nikon F3
Lens	300mm
Film	Kodachrome 25ASA

A splendid action picture of Ann Maria Carassio, a trick skiing champion, which shows fine timing and a lot of atmosphere as well as an excellent composition enhanced by the out-of-focus background.

Ausgezeichnetes Bewegungsbild von Ann Maria Carassio, Meisterin im Trickskilaufen, das gute Zeiteinstellung und viel Atmosphäre hat sowie eine ausgezeichnete Komposition, verbessert durch den verschwommenen Hintergrund.

Een uitstekende actiefoto van Ann Maria Carassio, kampioene stuntskiën, waarvoor perfecte timing, goede sfeeroverdracht en een fraaie compositie het succes bepalen dat nog wordt versterkt door de enigszins onscherpe achtergrond.

Espléndida fotografía de Ann Maria Carassio, campeona de esquí de espectáculo, en plena acción. Excelente captación del momento adecuado y de la atmósfera, así como una soberbia composición realzada por el hecho de que los planos lejanos estén desenfocados.

Une splendide photo d'action d'Ann Maria Carassio, champion de ski, qui est bien calculée, avec beaucoup d'atmosphère ainsi qu'une excellente composition rehaussée par le flou du fond.

170

Photographer	F Karikese
Camera	Nikomat EL
Lens	50mm Nikkor
Film	5 x 4in Ektachrome

A fashion picture with a difference! An original idea and a superb presentation.

Ein Modebild einmal ganz anders. Eine originelle Idee mit erstklassiger Präsentation.

Een buitengewone mode-opname. Een origineel idee en een uitstekende presentatie.

¡La moda con diferencia! Una idea original y una presentación exquisita.

Une photo de mode pas comme les autres! Idée originale et présentation superbe.

171 (Upper)

Photographer	Kevin Peschke
Camera	Sinar 8 x 10in
Lens	360mm
Film	E6
Lighting	Strobe flash

A very bold approach which demands attention, and the close cropping is very effective.

Eine sehr starke Lösung, die Aufmerksamkeit heischt. Der knappe Schnitt ist sehr wirksam.

Een bijzonder krachtige aanpak die de aandacht trekt; de krappe uitsnede is zeer effectief.

Un atrevido enfoque, que llama la atención por la efectividad del encuadre.

Une approche très audacieuse qui demande qu'on s'y arrête, et la proximité produit un effet certain.

171 (Lower)

Photographer	Forrest Smyth
Camera	Pentax MX
Lens	Vivitar 70-210mm zoom
Film	Kodachrome-64
Process	Colour separations and copy made on rostrum camera.

An ingenious double printing which is a technical achievement, very well carried out, and it carries a message which can be read in different ways according to the viewers' imagination and attitudes.

Genialer Doppelabzug, der einen technischen Erfolg darstellt. Gut ausgeführt, mit Aussage, die je nach Vorstellungskraft und Einstellung des Betrachters auf verschiedene Weise ausgelegt werden kann.

Deze ingenieuze dubbeldruk is een technisch hoogstandje. De interpretatie is afhankelijk van de instelling en het voorstellingsvermogen van de toeschouwer.

Una doble impresión llena de ingenio que constituye una notable hazaña técnica. Conduce un mensaje que quienes vean esta obra pueden interpretar de diversas formas, según su imaginación y actitud mental.

Un double tirage ingénieux qui est une prouesse technique et qui porte un message pouvant être lu de différentes façons en fonction de l'imagination et de l'attitude de l'observateur.

172

Title	"Kingfisher"
Photographer	Fritz Pölking
Camera	Olympus OM-2
Lens	Zuiko 4/200 mm
Film	Agfa Prof

An ever popular subject is given added interest by being caught in flight with its prey.

Ein immer beliebtes Thema erhält zusätzliches Interesse, wenn es im Flug mit der Beute aufgenommen wird.

Een altijd gewaardeerd maar zeer moeilijk onderwerp: deze opname is extra interessant doordat de vogel in de vlucht werd gefotografeerd met zijn prooi in de bek.

Tema popular de siempre, con el interesante añadido de la fuga con la presa.

Un sujet toujours très populaire dont l'intérêt est accru par la prise en plein vol avec sa proie.

173

Title	"Barn Owl Chicks"
Photographer	Robert Hallman
Camera	Hasselblad
Lens	85mm
Film	Agfa 50S

The eternal appeal of the very young is well recorded here, and with excellent technique.

Das ewige Interesse an sehr jungen Lebewesen ist hier sehr gut aufgenommen, mit ausgezeichneter Technik.

De aantrekkingskracht van foto's van jonge dieren wordt met deze opname weer eens bevestigd; de techniek is excellent.

El eterno atractivo de la juventud ha quedado bien grabado aquí, además, con una técnica excelente.

L'attrait qu'exerce inmanquablement les jeunes animaux est ici très bien traduit grâce à une technique excellente.

174

Title	"Motocross"
Photographer	David Lau Chi Wai

This is reminiscent of an oriental landscape with dust replacing mist and motor cycles replacing hills and trees. A beautiful design and full of movement.

Dieses Bilder innert an eine Landschaft im Orient, wo Staub den Nebel ersetzt und die Motorräder Hügel und Bäume. Ausgezeichnete Form, voller Bewegung.

Hoewel dit een sportfoto is doet hij vooral denken aan een opname van een oosters landschap, waarbij het stof de nevel vervangt en de motorfietsen de heuvels en de bomen. Een prachtige compositie, vol met beweging.

Reminiscencia del paisaje oriental; polvo en lugar de la neblina y motocicletas en lugar de colinas y árboles. Un diseño de gran movimiento.

Cette photo rappelle un paysage oriental dans lequel la poussière remplace la brume et les motos remplacent les arbres et les collines. Une belle disposition pleine de mouvement.

175

Title	"Action"
Photographer	Etienne Desmet
Camera	Nikon F2AS
Lens	35mm Nikkor
Film	Agfa

The drama of the upset motor cyclist is brilliantly framed by the riders and backlighting has provided plenty of atmosphere.

Das Drama eines gestürzten Motorradfahrers wird von den Fahrern brilliant umrahmt, und Gegenlicht schafft ausreichend Atmosphäre.

Het drama van de in moeilijkheden geraakte motorrijder wordt prachtig omlijst door de andere in het beeld aanwezige personen; door het tegenlicht wordt extra sfeer gecreëerd.

El drama del motociclista está brillantemente expresado por los otros corredores, y la iluminación a contraluz le proporciona todo el ambiente necesario.

Le drame du motocycliste renversé est brillamment encadré par les autres conducteurs et l'éclairage à contre-jour donne beaucoup d'atmosphère.

176

Photographer	Kevin Peschke
Camera	Olympus OM-1
Lens	100mm Zuiko
Film	GAF-500

Sunsets are always pleasing but so common a subject that to be successful a picture must have the striking form and colour composition seen here.

Sonnenuntergänge sind stets angenehm, jedoch ein so allgemeines Thema, daß ein erfolgreiches Bild die interessante Form und Farbkomposition aufweisen muß, die hier zu sehen ist.

Een zonsondergang doet het altijd goed maar om eruit te kunnen springen moet de foto een opvallende vormgeving en kleurcompositie hebben.

Las puestas de sol son siempre agradables; mas para que un tema corriente tenga éxito, ha de tener la sorprendente forma y composición de colores como la que se ven aquí.

Les couchers de soleil sont toujours agréables mais c'est un sujet si commun que pour réussir, la photo doit avoir la forme et la composition de couleurs frappantes que nous voyons ici.

177

Title	"The Duke of Wellingtons"
Photographer	Dave Hartley
Camera	Nikon F2 plus motor drive
Lens	85mm Nikkor
Film	HP5

A very unusual picture of H R H Prince Philip showing how he was feeling about the rain and mud that had cancelled the day's sport.

Ein sehr ungewöhnliches Bild von Seiner Königlichen Hoheit, Prinz Philip, das zeigt, was er vom Regen und Schlamm hält, der das Sportereignis des Tages verhinderte.

Een zeer bijzondere opname van Zijne Koninklijke Hoogheid Prins Philip die duidelijk laat zien wat zijn gevoelens waren toen hij door de modder en de regen liep, die zijn sportieve plannen voor die dag dwarsboomden.

Una fotografía fuera de lo corriente en la que se muestra a Su Alteza Real, el Príncipe Felipe, expresando lo que sentía cuando se había cancelado un día de deportes a consecuencia de la lluvia y el barro.

Une photo très insolite de Sa Majesté le Prince Philip qui montre ses sentiments vis-à-vis de la pluie et de la boue qui ont provoqué l'annulation de la journée sportive.

178/179

Title	"Moody Guy"
Photographer	Stephen Shakeshaft
Camera	Nikon F2
Lens	200mm
Film	Tri-X

Of the many pictures of John McEnroe this is one of the best in expressing his temperamental attitude to line decisions with which he does not agree. The supressed background detail suggests his loneliness.

Von den vielen Bildern von John McEnroe ist dies eines der besten, das sein temperamentvolles Verhalten zu Entscheidungen des Linienrichters ausdrückt, mit denen er nicht einig geht. Das unterdrückte Hintergrunddetail läßt Einsamkeit vermuten.

Dit is een van de beste foto's die van John McEnroe werden gemaakt; zijn temperament en zijn gedrag ten aanzien van beslissingen van scheidsrechter komen er goed in tot uiting. De eenvoudige achtergrond legt de nadruk op zijn eenzaamheid.

De las fotografías de John McEnroe, ésta es una de las que mejor expresa su actitud temperamental para debatir las decisiones con las que no está de acuerdo. Se sugiere la soledad por medio de la omisión de los detalles del entorno posterior.

Parmi les nombreuses photos de John McEnroe, c'est une de celles qui parvient le mieux à exprimer ses réactions capricieuses devant les décisions de l'arbitre qu'il désapprouve. La suppression des détails du fond suggère sa solitude.

180

Title	"Flying the Flag"
Photographer	Mervyn Rees
Camera	Nikon F2
Lens	300mm Nikkor
Film	Tri-X

International Gymnast Susan Cheesebrough beautifully held at the high point of the action.

Die internationale Turnerin Susan Cheesebrough, die hier herrlich auf dem Höchstpunkt der Bewegung festgehalten ist.

Internationaal topturnster Susan Cheesebrough gefotografeerd op het hoogtepunt van de actie.

La gimnasta internacional Susan Cheesebrough, bellísimamente tomada en plena acción.

La gymnaste internationale Susan Cheesebrough admirablement saisie au sommet de l'action.

181

Title	"What a Save!"
Photographer	Stephen Shakeshaft
Camera	Nikon F2
Lens	85mm Nikkor
Film	Tri-X

Joe Corrigan of Manchester City saves an attempt at goal by Kenny Dalglish of Liverpool. An outstanding sports picture.

Joe Corrigan von Manchester City rettet den Ball von Kenny Dalglish, Liverpool. Ein ausgezeichnetes Sportbild.

John Corrigan van Manchester City treedt reddend op bij een poging tot scoren van Kenny Dalglish van Liverpool. Een excellente sportfoto.

Joe Corrigan, del Manchester City, salva el intento de gol que había hecho Kenny Dalglish, del Liverpool. Una excelente fotografía deportiva.

Joe Corrigan de Manchester City rattrappe un essai de but par Kenny Dalglish de Liverpool. Une remarquable photo sportive.

182

Title	"Envious"
Photographer	Luis Placido Lopez Caballero
Camera	Nikon F2A
Lens	55mm Nikkor
Film	Tri-X

A thought-provoking and very natural portrait which fully expresses the longing suggested by the title.

Ein zum Denken anregendes, sehr natürliches Porträt, das die Sehnsucht voll zum Ausdruck bringt, von der der Titel spricht.

Dit natuurlijke portret doet het verlangen van het kind duidelijk uitkomen.

Un retrato muy natural que evoca la idea expresada por el título.

Un portrait très naturel qui donne à réfléchir et qui exprime la convoitise suggérée par le titre.

183

Photographer	Pedro Luis Raota
Camera	Hasselblad
Film	Kodak 400

Full advantage has been taken of studio lighting to concentrate attention on the faces and to produce a very pleasing tone scheme with remarkably good modelling.

Die Studiobeleuchtung wurde voll genutzt, um die Aufmerksamkeit auf die Gesichter zu konzentrieren und ein sehr angenehmes Tonsystem bei bemerkenswert guter Modellierung zu erzielen.

Hier is optimaal gebruik gemaakt van de mogelijkheden van studioverlichting om de aandacht op de gezichten te concentreren en een fraaie verdeling van de toonwaarden te krijgen.

Se ha sacado toda la ventaja de la iluminación del estudio para centrarla en las caras, y así producir una escala de tonos agradable y excelente modelación.

L'auteur a profité au maximum de l'éclairage de studio pour concentrer l'attention sur les visages et produire un ensemble de tons très agréables avec une répartition excellente des volumes.

184/185 (Upper)

Title	"Galina Samsova in Swan Lake"
Photographer	Denis Thorpe
Camera	Leica M3
Lens	50mm Summicron
Film	HP5
Lighting	Normal stage lighting

Almost a reverse of the picture below, this also relies on a simple background, a repetitive pattern and a "letter box" format to give an original effect.

Fast das Gegenteil des vorstehenden Bildes. Es beruht auch auf einem einfachen Hintergrund, einem sich wiederholenden Bild und "Briefkastenformat", um einen originellen Effekt zu erzielen.

Deze foto lijkt in vergelijking met de bovenstaande een negatief te zijn; de simpele achtergrond, het herhalingseffect en het 'brievenbusformaat' geven de opname een origineel effect.

Casi el contratrio que la fotografia anterior, ésta se apoya en la sencillez del entorno. El efecto original se logra por medio del formato "buzón de correos" y la repetición del diseño.

Cette photo qui est presque l'opposé de la photo ci-dessus, dépend aussi d'un fond simple avec un motif répétitif et un format "boîte à lettres" pour donner un effet original.

184/185 (Lower)

Photographer	Stanislav Barkov

The deliberate elimination of detail in the snow has given emphasis to the attractive pattern formed by the skiers. The "letter box" format complements the design.

Durch bewußte Fortlassung von Details im Schnee wurde das attraktive Bild der Skiläufer unterstrichen. Das "Briefkastenformat" ergänzt die Form.

Het opzettelijk weglaten van details in de sneeuw benadrukt het interessante patroon dat door de skiërs wordt gevormd. Ook hier is het aparte opnameformaat belangrijk voor de compositie.

La deliberada omisión de los detalles sobre la nieve aumenta el atractivo diseño formado por los esquiadores. También el formato de "buzón de correos" complementa la composición.

L'élimination voulue des détails dans la neige souligne le motif séduisant formé par les skieurs. Le format "boîte à lettres" s'harmonise avec la composition.

186 (Upper)

Photographer	S. Paul
Camera	Nikon F2
Lens	80-200mm f4.5 zoom Nikkor (80mm setting)
Film	Ilford HP5

Pictures in the rain often have a slightly humorous effect but the size of the umbrella makes this example really funny and original while not losing the gloomy atmosphere.

Regenbilder haben häufig humorvolle Wirkung, jedoch wird dieses Bild durch die Größe des Schirmes wirklich komisch und originell, obgleich die düstere Atmosphäre nicht verloren geht.

Vaak zijn in de regen gemaakte foto's enigszins humoristisch; het geldt zeker voor deze originele foto met de overmaatse paraplu.

Las fotografías en la lluvia suelen tener tono humorístico; el tamaño del paraguas hace que ésta sea realmente graciosa, siempre dentro de la tristeza del día lluvioso.

Les photos sous la pluie ont souvent un effet légèrement humoristique mais la taille du parapluie rend cet exemple vraiment comique et original sans pour autant éliminer l'atmosphère lugubre d'un jour de pluie.

186 (Lower)

Photographer	Erwin Kneidinger
Camera	Nikon
Lens	28mm f3.5
Film	Ilford HP5 400ASA

A most unusual picture which by eliminating the detail of the face has concentrated on the smile which is so typical of coloured youngsters while the hat completes a composition and balances so much black.

Ein äußerst ungewöhnliches Bild, das sich durch Ausschluß des Gesichtsdetails auf das Grinsen konzentriert, das für farbige Jugendliche so typisch ist, während der Hut die Komposition ergänzt und einen Ausgleich für das viele Schwarz darstellt.

Een zeer ongewone foto, waarin door details in het gezicht weg te laten de aandacht wordt gevestigd op de lach die juist door de donkere huidkleur zo opvalt. De hoed rondt de compositie af en is een fraai tegenwicht voor al te veel zwart.

Una fotografía original en la que se han eliminado los detalles de la cara para destacar la sonrisa típica de los jóvenes de color. El sombrero completa la composición y equilibra la gran cantidad de negro.

Une photo extrêmement insolite qui par l'élimination des détails du visage concentre l'attention sur le sourire, si typique des enfants de couleur, tandis que le chapeau complète la composition et équilibre toutes les zones noires.

187

Title	"Zeitung"
Photographer	Peter Hense
Camera	Nikon F2A
Lens	50mm Nikkor
Film	Tri-X

Situations such as this always tickle the sense of humour when they are not contrived and the animals are not made to look foolish. Nicely seen.

Situationen wie diese regen zum Lächeln an, wenn sie nicht gestellt sind und die Tiere nicht albern aussehen. Gut beobachtet.

Foto's als deze spreken ons gevoel voor humor aan als ze niet al te overdreven aandoen en als de benadering oprecht is. Goed gezien.

Siempre que se disfrute de buen humor y no se haga a aparecer a los animales como atontados, estas situaciones suelen ser bastante graciosas. Es una buena fotografía.

Des situations comme celles-ci éveillent toujours notre sens de l'humour quand elles ne sont pas artificielles et qu'on ne fait pas paraître les animaux stupides. Bien vu.

188

Title	"Socialist Speaker"
Photographer	Douglas Corrance
Camera	Nikon FE
Lens	20mm
Film	Tri-X

An action picture of a street corner orator "sending himself" is given extra interest by the inclusion of an amused spectator well placed to make a good composition.

Das Bewegungsbild eines Redners an der Straßenecke, der sich "gesandt fühlt", erhält zusätzliches Interesse durch Einschluß eines amüsierten Zuschauers, der richtig da steht, um eine gute Komposition zu erzielen.

Een actiefoto van een spreker op een straathoek die extra inhoud krijgt door de geamuseerde toeschouwer die precies op de goede plaats staat voor een goede compositie.

Un orador efusivo en plena acción. Se le ha añadido interés adicional y equilibrio a la composición al incluir al divertido espectador.

Un orateur de rue "s'écoutant parler"; l'intérêt de la photo est réhaussé par la présence du spectateur amusé qui équilibre la composition.

189

Title	"Scottish Nationalist Meeting —Inverness"
Photographer	Douglas Corrance
Camera	Nikon FE
Lens	35mm
Film	Tri-X

A picture taken at a Scottish Nationalist meeting which shows the intensity of the orator contrasted with the apparent indifference of the audience.

Ein Bild, das auf der Tagung der schottischen Nationalisten aufgenommen wurde, das die Intensität des Redners darstellt und als Kontrast das offensichtliche Desinteresse der Zuhörer.

Op deze foto vormen de inzet en de ernst van de spreker een opvallend contrast met de duidelijk nogal onverschillige houding van het publiek.

Tomada durante un mitin de los nacionalistas escoceses, la intensidad del orador contrasta grandemente con el desinterés aparente de la audiencia.

Photo prise lors d'une réunion du Parti Nationaliste Ecossais qui montre l'intensité de l'orateur contrastée avec l'indifférence apparente de l'auditoire.

190

Photographer	Brand Overeem
Camera	Hasselblad
Lens	150mm
Film	FP4

A delightful group which begs a question. What was the nun with the almost ecstatic expression saying to the others?

Eine reizende Gruppe, die dem wahren Sachverhalt ausweicht. Was sagte die Nonne mit dem fast ekstatischen Ausdruck zu den anderen?

Een prachtige groepsfoto met een vraag: Wat zei de non met de bijna extatische gezichts-uitdrukking tegen de andere?

Un gracioso grupo obliga a que nos preguntemos qué estaba diciendo la monja con expresión de éxtasis a las otras.?

Un groupe charmant qui suscite une question: que disait aux autres la Soeur à l'expression presque extatique?

191

Photographer	Denis Englefield
Camera	Olympus OM-1
Lens	70-150mm Zuiko zoom
Film	HP5 rated at 650ASA

This shot of a nun throwing a sponge for charity at a local fête is an example of illustrative photography at its best – good lighting, good viewpoint and good composition.

Dieser Schnappschuß einer Nonne, die auf einem Heimatfest für einen wohltätigen Zweck mit dem Schwamm wirft, ist ein Beispiel für illustrierende Fotografie in bester Qualität – gute Beleuchtung, guter Blickpunkt und gute Komposition.

Deze opname van een non die tijdens een spel op een liefdadigheidsbijeenkomst met een spons gooit is een voorbeeld van verhalende fotografie op haar best – goede verlichting, goed standpunt en een goede compositie.

Esta toma de una monja tirando una esponja por caridad durante una fiesta local es un buen ejemplo de las mejores fotografías de ilustración: buena iluminación, buen punto de vista y buena composición.

Cette photo d'une Soeur jetant une éponge pour une oeuvre de bienfaisance à une kermesse locale est un excellent exemple de photographie illustrative: bon éclairage, bonne prise de vue et bonne composition.

192

Title	"Royal Smiles"
Photographer	Howard Walker
Camera	Nikon F3
Lens	80-200mm zoom
Film	Tri-X

One of the pictures of the Prince and Princess Of Wales which was not so widely published as those of The Wedding, but it is full of unaffected charm.

Eines der Bilder vom Prinzen und von der Prinzessin von Wales, das nicht so stark veröffentlicht wurde wie die Hochzeitsbilder, jedoch voll von natürlichem Charme ist.

Deze foto van de Prins en de Prinses van Wales is niet zo veel gepubliceerd als die van hun huwelijk maar hij heeft een natuurlijke charme.

Una fotografía de los Príncipes de Gales que no ha sido tan publicada como las de la Boda Real, aunque tiene su propia gracia natural.

L'une des photos du Prince et de la Princesse de Galles qui n'a pas été aussi publiée que celles du Mariage mais elle est pleine de charme et de naturel.

193

Title	"The Kiss"
Photographer	Ron Burton
Camera	Nikon
Lens	1000mm
Film	Tri-X

Probably the most famous of all the Royal Wedding pictures. Taken with a 1000mm lens from the Victoria statue opposite Buckingham Palace.

Wahrscheinlich das berühmteste aller königlichen Hochzeitsfotos. Aufnahme mit einem 1000-mm-Objektiv von der Statue der Königin Victoria gegenüber dem Buckingham Palast.

Waarschijnlijk de beroemdste van alle foto's van de Royal Wedding. Opgenomen met een 1000 mm objectief, vanaf het Victoria standbeeld, tegenover Buckingham Palace.

De todas las fotografías de la Boda Real, es ésta probablemente la más famosa. Fue tomada con un objetivo de 1000mm desde la estatua de Victoria, delante del Palacio de Buckingham.

C'est probablement la plus célèbre de toutes les photos du Mariage Princier prise avec un objectif 100mm depuis la statue de Victoria en face de Buckingham Palace.

194

Title	"Old Couple"
Photographer	Boo Gil Choi
Camera	Nikon FE
Lens	35mm
Film	Tri-X

A sympathetic treatment of peasants in old age contrasted with the timeless quality of an unusual landscape.

Sympathische Aufnahme von alten Bauern im Kontrast zur zeitlosen Qualität einer ungewöhnlichen Landschaft.

De fotograaf heeft deze oude boeren op sympathieke wijze gefotografeerd in een contrasterend en vreemd aandoend landschap.

El tratamiento que ha recibido muestra la lástima que se siente hacia los campesinos ancianos, que con el paisaje poco corriente expresan una calidad eterna.

Traitement sympathique de vieux paysan en contraste avec la sérénité éternelle d'un paysage insolite.

195

Photographer	S Paul
Camera	Nikon EL
Lens	24mm f2.8 Nikkor
Film	Orwo NP 55

Low viewpoints are popular today but this picture "bucks the trend" with a high viewpoint that makes the most of the curve in the road in order to suggest depth and space.

Niedrige Gesichtspunkte sind häufig beliebt, jedoch unterstreicht dieses Bild die Tendenz durch einen hohen Gesichtspunkt, die den größten Teil der Straßenkurve darstellt, um Tiefe und Weite zu suggerieren.

Lage standpunten zijn erg populair maar deze opname gaat dwars tegen de trend in. Door het hoge opnamestandpunt komt de bocht in de weg beter uit waardoor diepte en ruimte beter worden gesuggereerd.

Los puntos de vista bajos tienen gran popularidad actualmente, pero esta foto las supera; por su punto de vista alto, la curva de la carretera sugiere la idea de espacio y profundidad.

Les angles de vision bas sont populaires actuellement mais cette photo reverse la tendance en repoussant la ligne d'horizon pour donner l'accent à la courbe de la route, créant ainsi une impression de profondeur et d'espace.

196

Title	"The Umbrella"
Photographer	R G Curtis
Camera	Olympus OM1
Lens	24mm Zuiki f/2.8
Film	FP4

The sheer simplicity, amounting to starkness and daring, seen in this picture won a place for itself at the London Salon of Photography.

Die reine Einfachheit dieses Bildes, die Stärke und Mut beweist, errang sich einen Platz auf dem Londoner Salon of Photography.

Alleen al vanwege de pure eenvoud, het resultaat van een gedurfde aanpak, kreeg deze foto een speciale plaats op de London Salon of Photography.

Esta fotografía destacó en el salón de fotografía londinense por su gran sencillez lograda por los oscuros atrevidos.

La simplicité même de cette photo lui donne une rigueur audacieuse qui lui a valu de se classer parmi les meilleurs clichés au Salon de la Photographie de Londres.

197

Title	"White Loneliness"
Photographer	V Stankevicius

Another picture in which simplicity has created most of the impact, while the strong contrasts have projected the coldness of winter under snow with clarity and force, coupled with an attractive design.

Ein weiteres Bild, bei dem Einfachheit den größten Teil seiner Durchschlagskraft ausmacht, während die starken Kontraste die Kälte des Winters und von Schnee mit Klarheit und Macht projizieren, verbunden mit attraktiver Form.

Nog een opname waarin eenvoud voor het grootste deel de uitwerking bepaalt, doordat de sterke contrasten de kou van de winter en de sneeuw duidelijk en krachtig overbrengen. De compositie is interessant.

Otra fotografía de gran sencillez, mientras que los fuertes contrastes proyectan la idea de frío invernal bajo la nieve. El atractivo diseño posee claridad y vigor.

Autre photo dans laquelle la simplicité créait la plus grande partie de l'effet, tandis que les contrastes accentués expriment avec force et clarté le froid de l'hiver sous la neige, combinés à une composition séduisante.

198/199

Title	"Spring"
Photographer	Vladimir Filonov
Camera	Praktica L
Lens	50mm Helios
Film	KH-3 320ASA

Line derivation coupled with minimal solarisation has given an original aspect to a familiar subject and the symmetrical composition is successful.

Die Ableitung von Linien, verbunden mit geringstem Sonnenlicht, ergab einen originellen Aspekt eines bekannten Themas, und die symmetrische Komposition ist erfolgreich.

Lijnomwerking, in combinatie met een lichte solarisatie, heeft aan dit vertrouwde onderwerp een origineel aspect toegevoegd; de symmetrische compositie is erg succesvol.

El aspecto original de este tema se ha logrado con la derivación de la línea y un mínimo de solarización. La composición simétrica se ha logrado con éxito.

Le jeu des lignes, associé à un minimum de lumière solaire, donne à ce sujet familier son originalité, la composition symétrique est heureuse.

199

Title	"Way to the Church"
Photographer	Jens O Hagen
Camera	Canon F1
Lens	17mm
Film	Tri-X 135

The contemporary fashion for simplicity extends to all subjects and adds mood to this nicely composed subject.

Die derzeitige Anziehungskarft der Einfachheit erstreckt sich auf alle Themen und verleiht dem hübsch komponierten Thema Stimmung.

De hedendaagse voorliefde voor eenvoud is in alle onderwerpen terug te vinden; in deze fraai gecomponeerde opname vinden we daarvan een voorbeeld.

La atracción actual hacia la sencillez llega a todos los temas y añade un toque característico a esta toma.

L'attrait contemporain pour la simplicité s'étend à tous les sujets et donne de l'atmosphère à ce sujet bien composé.

200

Photographer	T Keeler
Camera	Nikon F
Lens	105mm micro Nikkor
Film	Tri-X at 1,600ASA

Grain, which was once condemned, has become a powerful force in giving an original look to some types of portraits, and this is a good example of its use to advantage.

Körnung, die früher nicht gefragt war, wurde zur wichtigen Kraft, um gewissen Porträts ein originelles Ausehen zu verleihen. Dies ist ein gutes Beispiel für ihre vorteilhafte Verwendung.

Werd gekorreldheid bij een opname vroeger uitsluitend als een nadeel gezien, tegenwoordig wordt zij gebruikt als een sterk middel om bij bijvoorbeeld bepaalde portretten een origineel aanzien te creëren. Deze opname is een voorbeeld van een succesvolle toepassing.

El grano, que había sido tan rechazado anteriormente, representa la gran fuerza y original aspecto de este retrato.

Le grain, autrefois condamné, est d'une grande force dans certains types de portraits; ici l'auteur a bien su en tirer parti.

201

Title	"At the Window"
Photographer	Veikko Wallström
Camera	Nikon F
Lens	105mm Nikkor
Film	Tri-X

A mood of sadness or even frustration is well expressed in this excellent example of a popular theme.

Dieses ausgezeichnete Beispiel für ein beliebtes Thema bringt Traurigkeit oder sogar Enttäuschung zum Ausdruck.

Droefheid of misschien zelfs teleurstelling wordt goed tot uiting gebracht.

Un toque de tristeza y hasta de frustración se ven reflejados en este excelente ejemplo de un tema actual.

Un sentiment de tristesse et même de frustration bien exprimé dans cet excellent exemple d'un thème fréquent.

202

Photographer	Colin Whelan
Camera	Olympus OM-2
Lens	300mm Zuiko
Film	Tri-X

A picture which requires split-second timing and a lot of nerve to stay in place and hold the camera steady. A fine technical achievement.

Ein Bild, das eine absolut genaue Zeiteinstellung und viel Nervan bei der Aufnahme benötigt und um nicht mit der Kamera zu wackeln. Ein guter technischer Erfolg.

Een dergelijke foto vereist een tot op een fractie van een seconde nauwkeurige timing en stalen zenuwen om te blijven staan en de camera rustig te houden. Een uitstekende technische prestatie.

Fotografía que requiere una programacíon al milímetro y un buen control de equilibrio para mantener la cámara fija. Gran logro técnico.

Une photo calculée au quart de seconde et exigeant des nerfs d'acier pour garder l'appareil immobile.

203

Title	"A good seat"
Photographer	Margaret Salisbury
Camera	Pentax SP
Lens	100mm
Film	FP4

Very few would think of photographing such a view so well and the humorous title is a bonus.

Wenige würden glauben, daß sich eine Ansicht wie diese so gut fotografieren ließe. Der humorvolle Titel ist eine Zugabe.

Er zijn er slechts weinigen die dit beeld op een zo rake wijze zouden hebben gefotografeerd.

A pocos se les ocurriría fotografiar tal tema con tanta calidad, y el título le da el toque de gracia.

Peu de personnes penseraient à photographier aussi bien une telle vue et le titre humoristique est en prime.

204

Title "Bif"
Photographer Stephen Power
Camera Cosina CT4
Lens 50mm
Film HP5 rated at 800ASA

Bif, the vocalist with the heavy metal band "Saxon", waves his fist at a Liverpool audience. Taken by stage lighting it has an authentic atmosphere.

Bif, der Sänger in der Heavy-Metal-Band "Saxon" droht den Zuhörern in Liverpool mit der Faust. Diese Aufnahme, die mit Bühnenbeleuchtung aufgenommen wurde, hat authentische Atmosphäre.

Bif, de zanger van de groep 'Saxon', zwaait met zijn vuist naar het publiek in Liverpool. Omdat de opname bij de bestaande toneelverlichting werd gemaakt is de sfeer authentiek.

Bif, el vocalista con su "Saxon" de metal, saluda con el puño a la audiencia en Liverpool. Fue tomada durante la actuación, con la luz del escenario y el ambiente del momento.

Bif, le chanteur du groupe "Saxon", brandit le point devant un auditoire de Liverpool. Cette photo, prise sous éclairage de scène, possède une atmosphère authentique.

205 (Upper)

Title "Gypsy Violinist"
Photographer Zbigniew J Podsiadlo
Camera Olympus OM-1
Lens Tamron 135mm
Film Agfa Professional

A delightful character portrait with added interest because of the unusual dress for a musician. The diagonal composition with the opposing bow provides a lot of vitality and force.

Ein interessantes Charakterporträt, das zusätzliches Interesse erhält, da der Musiker ungewöhnlich gekleidet ist. Die Diagonalkomposition mit quer verlaufendem Bogen bietet viel Vitalität und Kraft.

Een bijzonder aardig karakterportret dat extra opvalt door de ongewone kleding van de muzikant. De diagonale compositie met de 'dwarse' strijkstok doet de foto winnen aan levendigheid en kracht.

Un atractivo retrato donde el vestuario poco común del músico sirve para añadir interés a la foto. La composición diagonal opuesta al arco le confiere vitalidad y fuerza.

Un ravissant portrait de caractère dont l'intérêt est accru par l'habillement insolite de musicien. La composition en diagonale avec l'archet dans le sens opposé donne beaucoup de vitalité et de force à cette photo.

205 (Lower)

Title "Ron Carter"
Photographer Erwin Kneidinger
Camera Nikon
Lens 105mm f2.5
Film Ilford HP5 400ASA

The rapt expression on this musician's face is the making of the picture but the author has chosen the right format and treatment to project it forcibly.

Der versunkene Ausdruck auf dem Gesicht dieses Musikers ist der Inhalt des Bildes. Der Fotograf hat jedoch Format und Darstellung richtig gewählt, um es kraftvoll zu projizieren.

De extatische uitdrukking op het gezicht van de musicus is het belangrijkste element in deze foto, maar de fotograaf heeft om dat optimaal te doen uitkomen gezorgd voor een juist formaat en precies de goede afwerking.

La expresión arrebatada del músico domina la foto, pero es mérito del autor el haber escogido el formato correcto y el tratamiento que la proyecta con fuerza.

C'est l'expression extatique du visage de ce musicien qui fait la photo mais l'auteur a choisi le format et le traitement qui conviennent pour la faire ressortir avec force.

206 (Upper)

Title "Love"
Photographer V L Pokorny
Camera Praktisix
Lens 120mm Biometer
Film Forma 21 DIN (100ASA)

The spirit of youth is well projected in this pleasing action shot featuring young lovers "letting off steam".

In diesem angenehmen Bewegungsschnappschuß mit jungen Liebenden, "die sich austoben", ist der Geist der Jugend voll eingefangen.

Deze foto van twee jonge geliefden die duidelijk aan het stoom afblazen zijn ademt een jeugdige atmosfeer.

El espíritu de la juventud queda bien proyectado en esta toma de los jóvenes amantes.

L'esprit de la jeunesse est bien traduit par ce cliché d'amoureux "dépensant leur énergie superflue".

206 (Lower)

Title "Homeward"
Photographer V L Pokorny
Camera Praktisix
Lens 80mm Tessar
Film Forma 21 DIN (100ASA)

An interesting contrast with the picture above and obviously specially arranged but very well done.

Interessanter Kontrast zum vorstehenden Bild und wahrscheinlich speziell arrangiert, aber sehr gut ausgeführt.

Een interessant contrast met de foto boven, duidelijk gearrangeerd maar erg goed uitgevoerd.

Un interesante contraste con la fotografía anterior. Aunque diseñada a propósito, no por eso ha perdido en calidad.

Contraste intéressant avec la photo ci-dessus; de toute évidence spécialement arrangée mais très bien faite.

207

Title "Rainy"
Photographer L B Ferosovi
Camera Minolta SR7
Lens 180mm Sonnar
Film Forma 21 DIN

Another photographer's interpretation of a similar theme to the picture opposite and it shows how no two creative minds think in exactly the same way.

Eine weitere Interpretation eines Fotografen mit ähnlichem Thema wie das Bild auf der genenüberliegenden Seite. Es zeigt, wie zwei kreative Gemüter genau das gleiche denken.

De extatische uitdrukking op het gezicht van de musicus is het belangrijkste element in deze foto, maar de fotograaf heeft om dat optimaal te doen uitkomen gezorgd voor een juist formaat en precies de goede afwerking.

Een andere benaderingswijze van een soortgelijk onderwerp als op de tegenoverliggende bladzijde; het laat zien dat het mogelijk is dat twee creatieve geesten tot een gelijke uitwerking komen.

Otra interpretación fotográfica del mismo tema que la fotografía opuesta. Como se pueda apreciar, las creaciones no son nunca exactamente iguales.

Interprétation par un autre photographe d'un thème semblable à celui de la photo ci-contre, qui montre que deux esprits créateurs ne pensent jamais exactement de la même façon.

208

Photographer Frank Peeters
Camera Nikon F2A
Lens 28mm Nikkor
Film Tri-X
Filter Red

A thought-provoking picture with plenty of mood created by an unusual composition and a powerful tone scheme.

Ein zum Denken anregendes Bild mit ausreichender Stimmung durch die ungewöhnliche Komposition und ein starkes Tonsystem.

Een stemmingsvolle foto met een ongebruikelijke compositie en een krachtige toonwerking die bij de toeschouwer zeker gedachten oproept.

Una fotografía que llama a la reflexión. Recibe el tono característico del tema por medio de la composición fuera de lo corriente y la fuerza de la tonalidad.

Une photo qui fait réfléchir; beaucoup d'atmosphère créée par une composition inhabituelle et un puissant arrangement des tons.

209

Photographer John Vandenberghe
Camera Nikkormat FT2
Lens 55mm Nikkor
Film Tri-X

A documentary subject rendered with activity in composition and tone. The high placing of the child adds poignancy.

Ein Dokumentarthema, das in Komposition und Ton aktiv gehandhabt wurde. Der hohe Sitze des Kindes verleiht ihm Prägnanz.

Een documentaire opname waarbij van de compositie in de tonen een bepaalde activiteit uitgaat. De hoge plaatsing van het kind maakt het beeld inhoudelijk extra scherp.

Un tema documental logrado con la actividad de la composición y los tonos. El toque patético proviene de la altura donde se ha situado la niña.

Un sujet documentaire rendu avec activité dans la composition et les tons. Le positionnement de l'enfant en haut de l'image augmente le caractère poignant.

210

Title "Peter Keane in World Canoe Championship"
Photographer Mike Brett
Camera Nikon F2
Lens 300mm
Film XP1 (uprated)

Canoe contest pictures are always exciting but this example is a nice change from the side views which rarely show the tension in the competitor's face.

Bilder von Kanurennen sind immer interessant. Dieses Beispiel ist jedoch einmal anders als die normalen Seitenansichten, die selten die Spannung auf dem Gesicht des Sportlers zeigen.

Kanowedstrijden zijn vaak een opwindend onderwerp; deze foto is een aardige afwisseling van de meestal in zijaanzicht opgenomen foto's waarop zelden de spanning van de kanovaarder is te zien.

Las fotografías que se hacen de las regatas siempre son interesantes, pero en este ejemplo apreciamos el perfil de tensión del competidor como pocas veces aparece.

Les photos de course de canoë sont toujours excitantes et celle-ci nous change agréablement des prises de vues latérales qui ne montrent que rarement la tension sur le visage du concurrent.

211

Title	"Howard Allen of Barrow"
Photographer	Mike Brett
Camera	Nikon F2
Lens	300mm
Film	HP5 (uprated)

A fine action shot which won the title of Sports Picture of the Year.

Ein schönes Bewegungsbild, das sich den Titel "Sportbild des Jahres" erwarb.

Een fijne actieplaat, die in Engeland tot sportfoto van het jaar werd uitgeroepen.

Un disparo excelente que la convirtió en la Mejor Fotografía Deportiva del Año.

Un très bon cliché d'action qui a remporté le titre de photo sportive de l'année.

212

Title	"Three Judges"
Photographer	Jenny Goodall
Camera	Nikon FE
Lens	50mm Nikkor
Film	HP5

Typically English characters at a horse show where they are acting as judges. A valuable documentary picture nicely presented.

Typisch englische Charaktere auf einer Pferdeschau, wo sie als Preisrichter fungieren. Ein wertvolles Dokumentarbild, gut präsentiert.

Echt Engelse types, gezien tijdens een paardententoonstelling waar ze deel uitmaakten van de jury.

Personajes típicamente ingleses durante una competición de saltos. Valiosa aportación documental y bien presentada de estos personajes actuando como jueces.

Des anglais typiques à un concours hippique auquel ils participent en qualité de juges. Une bonne photo documentaire, bien présentée.

213

Title	"The Riding School Manageress"
Photographer	John Heywood
Camera	Pentax Spotmatic
Lens	8mm Fish-eye
Film	FP4

The humorous effect made possible by the use of a fish-eye lens is well, if somewhat unkindly, projected here. One cannot avoid being impressed enough for a second look.

Humorvoller Effekt durch Verwendung eines Fischaugen-Objektivs, der hier gut, obgleich etwas unfreundlich, projiziert wird. Man kann nicht vermeiden, genug beeindruckt zu sein, um ein zweites Mal hinzusehen.

Het humoristisch effect dat door het gebruik van een fisheye-objectief kan worden verkregen is hier goed, zij het weinig flatterend, uitgewerkt. De indruk is toch zodanig dat men nog een tweede keer wil kijken.

Se ha logrado el toque de humor por medio del objetivo "ojo de pez". Aunque un poco despiadada, esta fotografía invita a que se la mire de nuevo.

L'effet humoristique rendu possible par l'utilisation d'un objectif fisheye est ici bien rendu même si le résultat est peu flatteur. Le genre de cliché sur lequel on ne peut pas s'empêcher de revenir.

214 (Upper)

Title	"Antiquity"
Photographer	Oleg Burbowskij

A familiar scene is given a very original presentation by dramatic contrasts of three planes, aided by a long focus lens. Did you spot the figure?

Ein bekanntes Bild erhält eine sehr originelle Darstellung durch drastische Kontraste auf drei Ebenen, unterstützt durch ein Fernobjektiv. Haben Sie die Frau entdeckt?

Een zo langzamerhand bekend tafereel heeft hier een zeer originele presentatie gekregen door de dramatische contrasten van de drie vlakken in de diepte, die wordt versterkt door het gebruik van een lang tele-objectief. In tweede instantie ontdekken we pas de aanwezigheid van de vrouw.

Una escena familiar presentada con originalidad por medio del contraste de tres planos. ¿Podemos ver a alguien?

Une scène familière présentée de manière originale grâce aux contrastes dramatiques des trois plans obtenus au moyen d'une longue focale.

214 (Lower)

Title	"Viejo Castillo"
Photographer	Alejandro M Gonzalez
Camera	Nikon FM
Lens	28mm Nikkor
Film	Tri-X

Extra hard printing is effective when employed for craggy rocks and ruined castles. The unusually dramatic sky adds to their impact.

Besonders harter Abzug ist ein Effekt, wenn er für zerklüftete Felsen und Burgruinen verwendet wird. Der ungewöhnlich drohende Himmel verleiht zusätzliche Durchschlagskraft.

Als men de sfeer en de aanwezige structuren van een dergelijk landschap met grillige rotsen en een kasteelruïne goed wil laten uitkomen, is afdrukken op extra-hard papier uitermate effectief. Het effect wordt nog versterkt door de lucht, die met behulp van een oranje streepje of roodfilter een dramatisch aanzien kan krijgen.

El positivado vigoroso da buen resultado cuando se trata de paisajes rocosos y castillos en ruina. El dramatismo del cielo aumenta el impacto.

Le tirage sur papier extra-dur donne des résultats convaincants quand il s'agit de rochers déchiquetés et de châteaux en ruines. Le ciel tourmenté accentue l'effet produit.

215

Photographer	Vera Weinertova
Camera	Pentacon Six
Lens	50mm
Film	Agfa ISS

Low angle landscape shots have become very popular in recent years and this one has plenty of drama as well as an artistic composition.

Landschaftsaufnahmen in niedrigem Blickwinkel wurden in den letzten Jahren besonders beliebt. Diese ist bei künstlerischer Komposition stark dramatisch.

Een zeer sterk voorbeeld van een zinvolle toepassing van een laag standpunt in combinatie met een groothoekobjectief bij landschapopnamen met een voorgrond, waarin een boeiende structuur te herkennen valt. De foto doet dramatisch aan, de compositie is artistiek.

Las vistas tomadas desde puntos de vista bajos son muy populares en la actualidad; ésta tiene gran dramatismo, al mismo tiempo de ser una composición artística.

Le cadrage en longueur des paysages est très populaire depuis quelques années; ce cliché nous frappe par son intensité et sa composition artistique.

216

Title	"Columbus Day"
Photographer	John Davidson
Camera	Nikon
Lens	180mm
Film	Tri-X

A brilliant choice of viewpoint which contrasts soldiers at ease against a statue which appears to look to the future they may help to shape.

Brilliante Wahl des Blickpunktes, bei dem zwanglos stehende Soldaten mit einer Statue kontrastieren, die in eine Zukunft sieht, an der sie bauen.

Dank zij de uitstekende keuze van zijn opnamestandpunt wist de fotograaf het contrast tussen de soldaten en het 'verheven' standbeeld dat in de toekomst schijnt te kijken goed tot uiting te laten komen; de vlakvulling is daardoor erg geslaagd. Ook de keuze van brandpuntsafstand en diafragma zijn een compliment waard: het onderwerp steekt scherp af tegen een duidelijk onscherpe maar toch nog herkenbare achtergrond.

Un punto de vista brillantemente escogido. La actitud de reposo de los soldados contrasta grandemente con la de la estatua, que parece poder ver los grandes cambios del futuro.

Un cliché pris sous un angle excellent; les soldats décontractés sont en contraste avec la statue qui semble contempler le futur dont ils seront les artisans.

217

Photographer	Eric Pamies I Carrete
Camera	Pentax SP1000
Lens	200mm
Film	Tri-X

A picture full of rhythm by repetition and the viewpoint from the rear gives movement and depth.

Ein Bild, das durch Wiederholung voller Rhythmus ist. Durch den Blick von hinten erhält es Bewegung und Tiefe.

Een foto met een sterk door herhaling verkregen ritme, die door het opnamestandpunt ook een indruk van beweging en diepte geeft.

Una fotografía con mucho ritmo, logrado por la repetición y el punto de vista desde detrás, dotándole de movimiento y profundidad.

La répétition du motif rythme la photo et l'alignement des dos lui donne son mouvement et sa profondeur.

218

Title	"Benedictine Monk"
Photographer	Trevor Fry
Camera	Microcord
Lens	80mm
Film	Tri-X

A well conceived portrait projecting the dignity of his calling against an appropriate background.

Ein gut aufgenommenes Porträt, das von Würde und Berufung spricht, mit einem entsprechenden Hintergrund.

Deze foto is het bewijs dat men alleen met een doordachte aanpak tot een optimaal resultaat kan komen. In de summiere verlichting komt de waardigheid van de roeping precies goed tot uiting, tegen een passende achtergrond.

Un retrato bien logrado, que proyecta la dignidad del modelo contra el adecuado ambiente.

Un portrait bien cadré, évoquant la dignité de sa vocation dans un décor approprié.

219

Photographer	Tom Gore
Camera	Nikon F2
Lens	20mm
Film	Tri-X
	Electronic flash

A good study in contrast of lines and curves presented in an original composition which defies the orthodox "rules" with great success.

Eine gute Studie im Kontrast von Linien und Kurven in origineller Komposition, die den orthodoxen "Regeln" mit großem Erfolg trotzt.

Goede studie, met contrasterende lijnen en welvingen. Een originele compositie die de orthodoxe regels met succes weet te trotseren.

Este estudio de rectas que contrastan con curvas está bien presentado dentro de la composición original, que se enfrenta con éxito a las "reglas" ortodoxas.

Une bonne étude dont les lignes et les courbes en contraste constituent l'originalité de la composition qui défie les "règles" de l'orthodoxie avec beaucoup de succès.

220

Title	"Mick Jagger"
Photographer	Felipe Iguiñiz
Camera	Nikon F2
Lens	55mm
Film	Tri-X rated 6,400ASA

The leader of the "Rolling Stones" caught in expressive attitude at a concert in New York. The grain has added to the mood.

Der erste Musiker der "Rolling Stones" in ausdrucksvoller Haltung während eines Konzerts in New York. Die Körnung verstärkt die Stimmung.

De leider van de 'Rolling Stones', gesnapt in een expressieve houding tijdens een concert in New York. De korrel is medebepalend voor de stemming.

El líder de los "Rolling Stones" en actitud expresiva durante un concierto en Nueva York. El grano le da el toque característico.

Le chef de file des "Rolling Stones" saisi dans une attitude expressive au cours d'un concert à New-York. Le grain renforce l'atmosphère.

221

Title	"Face of Shadows"
Photographer	Robert Mason
Camera	Nikon FM
Lens	135mm Nikkor
Film	FP4

A most exciting and original treatment for a portrait giving it tremendous impact.

Eine äußerst interessante, originelle Darstellung für ein Porträt mit enormer Durschschlagskraft.

Een zeer opvallende en originele benaderingswijze voor een portret waardoor het sterk de aandacht trekt.

Un retrato de gran impacto por su tratamiento original e interesante.

Un traitement fascinant et original d'un portrait, lui donnant toute sa vigueur.

222

Photographer	Denis Thorpe
Camera	Nikon F2
Lens	35mm Nikkor
Film	FP4

Texture rendering as strong as this seems appropriate for such a subject and has helped the vivid characterisation.

Die Wiedergabe der Struktur in einer Stärke, die für ein solches Thema zutreffend erscheint, unterstreicht die lebhafte Charakterisierung.

Deze levendige karakterschets laat mede zijn sterke indruk na doordat de structuur zo is benadrukt.

El fuerte acabado de esta foto parece el adecuado para este tema y ha aumentado su vivida caracterización.

La texture forte convient très bien au cliché et contribue à la mise en valeur du personnage.

223

Title	"Tovari"
Photographer	István Tóth
Camera	Hasselblad
Lens	150mm Opton
Film	Orwo NP22

A powerful portrait showing a lot of character and following the trend for an oblong portrait with rich blacks in the background.

Ein eindrucksvolles Porträt mit viel Charakter, der Tendenz zu Porträts im Querformat folgend, mit starkem Schwarz im Hintergrund.

Een krachtige portretopname die tevens als karakterstudie dienst doet; ook hier is de toepassing van een liggend formaat en een achtergrond met flinke zwarte partijen uitstekend geslaagd.

Un retrato de fuerza, donde gran número de personajes aparece enmarcado en un ambiente oscuro. El retrato triangular sigue teniendo gran actualidad.

Un portrait à la puissance et au caractère indéniables qui suit la mode du cadrage en largeur et des masses noires dans le fond.

224

Title	"My Pal the Elephant"
Photographer	Mike Hollist
Camera	Nikon F2
Lens	105mm
Film	Tri-X

Contrasts in size as well as tones can have a message and, as in this case, can also be very funny. This child of the circus obviously knows no fear.

Kontraste in Größe und Tönen, die, wie in diesem Fall, eine Aussage machen, können auch sehr komisch sein. Dieses Kind aus dem Zirkus kennt offensichtlich keine Furcht.

Contrasten in verhoudingen en in toonwaarden brengen vaak een boodschap over die zoals hier humoristisch kan zijn. Het circuskind is duidelijk niet bang.

Los contrastes de tamaño y de tonalidad sirvan para comunicar mensajes que, como en este caso, pueden ser cómicos. Este niño del circo, obviamente, no parece tener miedo.

Le contraste des volumes et des tons transmet un message et comme c'est le cas ici, peut être très amusant. Cet enfant de la balle n'a visiblement peur de rien.

Back Endpaper

Photographer	S. Paul
Camera	Nikon FE
Lens	80-200mm f4.5 zoom Nikkor at 80mm setting
Film	Orwo NP55

Masses of people from a high viewpoint do not often form a good composition but here the fact that nearly all are facing towards the camera moulds them into a unified design with a lot of depth.

Menschenmassen von einem hohen Blickpunkt aus gesehen, bilden häufig keine gute Komposition. Hier formt sie die Tatsache, daß sie fast alle zur Kamera sehen, jedoch zu einem vereinheitlichten Bild mit großer Tiefe.

Vanaf een hoog standpunt gemaakte opnamen van mensenmassa's zijn lang niet altijd in een goede compositie te verwerken, maar hier brengt het feit dat bijna alle mensen met hun gezicht naar de camera toelopen ze tot een eenheid, waarin tevens een indruk van diepte wordt gegeven.

Las tomas de multitudes desde un punto de vista alto no suelen dar la buena composición que tenemos en ésta, y el que todos estén mirando hacia la cámara, les ha convertido en un diseño uniforme donde se aprecia gran profundidad.

La composition d'un cliché d'une foule photographiée d'en haut est rarement satisfaisante; ici néanmoins, l'unité et la profondeur sont assurées par le fait que pratiquement tous les personnages sont tournés vers le photographe.

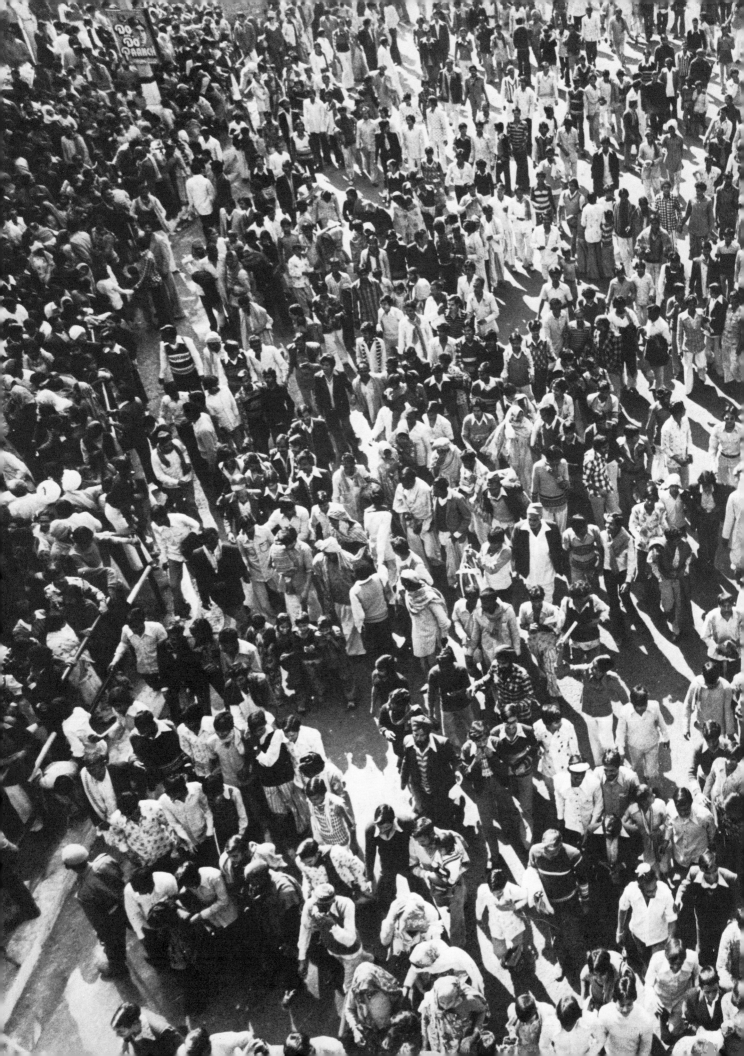